Painting Portraits

Painting Portraits

BY EVERETT RAYMOND KINSTLER

Edited by Susan E. Meyer

WATSON-GUPTILL PUBLICATIONS / NEW YORK
PITMAN PUBLISHING / LONDON

For Lea. For Kate and Dana and my mother.
Without them it wouldn't have meant a damn.

First Published 1971 in New York by Watson-Guptill Publications,
a division of Billboard Publications, Inc.,
One Astor Plaza, New York, N.Y. 10036

ISBN 0-8230-3820-3

Library of Congress Catalog Card Number: 76-159563

Published in Great Britain 1975 by Pitman Sir Isaac & Sons Ltd.,
39 Parker Street, London WC2B 5PB

ISBN 0-273-00923-0

Manufactured in Japan

First Printing, 1971
Second Printing, 1972
Third Printing, 1975

Contents

Foreword

You say you are studying to become a portrait painter and I think you'd be making a great mistake if you kept that only in view during the time you intend to work in a life class, for the object of the student should be to acquire sufficient command over his materials and do whatever nature presents him. The conventionalities of portrait painting are only tolerable in one who is a good painter. If he is only a good portrait painter, he is nobody. Try to become a painter first and then apply your knowledge to a special branch. But do not begin by learning what is required for a special branch or you will become a mannerist.

John Singer Sargent, *Letter to an art student, 1901*

This book came into being because of my teaching painting and drawing at the Art Students' League in New York City. This is not a "how to do it" book. Nor does it offer a recipe, short cut, or easy way to paint. Rather, it is my approach to the particular area called portraiture.

For those attracted to painting portraits, I would say that the artist must be interested in, and respond to people. It is an attitude, and must be a positive one. If the artist painting portraits feels he is doing work that is strictly a commercial adventure or approaches his subject with condescension, I would say, "Don't paint portraits!" A portrait is a personal work and must reflect the artist's interpretation and artistry in presenting his subject. He must remember that each commission represents an individual and separate problem. This requires insight, taste, and an approach that takes into consideration the differences, uniqueness, and many facets of his subjects. There are other necessary ingredients for the artist: self-discipline, good humor, and the desire to communicate his impressions. But, above all, he must want to paint portraits! Bearing Sargent's admonition in mind, this does not mean the portraitist doesn't want to paint landscape, still life, or the figure. It does mean an intense desire to interpret the human being.

I hope those interested may find among these pages some signposts and stimulation.

And fun.

Everett Raymond Kinstler

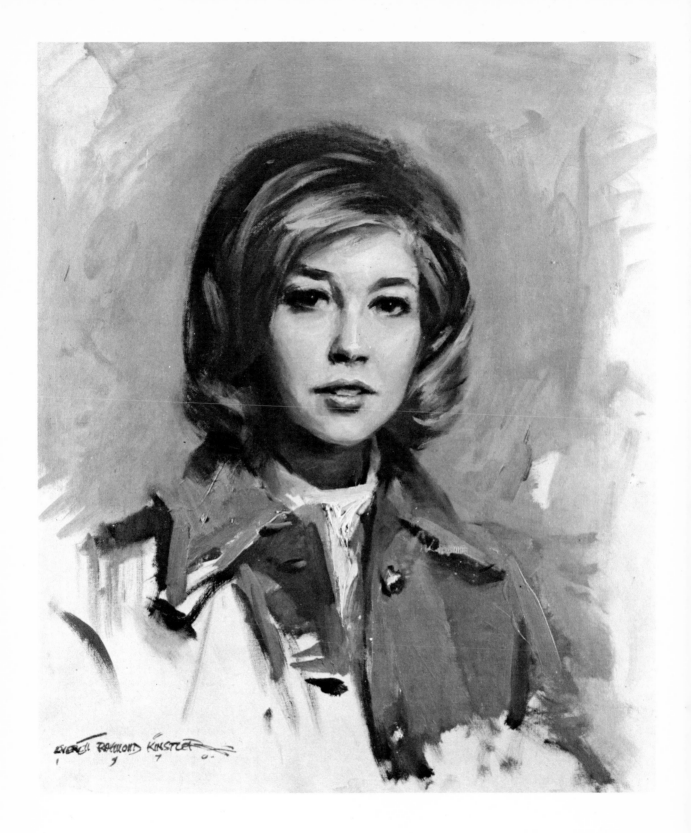

Pamela Hall *24″ x 20″ I intentionally retained the sketchy quality in this head and shoulders portrait to express youth. The background was left very simple, so it would not detract from the head itself. The portrait is also lively due to the colorful salmon colored suit. I asked Miss Hall to open the collar because I felt its being closed was too severe. Collection, Mr. and Mrs. Jansen Noyes.*

CHAPTER 1

Materials and Tools

Painting is tough enough. If you stint on the tools you use, you only make the task that much more difficult. For this reason, I prefer high-quality materials. I find that if I use the best tools and materials I get the best performance from them, and they are actually more economical in the long run.

In my portrait work, I strive for a broad and bold effect and paint in a direct approach. What this means, simply, is that I don't lay on a succession of layers of paint over the entire canvas each time I paint. Some painters, when they work in oil, build up their paintings in layers, working for transparent effects. First, they apply an underpainting, then glazes (transparent layers of paint which are laid over other colors, much like placing sheets of tinted cellophane over the surface) and scumbles (opaque paint placed over another color).

It's not that I disapprove of painting in this method. It's simply that I find the direct method of painting more suitable for my portraits and my personality—it allows me to achieve a certain freedom and spontaneity which may be lost by constant reworking. I may repaint and rework passages, but I seldom rely on under layers to achieve specific effects.

My technique assumes that the portraits will be viewed and evaluated from a distance. Occasionally, when I do an oil painting which is specifically designed for reproduction and which I know is going to be reduced considerably, I may produce a painting that is very "tight," working in glazes and scumbles, using paint that is fluid enough for me to draw precisely so that when it is reduced it will still retain the details. But in my portrait work, the painting itself is the final result, not a reproduction.

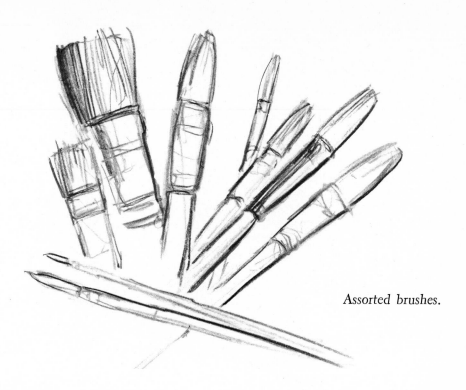

Assorted brushes.

Brushes

The direct method of painting suggests my choice of brushes.

There are two basic categories of brushes: sables and bristles. The sable brush is noted for its softness; it's a flexible brush without having much spring. With its ability to hold more liquid paint, this brush is most suitable for detail and is an ideal brush for blending. The sable is effective in passages where you don't want any texture—where you don't want the brushstroke to show. For example, I use the sable mainly for transitional areas in the painting: I tend to apply a heavy amount of paint (impasto) in the light areas, where I want a certain texture, and I move toward a wash in the shadow areas. I may use the sable to make the transition between these two areas. Frankly, this is about the only consistent use I find for the sable brush because it's too soft for most of my needs.

The bristles are another story. Unlike the sable—which is ideal for watercolor—the bristle brush has resilience and spring and is capable of holding considerable quantities of paint, all of which make the brush excellent for creating texture. Bristles are divided into three categories: rounds, flats, and filberts. The round bristle contains hairs carefully tapered to a point. I almost never use rounds, even though many portrait painters do like them. They aren't resilient enough for me and their stipple-like character rarely appeals to me.

The flats are brushes whose bristles have been squared off abruptly, which gives the brushstroke a bold, hard edge. Flats have a tendency to fan out as you work, which you may or may not find desirable. Since they are so suitable for textural passages, I tend to use them—particularly the large 2″ flats —for backgrounds.

Of the brushes I've mentioned so far, none gives me more service than the filberts. These are brushes whose bristles have been tapered. Their ends give me a more incisive stroke. The filberts never fan out as the flats do, which is one reason I prefer them. For me, the filbert is a seductive brush.

Because I use filberts for practically everything, I have a pretty extensive collection of them, ranging in sizes from no. 3 to no. 12. These ten brushes can carry me through any job, and since I keep them clean as I work, I can really paint an entire picture using just these ten. Even after the brushes are worn, I may use their ragged edges for rough, textural passages.

In fact, if you keep your brushes clean as you work, you can even paint within a range of six brushes—as I have—keeping certain brushes for light areas and others for halftone areas.

As I paint, I select the brush that will suit the particular volume of paint and area of canvas I want to cover. In other words, if I'm going to paint a background, I use a large brush. If I paint something that will be ¼″ in diameter, I use a brush that will give me that stroke. I pick the brush that will enable me to follow that form in the stroke.

Painting Knives

Although I use the painting knife for painting only infrequently, I do find it a handy tool for certain purposes. When I've built up a passage with thick applications of paint, I may find that the texture is too strong, that it picks up too much light. In some instances, I scrape off the thick paint to subdue or eliminate the passage.

I tend to use the knife more frequently in painting landscapes, applying the paint with the flat edge of the knife for broad, flat expanses of color.

Palette and painting knives.

Drawing Tools

I do a great deal of sketching, particularly where larger compositions are involved or when working out certain ideas before I set them down on canvas. Therefore, I always have on hand some materials I can use for drawing. Sometimes I enjoy working on a paper with a strong texture ("tooth");

sometimes I work on a smooth-finish sheet. As a matter of fact, I'll draw on anything I can find, even a paper bag if necessary.

For drawing, I use just about any material except pastel. In other words, I'll work with lithographic crayon, charcoal, wax crayon, pen and ink, or felt tip pens whenever I'm drawing in monochrome. As soon as I consider doing a multicolored sketch, I almost invariably move into oil—the medium in which I can most easily record an impression. Because I prefer the fluidity of oils, I do not respond well to pastels. In fact, the only time I use chalk of any kind is when I'm blocking in something on the canvas which is just a tentative idea, knowing that I can easily eradicate the chalk and paint over it in oil.

Canvas

I always paint on linen canvas which has already been primed (precoated with white lead) so that I can paint immediately on the surface without having to prepare it myself. I buy the canvas in six foot rolls, 54″ and 90″ wide. I keep both widths in stock so that I can avoid unnecessary waste of canvas by considering the size of my painting in relation to the widths of the rolls. For example, if I'm doing a portrait that is 40″ x 50″, I only lose 4″ of canvas by cutting from the smaller roll. However, if I'm painting a 30″ x 40″ canvas, I'll cut the piece from the 90″ roll, knowing that I have enough left over for still another canvas of the same size.

I like to paint on a surface with some tooth, but not too much. If the canvas happens to have a very coarse texture, I buy double-primed canvas which reduces the amount of texture. If the surface happens to be less textured, I buy single-primed canvas. However, I may change canvas textures from time to time for variation. And on occasion, I use prepared canvas panels for studies, although the board doesn't offer the resilience or spring I find so desirable in the stretched canvas.

Stretching Canvas

Once I've cut the size canvas I want, I stretch it onto a stretcher frame. I always allow several additional inches of canvas beyond what I need for stretching. There's a good reason for leaving this extra canvas: I have more flexibility in my composition. For example, I may find that the composition of my painting would be improved by cutting off something near one edge of the canvas. I still have the extra inches from the opposite edge which I can bring around from other edges.

I put together the stretcher and I tack or staple the canvas onto the frame. First I stretch the canvas in the center of each side, and staple that. (Tacks are just as suitable as staples.) Then, taking a side at a time, I staple to the left and to the right of each staple. I continue stapling each side, two staples at a time, one to the left and one to the right of the previous staples, until I reach the corners. At this stage, I hammer in the wooden keys which have been placed in the corners. The farther in I drive the keys—there

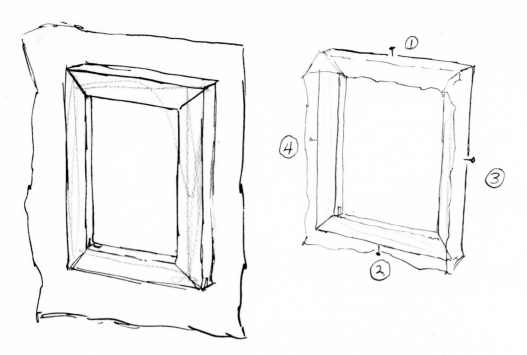

I leave extra canvas around the edge of the frame. Tack the canvas onto the frame from the center out. After all the tacks are secured, tighten the stretcher with the keys in the corners if necessary.

are two in each corner—the more they open the corners, and stretch the canvas still more tautly.

I use ordinary stretcher frames available at the art materials supply store. In the case of larger canvases (let's say above 30″ x 36″), I use heavy-duty stretcher frames—they're simply a bit broader than the ones for the smaller canvases.

Restretching Canvas

While I'm on the subject of stretching canvas, I might also mention the problem of restretching. As I work on a painting, I may find that the composition can stand improvement. For example, I may want to move the position of the head slightly off center. This question will determine the final size and shape of my canvas. Since I cut the canvas larger than I needed, I can restretch it onto another frame or I can bring the canvas around from other edges on the same frame. However, there may be an unattractive crease in the canvas where it had folded over the original frame. Before placing the canvas onto the new frame, I fold back the canvas to even it out. If necessary, I use a palette knife to scrape down some paint that may have accumulated on the crease. Then I slightly moisten the back of the canvas with water, all along the line of the fold. I then restretch the canvas tautly onto the frame. As the wet canvas dries, it shrinks and stretches tautly, like a drum, and the ridge is smoothed out.

Palette

The kind of palette you select has to do very much with how you like to paint: do you like to hold the palette as you work, or do you prefer to have your palette in some fixed place? With portraiture, I like to hold my palette with me as I work, so that I can record impressions quickly as I move. My canvas may be six feet away, but I often move back fifteen feet or so to get an over–all impression. By holding onto the palette as I work, I can mix my colors as I move, mix them from far away, mix them from up close. I don't have to go back to my table to get the correct color. Instead, I step back, look at the model, mix my colors, then return to the painting. This method helps me retain the broad impression, large planes, and volume. So for painting on the move, I highly recommend a standard oval or circular style wooden palette, with the thumbhole to get a good grip.

Occasionally, I use a stationary palette when I paint in the studio. I simply place my palette on the taboret and mix my colors on it. At one time, I used to supplement this with a sheet of off-white paper placed over the top of my taboret, then I covered the paper with glass. I mixed my paints on this glass and the paper furnished me with a clean middle tone which enabled me to see my colors clearly.

Colors

My attitude toward colors is very uncomplicated. You can't mix colors without the primaries—red, yellow, and blue—the colors from which all others derive. You could paint anything with just these colors and white. From there on it's simply a matter of taste, as far as I'm concerned.

As you will see in the demonstrations, I make my choice of colors on the basis of their values—how light or dark they are—and their warm or cool qualities.

My palette of colors is fairly limited so that I can control the palette, not the reverse. I use no more than fourteen colors, and five or six could really be enough, since they are all variations of the primaries. Color should pulsate in a portrait. By limiting the colors on the palette, there is greater likelihood that the colors will constantly repeat themselves, harmonizing and complementing one another like themes in a piece of music.

On my palette, I lay out my colors from light to dark; from white to black. To make the paints more transparent, I simply dilute them, rather than use so-called "transparent" paints. How I handle these colors specifically will be dealt with later in the demonstration chapters. Basically, however, I key my colors to the subject. The colors I select and the ones I omit will be governed by what I'm painting. If the subject happens to be a child, for example, I'll lean toward the cadmiums because their intensity emphasizes youth. Someone wearing a very striking blue dress may require a Prussian blue. This is all a matter of personal taste. On the opposite page is a diagram of my "normal" palette, showing the colors I use and the way in which they are laid out, from black to white.

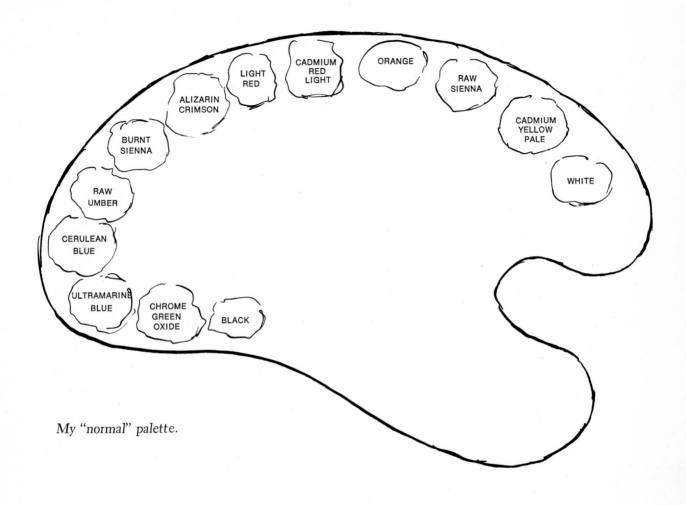

My "normal" palette.

My taboret.

Mediums

A medium is a liquid vehicle used for diluting paint. It is advisable to avoid excessive use of mediums, tempting though they may be. As a rule, keep the medium thin and use it sparingly!

For the early stages of painting, I rely heavily on turpentine. Keeping a cup filled on my palette when I paint, I dip my brush into the turpentine for a large wash of color, or when I want to clean my brush.

Sometimes I supplement the turpentine with a few drops of cobalt drier. This expedites drying, which is often necessary when I'm painting on location. However, avoid using too much cobalt drier because it tends to flatten color, making it look much the way ink looks when it soaks into a blotter. I think that cobalt eventually corrodes the canvas as well.

Once the painting has progressed, and I've achieved its general character, I may move from turpentine—which tends to thin and dissipate color—to linseed oil. In general, I use as little oil medium as possible for four reasons: oil encourages cracking; oil tends to yellow in time; oil produces a shine I rather dislike; and oil retards the drying process. In spite of my reservations, it *is* true that oil retains the intensity of color. It also makes the paint handle like butter, so I may use it the way I use a sable: for passages where I want a fluid effect. Furthermore, some paints may call for a medium more than others: earth colors, for example, tend to harden quickly and the medium makes them more pliable; cadmium colors, on the other hand, are more pliable and need less medium.

When I have just one sitting to do a portrait—in a painting demonstration, for example—I may use copal varnish as a medium. It dries quickly and retains the intensity of color.

Varnish

Varnish protects the surface, restores brilliance to the paints, and provides an evenness to the painting surface.

Colors sink in as the painting dries, so I use a retouch varnish to restore the brilliance—sometimes over the entire canvas, sometimes only in specific passages. Retouch varnish (the thinnest of the varnishes) comes in aerosol cans which best suit my purposes. Before the sitting, if the colors have lost their intensity, I simply spray on the retouch varnish in the areas that need some brightening up.

Dana 10" x 8" This portrait of my daughter was painted in transparent watercolor on a white ground. The danger in painting a watercolor portrait is that you can't make corrections and changes, unless you use opaque colors. However, watercolor is a spontaneous medium and opaque colors impair its appeal. I find watercolor particularly conducive to painting children: there's a quality in the freshness and openness of the medium which captures something particular in children, especially if the watercolor is handled loosely. The painting must be completed in one spurt; less than an hour here was sufficient.

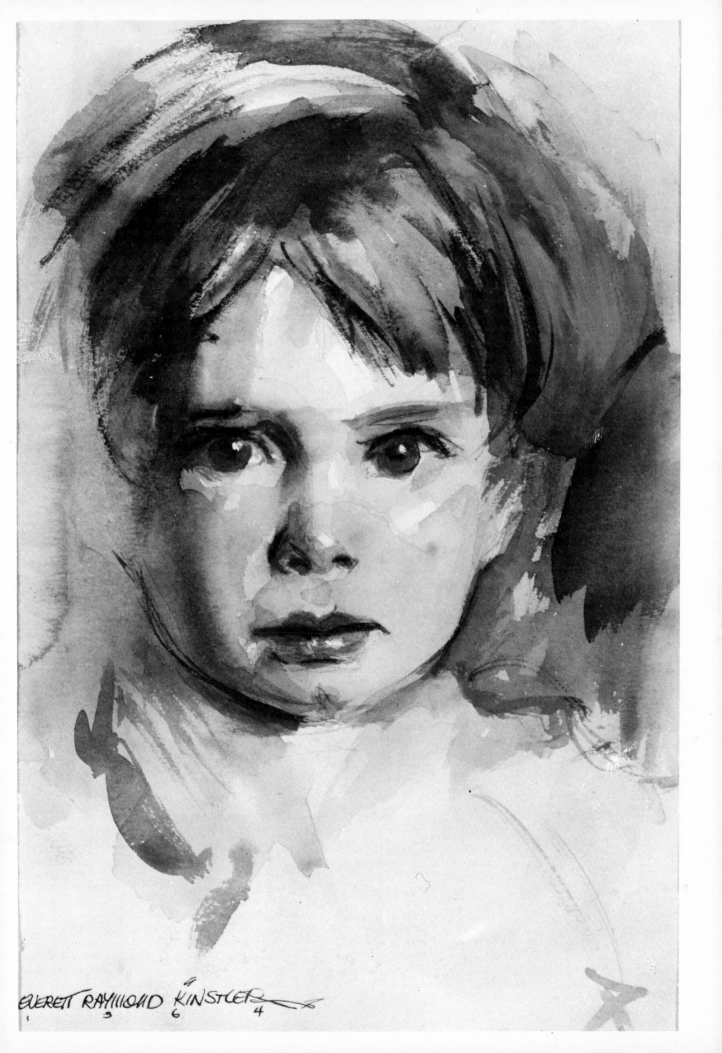

EVERETT RAYMOND KINSTLER

As a protective coat, final varnish should be applied over the finished painting, preferably not before a month or so after you've finished. For this purpose, I usually apply retouch varnish, where needed, rather than another heavier varnish, such as damar.

Although the final painting may look fine in the studio, its appearance may be affected later by circumstances beyond your control. You have to anticipate that the painting will hang in a less favorable atmosphere than that of your studio. For instance, the painting may be hung under the light of a chandelier or in the glare of direct sunlight. For this reason, avoid excessive coating when you varnish your painting.

The amount of varnish you apply is also affected by the amount of paint you've applied to the portrait. The more paint, texture, and oil you apply, the more sheen you create, and varnish added to this may produce a surface that's artificially glossy, like a coat of plastic. Turpentine, on the other hand, tends to flatten color and may need varnish to restore it. In order to achieve a consistent sheen, you may have to apply more varnish in some areas than in others. Another factor is the character of the portrait itself. You may feel, as I often do, that a duller surface retains a certain character of the painting.

Easels

I have two different kinds of easels: one for the studio and one for travel. My studio easel is large enough to support a heavy canvas. Occasionally, I want to see how a portrait looks in its final frame, so my easel must be strong

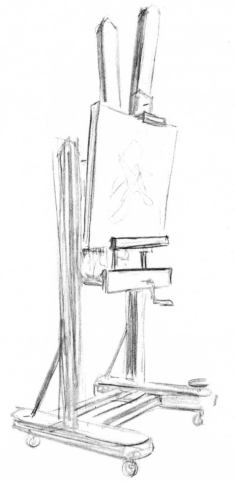

My studio easel.

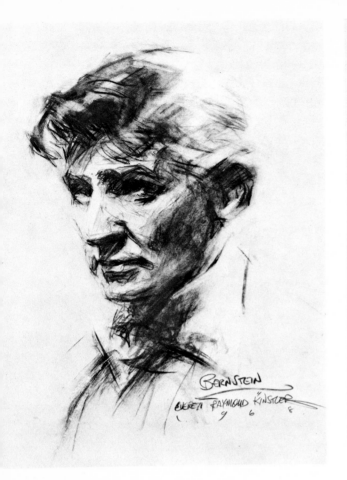

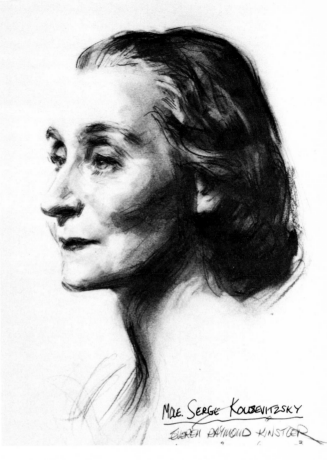

Leonard Bernstein (left) and **Mrs. Serge Koussevitzky** (right) each 20" x 16" I drew these with charcoal pencils and sticks, on three-ply kid finish bristol board. I sometimes work on a pad, particularly when I'm doing successive sketches, but for a single work I prefer stiff paper. Sketching is challenging because it forces you to think rapidly in large generalizations and broad tones. Lacking any color, the portrait is a simple statement of character. The white paper here establishes the light volume. For example, in the profile—a favorite angle for my portrait drawings—the point of the right brow and the hairline establish the entire forehead, without my defining either. Collection, National Arts Club.

enough to hold the canvas in its frame. The easel is adjustable to any height and is mounted on rollers so that I can move it easily around the studio.

For traveling, I need an easel that is simple, portable, and light. I once used a collapsible aluminum easel, but now I have found something even more compact: a wooden French paintbox easel. It consists of a box—which contains all my painting materials—and three legs which open. This unit, then, is both a carrier for my materials and an easel for supporting my canvas.

Mirror

I have a large mirror positioned behind me, to catch the reflection of the model and my painting in progress. I continually check my canvas and subject against the reflection in the mirror as I work. Seen in reverse, the reflection gives me a fresh viewpoint and a quick impression of the over-all effect. I strongly recommend this device for your portrait work. When traveling, I carry and use a hand mirror for the same purpose.

Care of Tools

To get the longest life from your tools, constant care is mandatory. Since you're so dependent on them, it's good sense to take care of them.

I make a handy device for my brushes so that they can stay clean while I work. I take an empty ice cube tray and place a wire mesh screen from the rim running lengthwise into the tray, like a ramp. I pour some turpentine into the tray and rest my soiled brushes on the screen so that they can bathe in the turpentine while I work, without any pressure being applied to their bristles. The paint residue drops through the screen to the bottom of the tray.

At the end of the portrait sitting, I wipe each brush, then wash it with soap and lukewarm water, rubbing the brush gently into the palm of my hand until I work up a good lather. Then I rinse the brush in clear water and repeat the process until all the paint is removed.

After each sitting, I also clean the mixing area of the palette. With a palette knife, I lift off some of the tube colors around the edges of the palette, place them on a paper palette, then return them to their position after I've cleaned off the surface of the wooden palette. From time to time, I give my palette a really good working over: I clean off the globs of paint, apply paint remover to the surface of the palette, then cover the surface completely with a light coat of shellac.

I don't want to sound doctrinaire about the materials I use or recommend that you use. In times of stress—working on location, for example—all sorts of things can go wrong and you may have to find ingenious and resourceful ways of substituting materials. What I *do* suggest is that you develop the attitude of a craftsman toward your tools so that you can control your tools efficiently. And being a professional demands the artist be informed about his materials to ensure the permanence of his work. This is a matter of integrity and responsibility both for the artist and to his clients. Experiment

with new materials, adopt old ones to other uses. Somerset Maugham once said: "Only two types can make their own: the artist and the thief." You work with your wits.

My system of keeping brushes clean as I work: an ice cube tray with a wire screen base.

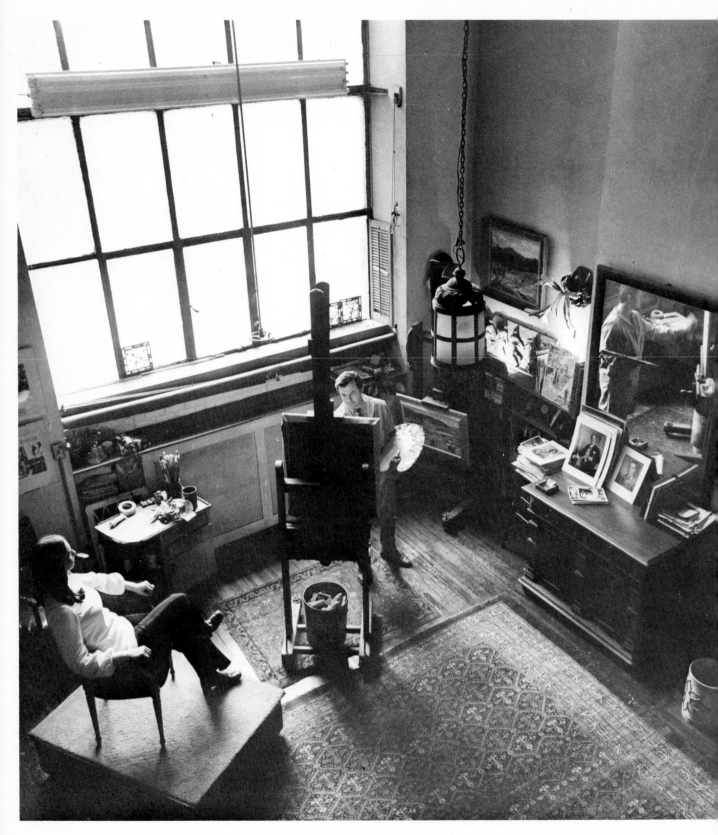

This photograph of my studio illustrates the entire set-up: the large window (the shade at the sill is completely furled), the fluorescent attachments on the window, the easel holding the canvas in the same light as the model sitting on the model stand, the mirror over my shoulder. Photo, Susan E. Meyer.

Setting Up the Studio

Now that I've touched on some of the materials I use for portrait painting, perhaps I should say a few words about the studio itself, since your place of work is every bit as important as the tools you work with. Above all, the studio must have two features: light and space. Using these to best advantage depends largely on what you have available to you. Here is how I work in my studio.

Painting in Natural Light

I prefer to paint with natural light rather than artificial. To qualify this even further, I work in an *unobstructed north light*. This is a clinical and critical light, a constant light that never changes, so that I am never disturbed by unwanted reflections or shadows. If a picture looks good in north light, it should look as good or better when it is placed anywhere else.

This doesn't mean you can't paint in west or east light. (South light is the most difficult light for painting!) These lights are more subject to the movement of the sun, to shadows and reflections, so that if you begin to paint in the morning you may find your subject very altered by the light in the later afternoon. North light increases or diminishes, but it never changes. (I should add that there are times, when I'm painting out of town, that I'm forced to work in a light coming from another direction, but I'll discuss that in greater detail in Chapter 9.)

Controlling the Light

My studio is twenty feet by thirty feet with a twenty-five foot ceiling. Ideally, a skylight is the best kind of window for the studio because it's a high light and illuminates the entire room equally. But I have a very large window along one wall of my studio which is almost as good: seven feet wide and eighteen feet high. As long as I rely almost exclusively on the light coming from this source, I have to be able to control it.

If you're working alone on a landscape, you need only enough light to illuminate the canvas. In portrait painting, however, you need light on both the model and the canvas. If I'm painting a full figure, for example, I need to stand far enough away to "take him all in," which means he must be positioned deeper in the room. You can see that if I need light on both my canvas and my subject, I will have to control the light differently than if I were working close.

An opaque window shade runs up from the bottom of my window, and I can pull this up to any desired height. With the shade, I can diminish or increase the light, which I may want to do, for example, to reduce the reflection of wet paint on my canvas. The higher I force the light with the shade, the longer and deeper (or more intense) the shadows. To dramatize the head, I may want this deep-shadowed effect. If I want a more diffused light I lower the shade.

Using Artificial Light

How wonderful it would be if natural light were always so reliable that we wouldn't have to resort to other means of doing its job. It doesn't always work that way, so I have found that artificial light is necessary or can provide the solution.

Because of the shorter days in the winter, I'm either forced to cut my work short, or to supplement the natural light so that I can continue painting. Across my window I have placed a battery of fluorescent lights, alternating blue and yellow, which simulate daylight. Four of these lights are placed slightly over half way up the window, supplementing the light in the same direction without any reflection. When the day begins to fade, I can fill in with this artificial light.

There are also times when the shadows produced by natural light are simply too dense. To fill in the shadow areas with a little light, I use a photographer's lamp, a 100 or 150 watt bulb that attaches to an adjustable stand lamp which I can raise or lower. Always painting with natural light coming from the same direction means running the risk of repeating myself, so I look for other ways to give variety to my work. On occasion, I use my photographer's lamp to create effects that keep my work varied. I place a screen (which I'll describe in detail a little later) around the model, blocking off the daylight and using the artificial light. The shadows created in this way and the reflection of light from the screen form an interesting light pattern and my work is stimulated by this change.

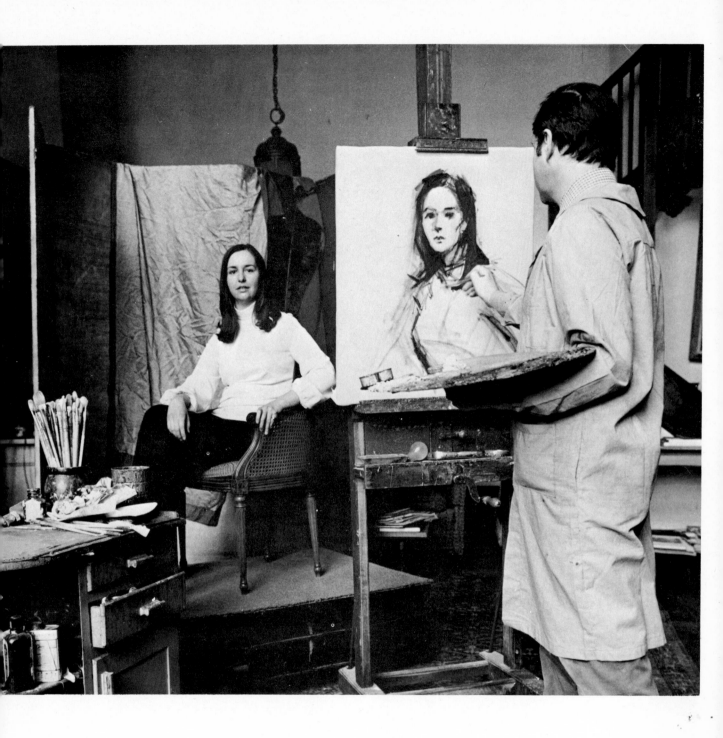

This photograph shows the relationship of canvas to model and the screen set up behind the model. This arrangement allows me room to move back and forth as I paint, carrying my palette with me as I move. Photo, Susan E. Meyer.

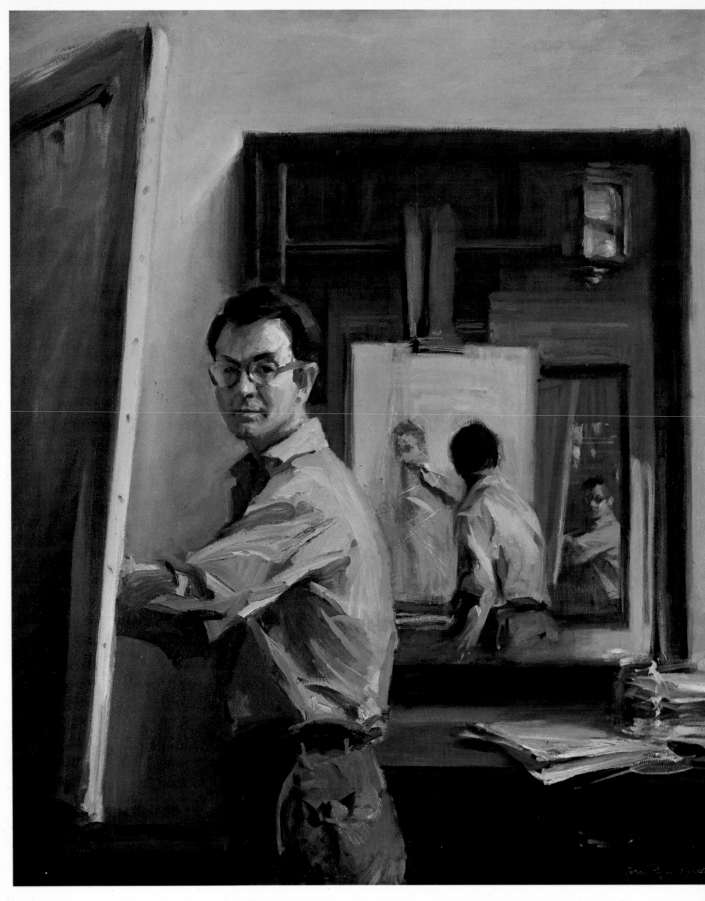

Self-Portrait 34″ x 40″ It's fun and challenging to paint yourself. There's no one else to satisfy and you can try anything. Here, I've painted three reflections as a loosening up exercise for myself.

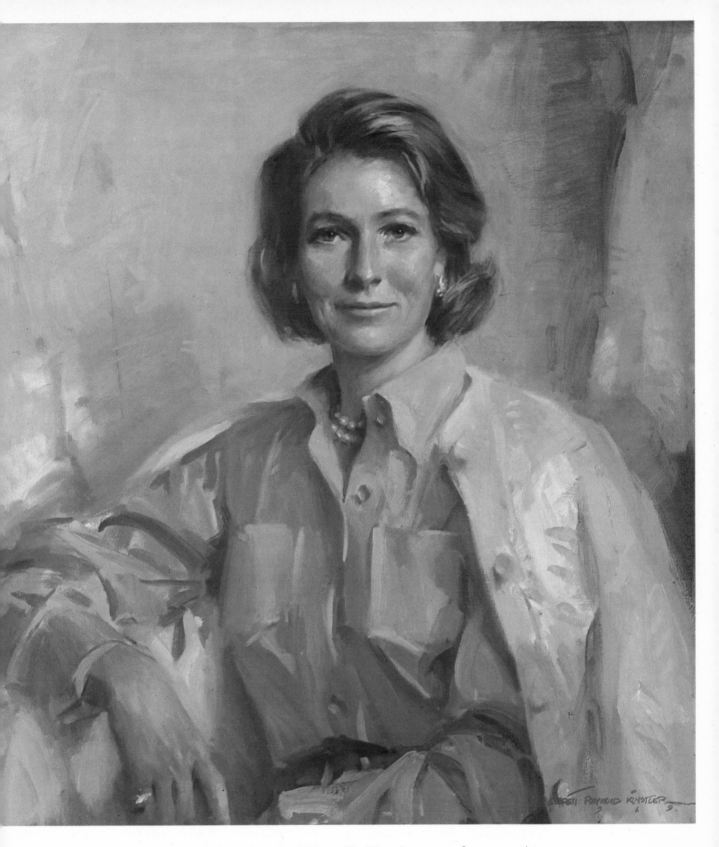

Mrs. J. Hamilton Crawford 32" x 32" Here is a case where an artist must follow his own inclinations, even if it means altering original intentions. This was initially meant to be a head-and-shoulders portrait. I felt it would be much more desirable to get some movement and gesture. The blouse and sweater were very appealing and they would have been lost in the smaller portrait. Collection, Mr. and Mrs. J. Hamilton Crawford.

Working in the Studio

Ideally, you should have a studio that offers you enough room to maneuver. When painting, I move back and forth, which means I need plenty of space when I work. I also need space to keep the items I use for my paintings, such as my screen and drapes, a model stand, chairs, and table. How you use these items and where you place them will greatly affect your work. This is how I use them in my studio.

Screen and Drapes

I have an eight foot screen which opens—accordion fashion—to about seven feet wide. By hanging drapes over the screen, I am furnished with a suitable background for my subject. For example, I may want to accentuate the white hair of my sitter, so I put dark drapery behind him. For dark hair, I may hang a lighter drapery. I have a score of drapery fabrics in a variety of colors and textures, ranging from velvet (which provides depth and richness of color) to satiny finish fabrics, to monk's cloth.

The screen itself has a kind of warm metallic finish which I can use without drapery, when I want reflected lights. If I pull the screen around the model I can get varying degrees of light, depending on how I draw it around the sitter. I can get lovely reflected lights or I can bounce a light off the screen.

Frequently, I surround my subject with the screen, blocking the light, providing a total atmosphere for the portrait. Shapes can be created with the screen, and by placing it in a certain way I have the feeling of a wall or panel in the background, moldings, recesses, windows.

Model Stand

I place the model on a stand so that his eyes are level with mine. You've heard about "the eyes that follow you." This effect is created primarily because the subject's eyes are at the same level as those of the viewer. If you lower him, so that he is sitting on a chair on the floor, his eyes will not give that effect. In a woman, in fact, the portrait below eye level is generally unflattering because the perspective reduces the line of the neck, giving the model a hunched look and distorting one of her distinctive characteristics.

My model stand is three and a half feet square, made of wood, and standing on four casters, allowing me to maneuver it wherever I want (away from the light, toward the window, etc.). I have tacked a piece of carpet

C. D. Batchelor 28″ x 22″ The subject was the brilliant editorial cartoonist of the New York Daily News. I included in the portrait some things I associated with him: a walking stick (he had a great collection, over 400!), and his rings (he wore several on each hand). This was painted on a toned canvas in two sittings. Collection, Mr. and Mrs. C. D. Batchelor.

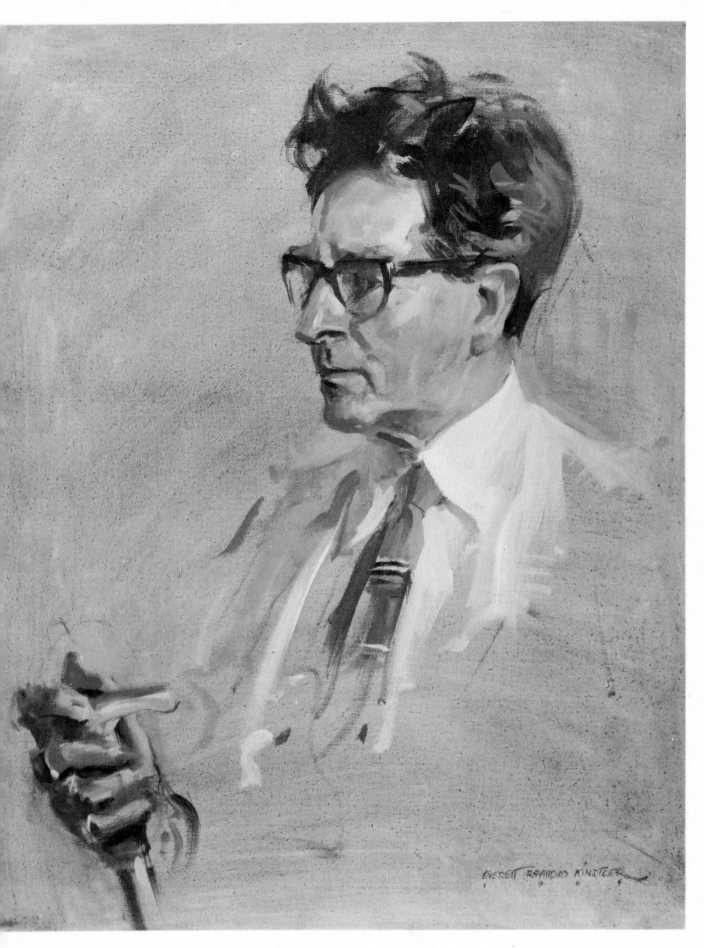

EVERETT RAYMOND KINSTLER
1 9 6 4

on the stand so that the subject's chair will not slide on the platform. And there is a drawer in the base of the stand, furnishing handy storage space for drapes and other miscellaneous items.

Chairs and Bridge Table

In my studio, I keep various styles of chairs which I use in a portrait if the painting calls for hands. I select the chair I feel best suits the sitter's size and character.

A bridge table is also a handy item I keep when I need to improvise something for the background—a desk, a table, or even a mantelpiece. I'll have more to say about chairs and tables in Chapter 8, since I feel this relates directly to how I handle the background in my paintings.

Leo Gottlieb president New York County Lawyers Association 40″ x 34″ *Painting this official portrait in my studio, I used the bridge table to suggest space. I transformed the table into a desk because it was in keeping with Mr. Gottlieb's profession as a lawyer. I used part of my studio screen to suggest a background. Since he spent a great deal of time with law books, this seemed a natural environment for him. Collection, New York County Lawyers Association.*

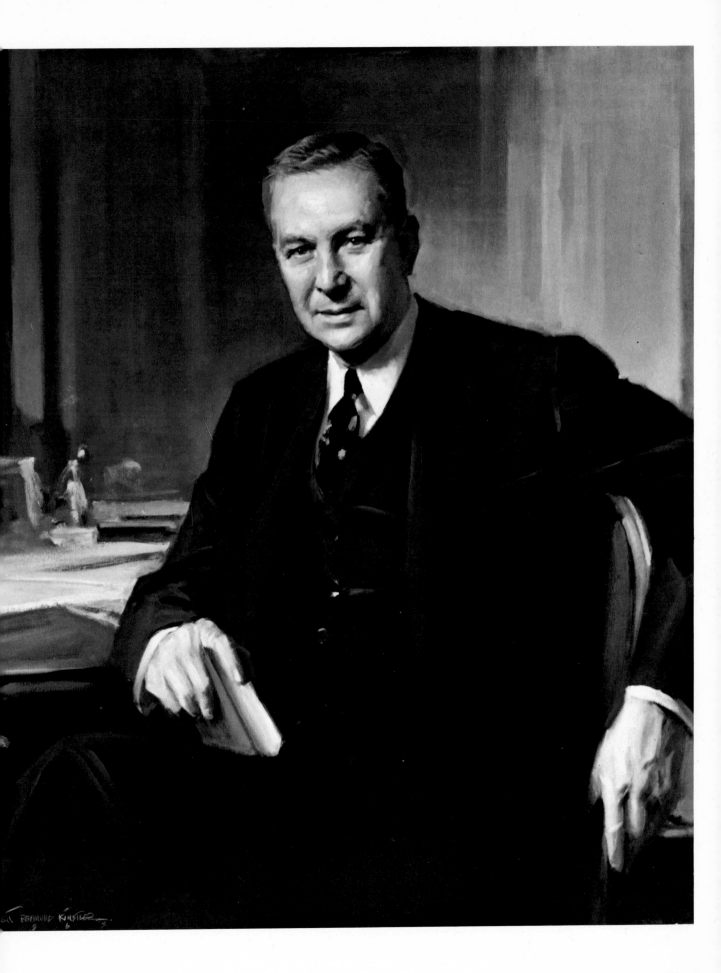

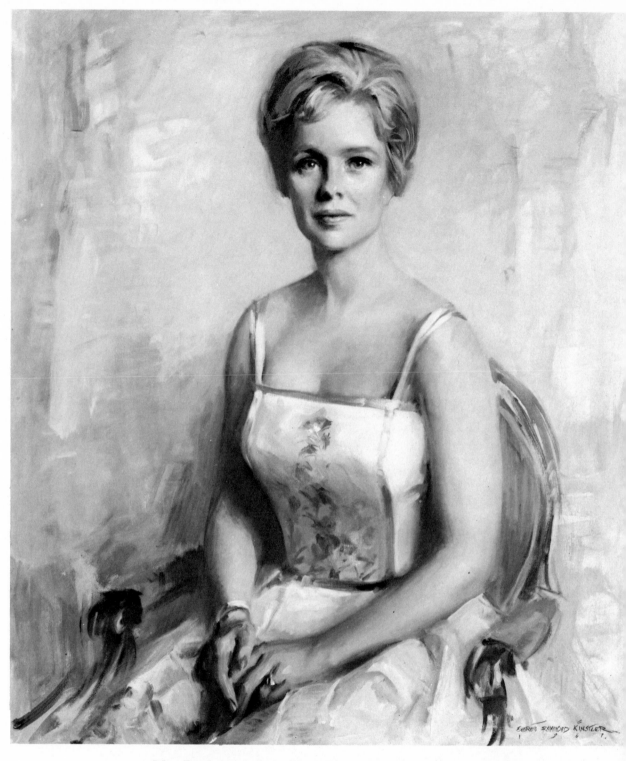

Mrs. Benjamin J. Lake 38″ x 32″ Unlike the portrait of Gottlieb, no attempt was made here to create an interior. Because the model was wearing a dress of such distinctive fabric, I didn't want the background to distract at all. If you have considerable fabric on the person—an outfit that's very active—avoid too much drapery in the background. I took the screen, opening it quite flat, and draped on an offwhite cloth. I wanted a light background to emphasize and harmonize with the pastel character of the colors in the dress. Collection, Mr. and Mrs. Benjamin Lake.

Your Attitude Toward the Portrait

Portraiture is composed of many tangibles: the commission, the materials, the model. You have a specific task: to paint a portrait of the subject before you. But portraiture is something more than just these tangibles. The human content of your work brings you into psychological areas as well, and for this reason I would like to reflect on some of those aspects, specifically in regard to your attitude toward the painting, your relationship to the sitter, and to the person who has commissioned the portrait. My talk about technique will be of no use if you haven't done some thinking about this question of attitude.

Your Attitude Toward the Contract

If you choose to paint a landscape, interpreting it in whatever manner pleases you, your painting may be sold to someone who is attracted to that painting. What you paint is your decision and the painting is sold after the fact. With portraiture, you are commissioned to produce something in advance. Once you agree to do a portrait, you are entering into a contract, the terms of which can have many limitations. These limitations are challenging to me; they may not be to you.

In accepting a portrait commission, I think it's important to remember that it *is* a contract you have made; that you have participated in this agreement, and therefore you have a responsibility to produce the product being commissioned. Your client has every right to expect a reasonable likeness of the subject.

Your attitude toward this contract will, to a large extent, determine the success of your portraiture. I've talked with some students and painters

who find this compromising, as if they were prostituting their talent. If you feel that way about it, avoid accepting a commission. You probably won't be receptive to your client's criticisms.

I don't happen to feel that a portrait commission means compromising my art. The portrait painter who is successful enjoys his work and does it with a good deal of love. Each painting and each personality is a little different, each having its own particular challenge. And the artist reacts according to his personal feelings and taste.

Understanding the Terms of Your Commission

You and your client will first determine the size and "spirit" of the portrait. In arriving at a size, price will usually be a deciding factor: the larger the painting, the greater the expense to the client. The standard portrait sizes are 20"x24" (head and shoulders); 25"x30" (head and perhaps one or two hands); 30"x36" (almost half figure); and larger for a full figure painting. These dimensions aren't rigid; they can be adjusted. Unless the portrait must fit the assigned area to the inch, the artist will add or reduce a few inches or adjust the size if he thinks it will produce a finer portrait.

The function of the portrait and where it is to hang will also affect the size and will certainly determine the character of the painting. A personal portrait tends to be small, just head and shoulders; and institutional or professional portrait tends to be larger, 30"x36". Naturally, if the painting is going to hang in a boardroom, it will be larger than if it's hanging over a mantelpiece in a livingroom. I'll discuss these considerations at greater length in the next chapter, but bear in mind that where the portrait hangs must be part of the understanding you have with the client. I strongly feel that these decisions should be made to the benefit of the painting alone. I have a decided prejudice against the portrait painter who encourages a larger painting because it means more money. The commercial prospects should never affect the choices made for a portrait.

The function of the portrait also affects the clothing to be worn by the sitter. How often I've preferred the look of a man in his sports jacket, but have been required to paint him in his business suit! Just as he wouldn't walk into a formal affair in a sports jacket, he must appear formal for the requirements of the portrait. This isn't a question of being stuffy; it's simply that some outfits are not in keeping with the occcasion. I'll have more to

James Montgomery Flagg 30" x 25" For this portrait of my illustrator friend, I selected a toned canvas. Although I may rework a painting many times, I don't paint in glazes, in layers of paint. For the most part I work directly in the opaque paint, even though some of the pigment may be washed in. By painting your friends you can have much more latitude, just as you do in self-portraits. This type of work is a great benefit in loosening up and in experimenting. (Incidentally, Flagg didn't wear a monocle. The pose was suggested by a photo and we used it just for fun.) Courtesy, Grand Central Galleries.

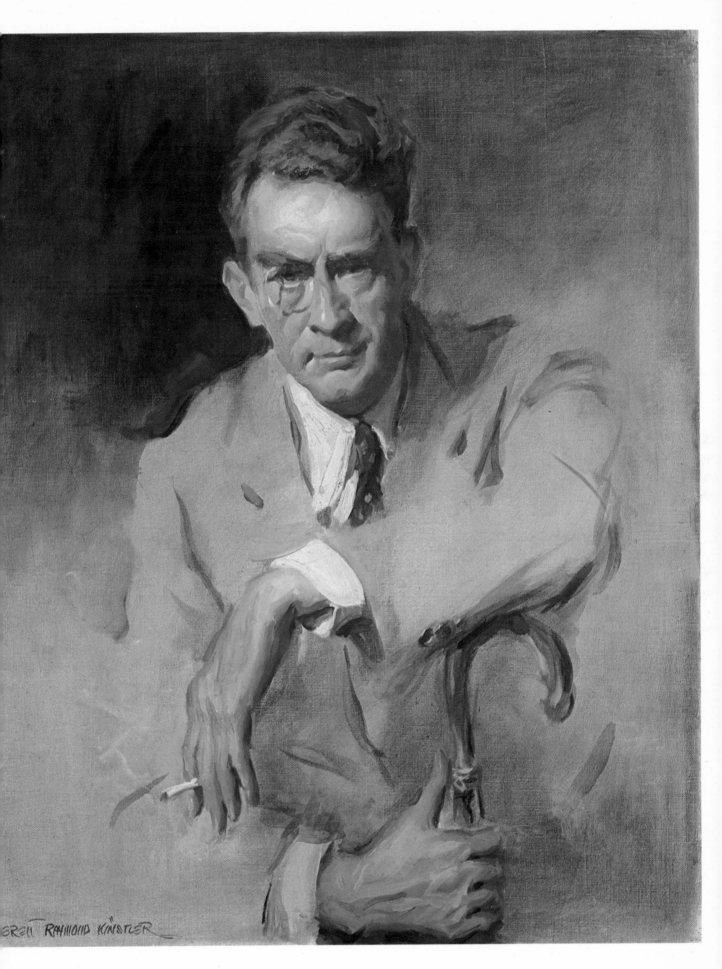

ERETT RAYMOND KINSTLER

say about clothing in Chapter 7, but I want you to bear in mind some of the practical aspects which you must establish with your client. As a portrait painter, you have a responsibility to your client to take these things into consideration.

Painting the Portrait

Your relationship to the sitter continues as you begin to paint the portrait. He may be self-conscious and ill at ease, so I make a point of keeping the sittings informal and relaxed. My own manner of working is to talk to the sitter as I paint. I enjoy my conversations with the subjects, but from a practical standpoint I can better see the particular characteristics of his face. I don't use a third person to distract the sitter, as many portrait painters do, because I want to retain a relationship between the two of us. A third person tends to interfere with this communication. The rapport created produces a kind of directness in the portrait which I don't want damaged in any way. (The exception to this, of course, is if I'm painting children. Here I may ask the mother to remain, to keep the children entertained and animated. After all, Sargent would paint his nose red to keep children attentive!)

My conversations with the sitter tend to put him at ease, and he feels as if he is participating with me in the creation of his portrait. Unlike many portrait painters, I intentionally show the subjects their painting in progress. I want them to share in the growth of the portrait, and I feel that this also helps our relationship. His observations frequently suggest points I should consider in the painting.

Once the painting is started, the sitter generally becomes interested and often fascinated seeing himself being portrayed. I might also add that I show the portrait in progress only to him, not to a third party. He is seeing the painting evolve and it has meaning for him. If his wife should see it after the fourth sitting, she might be dismayed that it looks nowhere near what she had imagined. And, in fact, it doesn't necessarily represent the final painting. But the sitter and I both know how many changes take place from sitting to sitting, and he can enjoy watching its growth in a way that no one else can.

Fatigue can harm our relationship. For this reason, I keep the sittings relatively short—never more than two or two and a half hours each. After this time, the sitter needs a change, and so do I. If the sitting is in the morning,

Albert Moss 40″ x 33″ I started to paint this in a similar pose for Mr. Moss' boardroom. He was wearing a dark business suit. After two sittings, Mrs. Moss asked me if it would be possible to change this so that her husband could be shown in his red hunting jacket, because they wanted the portrait for their home in North Carolina. The idea appealed to me because the costume was more colorful. The crop and gloves replaced the newspaper that had been in his hands, but the pose remained the same. I completed the portrait in two more sittings. Collection, Mr. and Mrs. Albert Moss.

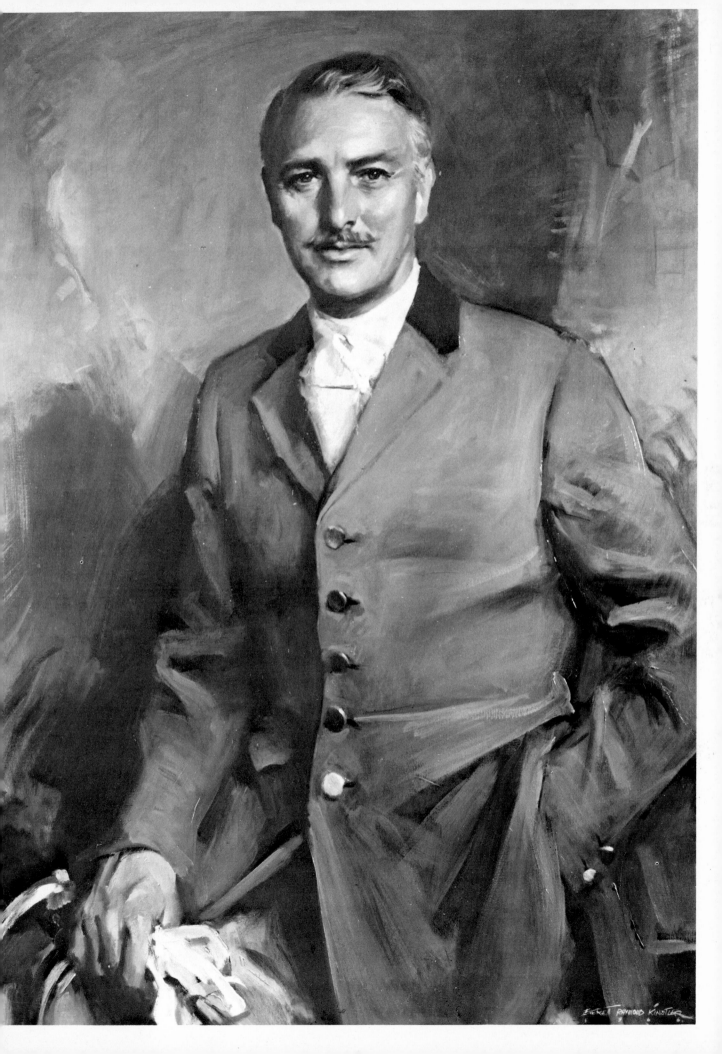

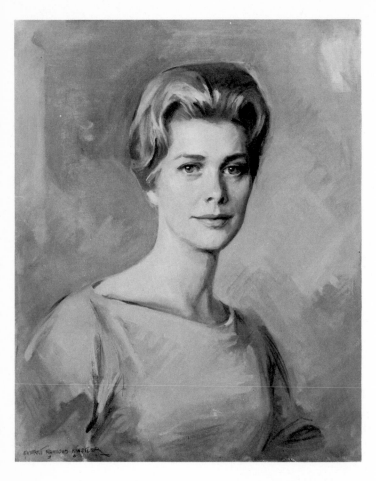
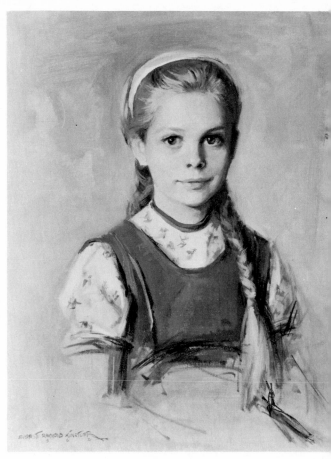

Mrs. S. Richard Leatherman, Jr. (above left) and *Mary* (above right) each 24″ x 20″ These paintings of mother and child indicate a difference in composition. Although the canvases are each of the same size, the child—because she is smaller—occupies less of the small canvas than her mother. I intentionally left the child's canvas sketchy to retain the freshness of the portrait. Initially, the clients wanted to see it more finished. I asked them to live with the painting for a while, and with time they grew to change their minds, preferring the unfinished quality after all. Collection, Mr. and Mrs. S. Richard Leatherman.

Miss Irene duPont (right) 96″ x 40″ This was my first full-length portrait and I learned a great deal from painting it. I had assumed that if the subject is 5′5″, a 6′ canvas would be sufficient space to include the whole figure. Not so. You've got to allow for shoes and the floor beneath and the space above the head as well, roughly six extra inches above and below the figure. I had brought enough canvas with me to their home in Wilmington, Delaware, but my stretchers weren't long enough. I confessed my oversight to her father, asking him where I could buy some lumber to build a bigger stretcher. His hobby was carpentry and he immediately offered to build one for me saying, "Now I can tell people I had something to do with the portrait." He built a frame that ran almost 7′, which meant that I painted part of the portrait on the floor, and part standing on a ladder. Collection, Mr. and Mrs. Irenée duPont, Jr.

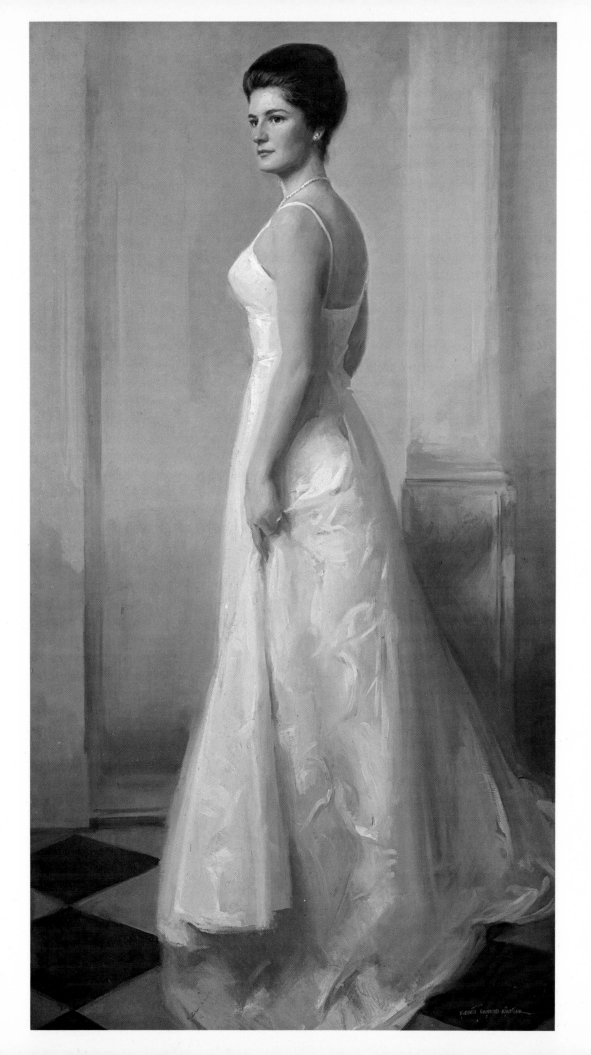

I may break for lunch, then continue painting in the afternoon with my subject or on my own. During the sittings, I call for a break every fifteen or twenty minutes, depending on the difficulty of the pose or the age of the sitter. This gives us a chance to walk around the room and refreshes both of us. (While I'm on the subject, incidentally, I suggest sittings be scheduled regularly over a period of weeks. Wherever possible, I like to complete a portrait within a reasonable time. Physical and emotional impressions change over longer periods.)

I mention these things because I feel that the relationships to your client and sitter are vital to the success of your portrait. Good will and a relaxed relationship will show in your work. It occurs to me, for example, that I've never actually disliked any of my subjects. I do respond more to one person than to another, but my main concern is in making a good painting and my likes and dislikes don't really enter into the process. This is a partnership and I want to make the best of it.

Approval of the Portrait

Rarely is it the sitter who commissions the portrait. There is generally a third party—the husband or wife, the mother or father, the company or university. And the person who commissions the portrait is most likely the one who passes approval on it.

This is always a tense moment, when you show twenty or thirty hours of intense work to the third party. I feel like an actor on opening night, waiting for the reviews. This is perhaps the critical test of my relationship to the client.

I've had several sittings with the subject, and attempted to capture what I feel is his likeness and character. In essence, I've frozen him in time. The wife who has commissioned the portrait may have known her husband forty years, seen him in every mood, through every difficult and pleasurable phase, and unconsciously she anticipates that it will all be captured in the one painting. This is why the first view of the portrait has so much emotional content.

I like to be present when the painting is to be approved. Because of the emotion involved in passing on a portrait, I've learned that people don't always express their reactions clearly. I try to understand and to pursue what's being said, so that I can get at the bottom of what the real criticism is, which is more apt to happen in my presence. For example, "I wouldn't

Mrs. Albert Rhett Heyward III 36″ x 30″ *I had already met this subject in her South Carolina home before she posed in my New York studio. Although she was an avid sportswoman, the feeling of the home—where the painting would hang—was more formal and we agreed that she pose in a formal dress, in keeping with the quiet elegance of the house. The room would harmonize with the bright color of the red dress. I used a screen, darker on one side than on the other, to accentuate her attractive hair. Collection, Mr. and Mrs. A. R. Heyward III.*

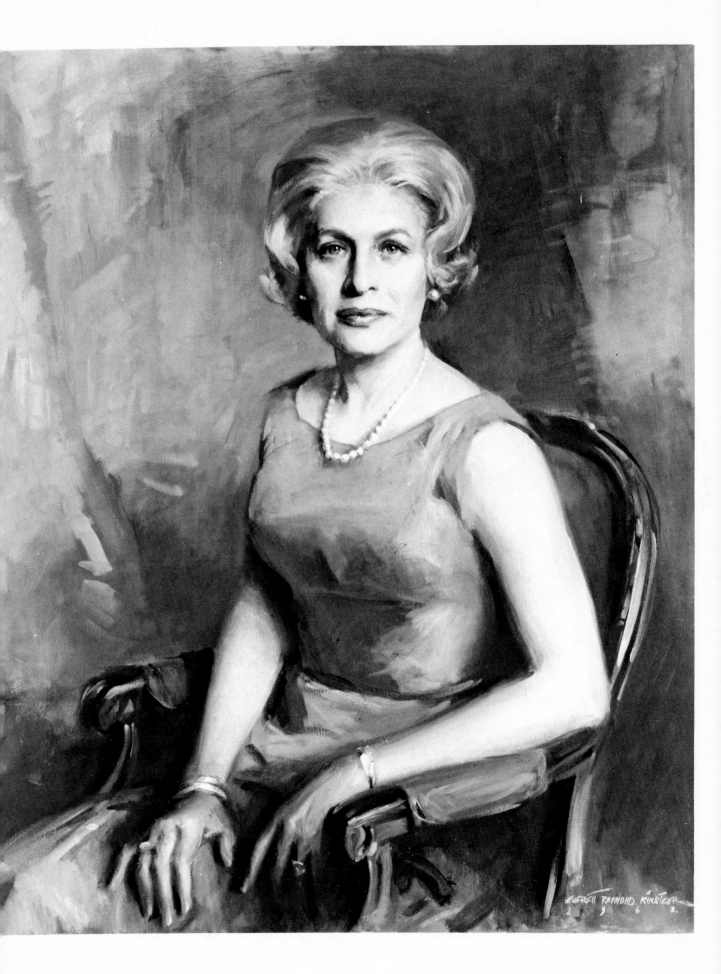

know who it was" a few minutes later can mean "If you fix the corner of that cheek and make it a little fuller, it would be perfect." Being patient is not compromising. Often there are emotions involved which will need some understanding. "It hasn't quite caught him" means nothing until you pursue it further by asking, "What do you think I missed?"

Often the suggestions are very good. The client frequently finds something that is not quite right in the painting, even if he can't exactly locate it. For example, "The chin is too long" may mean that the cheeks aren't quite full enough. "The chin isn't strong enough" may mean strengthening a highlight just a bit.

So much depends on how the fault is expressed. One person might say, "I like the over-all effect, but I think such and such could be improved." Another person may have the same criticism, but be so conscious of the particulars that he might say, "You missed him entirely." I think it has less to do with the quality of the portrait than with the quality of he client. But this is all a question of human relationships, which the portrait painter accepts as part of his work.

I seriously evaluate every suggestion that's made. If I feel that making a change will violate my integrity or hurt the painting, I say so. On occasion I've asked the client to live with the painting a little while—two or three months—and if after that time he still feels the same way I'll consider the change. Most people will show that courtesy, and not infrequently will say, when time has passed, "It's grown on me." But often, I find the advice worth taking. It's silly not to consider suggestions of a client.

One of the first portraits I ever painted was a posthumous painting of a young Marine flyer who was lost at sea. I painted the portrait for his mother —in profile from photographs—with a very active, stormy sky behind him. His mother was enthusiastic over the portrait, but the sky troubled her. The dramatic clouds made her think of how her son had been lost in a storm, a point I had totally overlooked in painting the portrait. I wasn't trying to convey the feeling of a storm in the background, and there seemed no need to bring this association to the painting, so I softened the sky.

I wanted to discuss these attitudes because I feel you must take them into consideration if you are going to pursue portrait painting with any degree of enthusiasm. They are the human elements of the profession. This doesn't mean that, in spite of all the restrictions, your own personality doesn't emerge in the painting. Look at the portraits of Sargent, Zorn, and Sorolla and you see three totally different personalities, even though they all painted portraits, were all contemporaries—even friends! When you hear someone say, "Look at the soul in Rembrandt's portraits" it's really the personality of Rembrandt in his painting. It's in the artist.

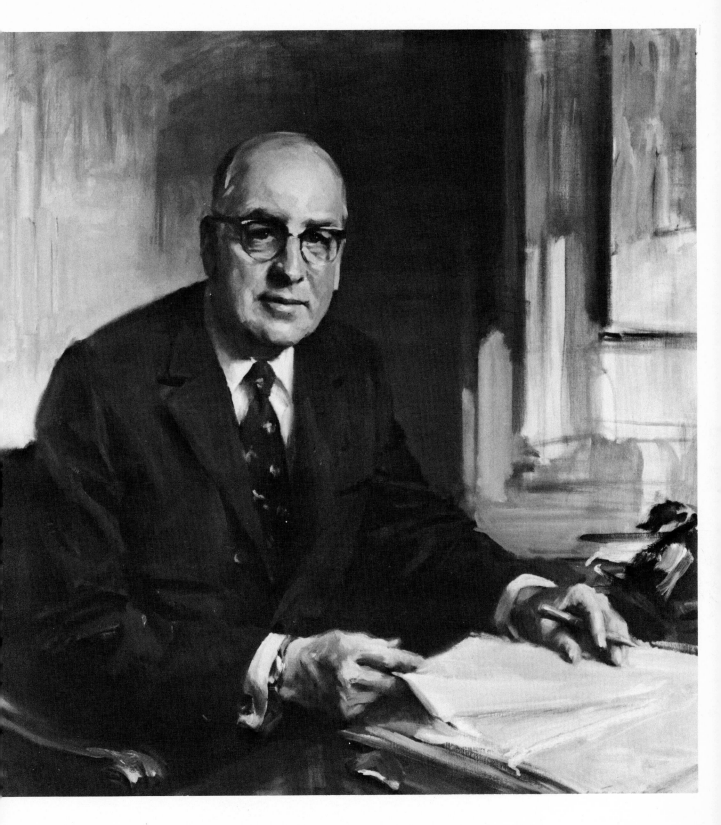

Hermon J. Arnott, Chairman, Farmers and Mechanics Bank. 30″ x 37″ Notice that the light is moving across the canvas. The painting is actually wider than it is long, although it appears to be square, a result of this kind of lighting. It's a question of working musically—abstractly—to create shapes, moving light to the edges. Collection, Farmers and Mechanics Bank.

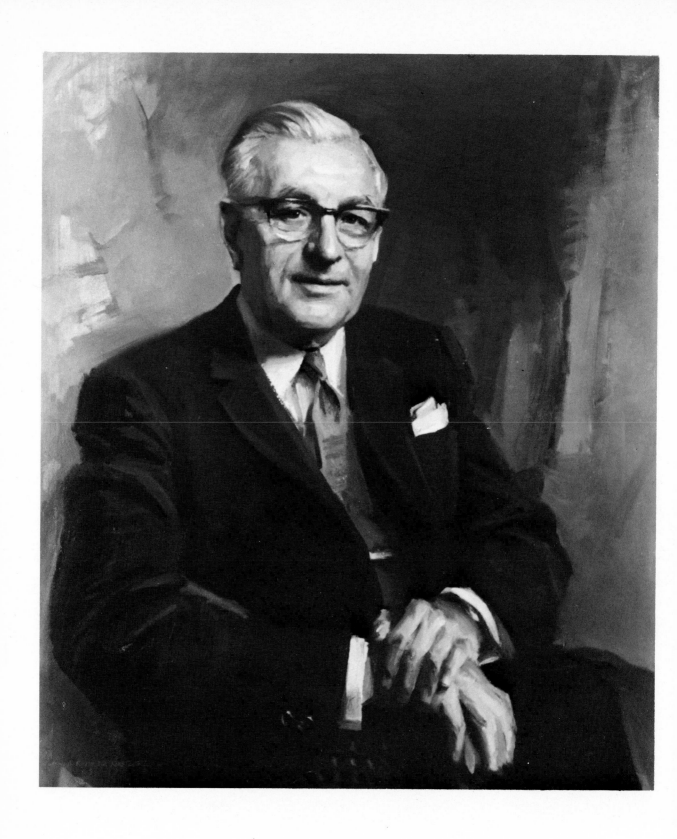

James Roycroft Gordon, Chairman, executive committee, International Nickel Corp. 36″ x 30″ We arrived at this pose very late in the portrait. Originally, Mr. Gordon was sitting, but as he talked he frequently leaned over and I felt this pose was more natural to him. The head was still in the same position; only the position of the hands was changed. Collection, International Nickel Corp.

CHAPTER 4

Preparing the Composition

When I agree to do a portrait, there are a number of crucial questions I ask myself at the outset: What is the size of the canvas? How will I pose the model? What is the "spirit" or character of the portrait? Prior to the first sitting, I try to meet the sitter to discuss such concrete things as attire. Then I have a sitting with him alone at my studio. During that sitting, I make most of my decisions concerning composition. These decisions are based primarily on my response to the subject and we begin the sitting by chatting informally for about an hour. During this time, I get the feeling of how his face works—does he smile easily? Does he look directly at me? I notice how he sits and moves his hands as he talks. Since I don't want him to think we're just wasting time, I explain the purpose of this sitting. These early meetings plot my course for the entire painting.

Size of Canvas

The size of the canvas determines how much of the body will be included in the portrait. I've already described some of the commercial reasons why a canvas is one size rather than another. Considerations such as price and whether a canvas must conform to certain size specifications are what I call commercial considerations. But beyond that, there are esthetic considerations as well.

First I ask where the painting will hang. The architecture of the room, the space it offers, may mean that one size will look better than another. A few years ago a woman asked me to do a full-length portrait of her

husband. He was a scholar, a man of great stature, and she felt that a full-length portrait would be a greater tribute to him than a smaller canvas.

I asked her where the painting would hang and she said in her large home. When I saw the home, I knew a full-length portrait would be less than ideal. Although the house was large, the ceilings were only 8 feet high and a full-length portrait would have meant squeezing the portrait between floor and ceiling; the painting would have dominated the entire room in an imposing and unappealing manner. I recommended a smaller size.

Obviously, if a painting is going to hang over a mantelpiece, it must fit in that space. Conversely, if the room is enormous, with high ceilings and long, bare walls, a small head and shoulders portrait would swim in empty space.

Therefore, when you consider the composition of the painting, you must also consider the composition of the room, the space in which it is hanging. This does not mean to say that you must think like an interior decorator. I rather prefer to think in terms of the architecture as a whole. How the painting will hang, where it will be placed ultimately, strongly affects the way in which the portrait will come across. In some cases, the client cannot allow you this flexibility because the painting may have to conform to the size of other portraits hanging in the same room. But wherever possible, I take advantage of the alternatives.

Not only the room, but the subject himself will give me some ideas about how large a canvas I will ultimately prefer. This is what I look for in our first meeting in the studio. A person may not have a particularly interesting face, but a portrait with his hands placed in a manner that is characteristic of his personality may make the painting more interesting than a head-and-shoulders portrait.

I was once supposed to paint a head-and-shoulders portrait of a man who was six foot four. When I met him I was struck by his relaxed manner. He was angular and rangy, and settled very comfortably into the chair. I just couldn't imagine compressing him into a small canvas. The larger portrait could more effectively give the impression of his easy, relaxed bearing.

Deciding which subject is more suitable for a large canvas and which more suitable for a small one is strictly a question of personal judgment. A subject's head, for example, may be so expressive—perhaps the look of gentleness in his eyes—that you want to stay within the area of the head alone to express his mood. I always make these decisions in terms of what I think best

Charles Carpenter Batchelder 80" x 40" *This was the second of the full-length duPont portraits painted in Wilmington, Delaware. Mr. Batchelder was young and the portrait called for a relaxed pose, rather informal. At first he was eager to include his two Doberman Pinchers. I suggested one. I painted him on the porch as I had the others of his family, but I couldn't get the dog to pose too long. So I sketched and took photographs of the dog in the same light and I painted Batchelder with his hand propped on a child's pillow—placed at the same height as the dog's head—and later painted in the dog in that space on the canvas. Collection, Mr. Charles C. Batchelder.*

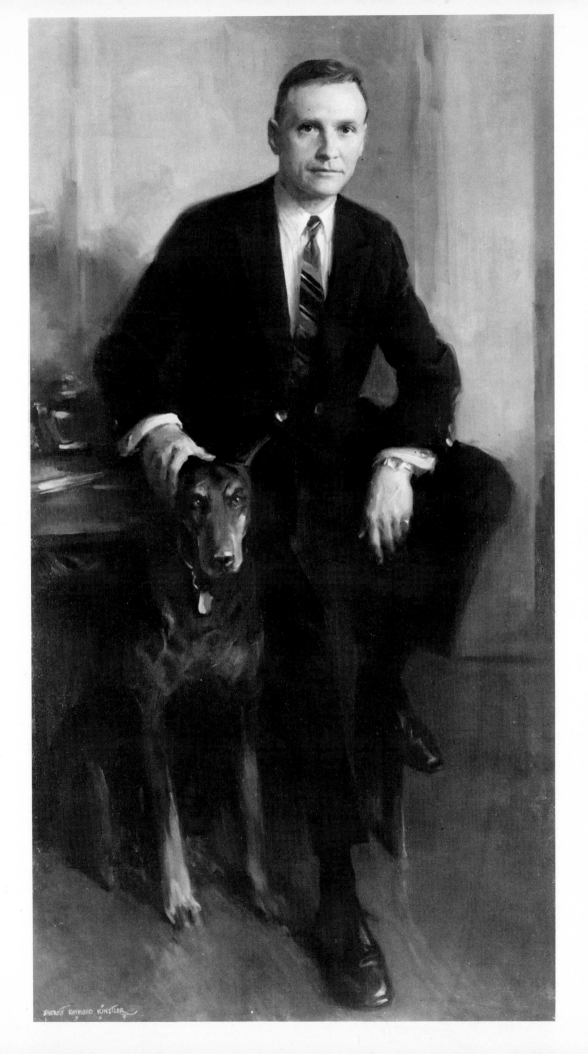

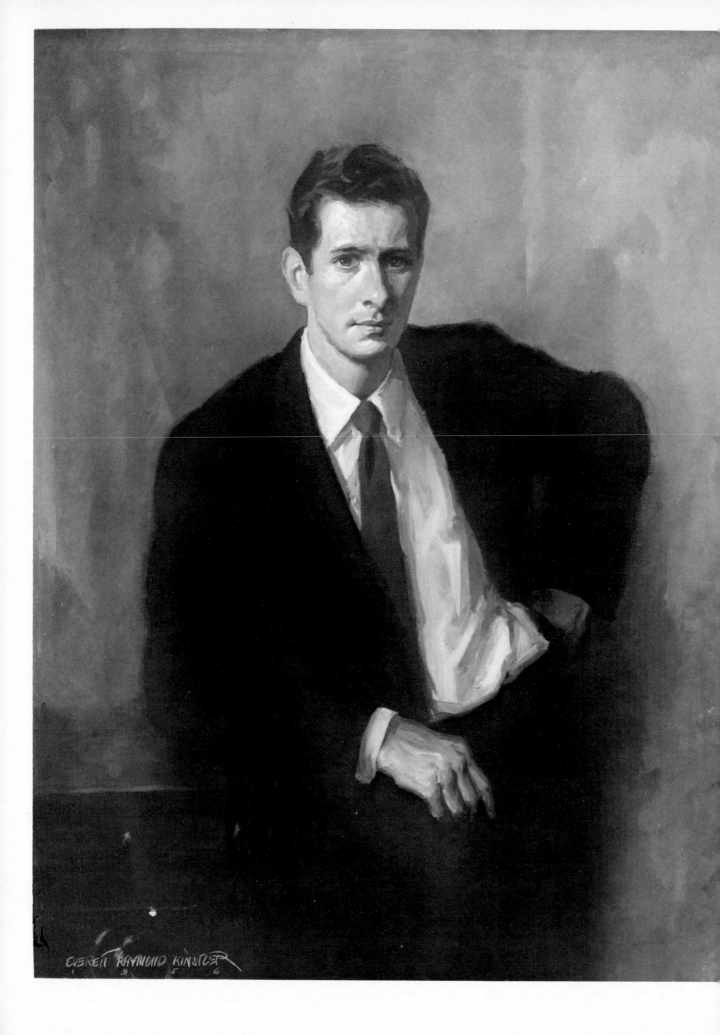

captures the character of the person. And because this is a question of personal response—a feeling—it's impossible to qualify or generalize about what kind of person makes what kind of portrait. My response may be very different from yours. This is why portrait painters vary as much as they do.

Incidentally, I do think it's important to vary the size as much as possible. Experiment with different sizes—head and shoulders, head and hands, three-quarter, full length—so that you can shift from one to the other freely. Always painting one size will make your work mechanical and uninteresting.

Character of the Portrait

I have just described some of the thinking that goes into selecting the size of the canvas. Many of the same considerations will also determine the over-all character of the portrait: the clothing, background, and lighting which give the mood and expression in the painting. I'll have more to say about these in later chapters, but for the moment I want you to bear in mind the relationship of the character of the portrait to what he is wearing, to his background, and to the over-all effect of the portrait.

Will the portrait be formal or informal? Will it be dramatic or will this be a quiet mood? I can answer these only by looking at the sitter and getting a response from him. Does he tend to lean back with his arms crossed, or forward, intently, with his elbows resting on his knees? Does he tilt his head? What angle seems most expressive? While we talk, he settles into these familiar positions and I begin to get a feeling for his character.

I begin to think about the setting in which he seems most appropriate. Will the background be informal and undefined, or should the background suggest the man's life style: a drawing room to reflect a certain gentility, or rough woodwork to suggest a rugged man.

I consider the lighting. If his face is angular and intense, I might want a dramatic lighting. In the case of a woman, I probably lean toward the diffused, softer lighting.

These are quick impressions; feelings which are very important to the course of my painting, even if I change my mind later, which frequently happens.

Once I think I've gotten the feeling for the subject, I ask him to sit in the model stand in a relaxed manner. I don't want him to feel that he's posing. I generally place him in this or that direction—an angle I feel has possibilities for the painting—and continue to talk with him as I study this new perspective. I always explain what I'm doing and why, to help him feel less self-conscious. Then I begin to paint directly on the canvas.

Robert Brustein, Dean, Yale School of Drama. 40" x 32" The subject is one of my oldest and dearest friends. Consequently, we were very relaxed with each other and he took this position quite naturally. It was, I felt, a characteristic pose, even though his mother was a bit disturbed that his coat was open. Collection, Mr. and Mrs. Robert S. Brustein.

Composing the Portrait

At this point I'm going to pause to discuss the composition of the portrait in general. No matter how good the concept of a painting may be, the effect may be destroyed by a misjudgment in placing the shapes on the canvas. So I'll review here some of the fundamental principles of composing the portrait. Most of this information is applicable to portraits larger than head and shoulders, situations where the composition becomes more involved and demanding.

Placing the Head on the Canvas

In a head-and-shoulders portrait you'll be painting the head in approximately the same position, at the center of the canvas. In larger compositions, I generally place the head off-center.

Composing the Hands

The hands are vital to giving the composition a feeling of movement. Avoid placing them both on the same elevation—both hands clasping the arms of a chair in a horizontal line across the canvas, for example—and keep the hands in an interesting relationship to the face. You can balance the composition of the portrait by placing the head to one side of the canvas, in a horizontal portrait, and the hands at the opposite side. If you are going to include hands in the portrait, try to include all of the hands—If you can't, crop them intelligently.

*Head is placed
too high on canvas.*

*Head is placed
too low and far left.*

*More desirable
placement for head.*

Try to place hands at different levels. The head also can look better off center.

Avoid cutting off bare arms. Consider a smaller, larger, or different shaped canvas or the possibility of vignetting.

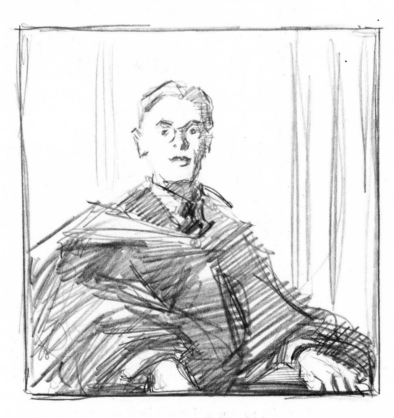

Be cautious about cutting off fingers or hands in the composition.

Adjusting Tones in the Composition

The way in which you place light and dark tones in the composition plays a vital part in the success of the painting. I tend to work for contrast. For example, if I'm painting a girl with blonde hair, I may put a darker tone in the background to accent the color of her hair and the shape of her head. Without it, the color and shape would be lost. By painting a contrasting tone, you will outline her head a bit more, making it more dominant.

I would consider the reverse for a bald-headed man. It would be a mistake to paint black velvet behind a bald head, outlining the shape of his dome as if it were cut out of a sheet of paper. Here I would place a softer tone behind him to soften the line of the head.

Consider the Line

Interest is achieved with an imaginative use of lines and angles. Avoid too many curved or too many straight lines. Break one up with the other when you can to create a feeling of movement across the canvas.

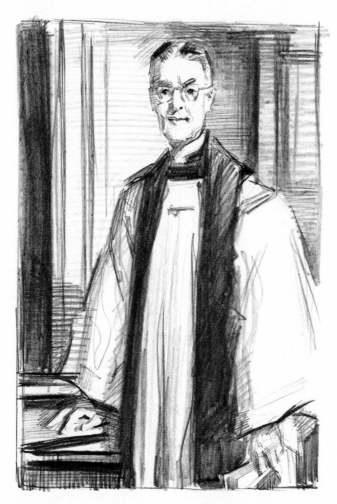

Vertical lines can add height and dignity, desirable in certain subjects. Be sure to establish horizontals to add depth and balance.

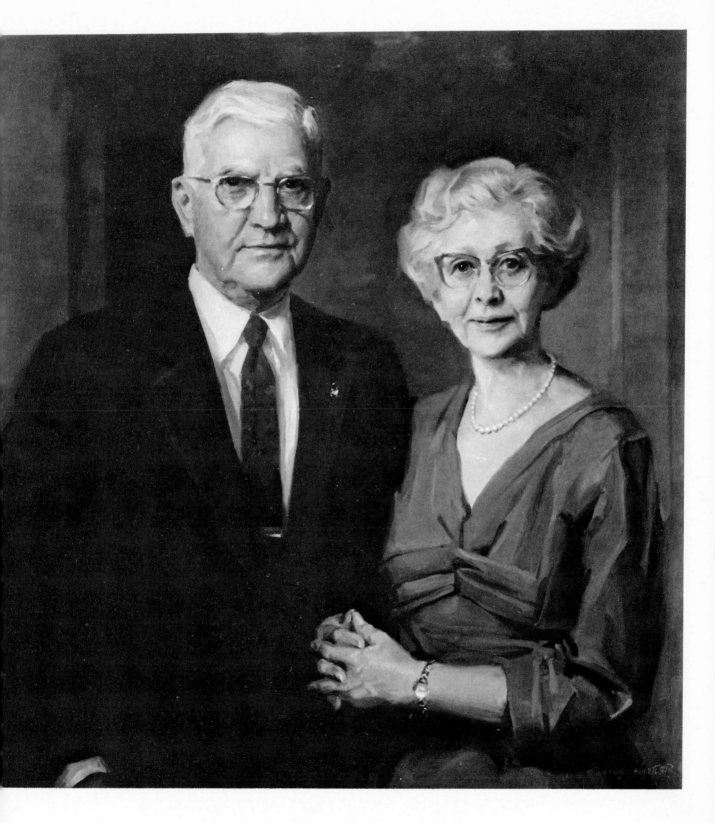

Mr. and Mrs. Dale W. McMillen, Sr. 45″ x 45″ The family wanted the McMillens' portrait painted for the occasion of their fiftieth wedding anniversary. I decided upon a square shaped canvas—in this way I could use the two hands, linked in a way that made a more interesting composition and, at the same time was more natural and affectionate. Collection, Mr. and Mrs. Dale W. McMillen, Sr.

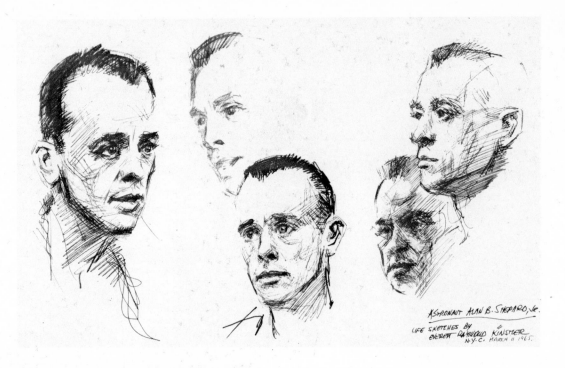

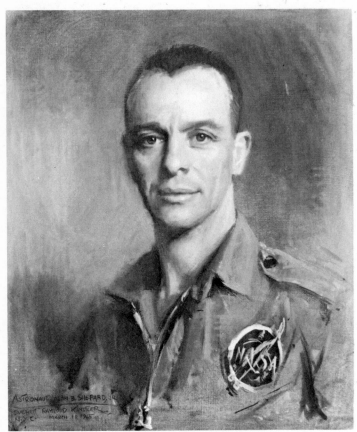

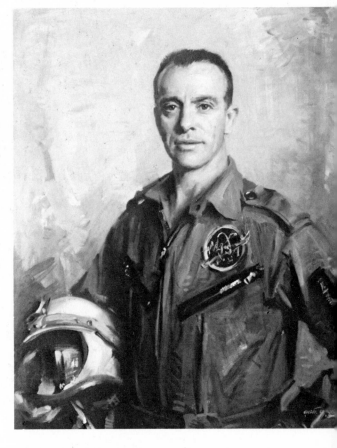

Alan B. Shepard, Jr. 24″ x 20″ *I made several sketches of the astronaut before I decided on the exact angle of the head. First I made sketches in charcoal, and pen, then I made an oil sketch. I completed the oil sketch the second sitting and stayed with this angle for the final painting. Courtesy, U. S. Navy Combat Art Collection.*

Blocking in the Composition

Although I may not always be conscious of these principles when I paint, they do play a large part in the way I block in the portrait on the canvas. I put my ideas down immediately in color, even though I may totally change everything before long. I find that as soon as I have a brush in my hand and a palette before me, I can concentrate much better on the specific qualities of the face. Even if I were to meet someone countless times, and I knew his eyes were blue, it wouldn't be until I began to paint those eyes that I would become really sensitive to their particular qualities.

At this stage, I establish the colors, values, and tones of the portrait. I even block in a suggestion of the background. If a man has bushy black hair, I may paint in a red tone for the background to set off the color of his hair. Later I'll turn that into a wall or drapery, but I establish the tone immediately. What I'm after is the relationship of the face to the background, not the particular details. How important are the hands going to be? I block them in also, in approximately the position I think will work.

Preliminary Sketches

If a painting is particularly complex, I always do a series of preliminary sketches. In a group portrait, where there are many compositional possibilities, I do several sketches and assemble them to arrive at a final composition. I usually do sketches for a full-length portrait as well.

There's something very fresh and alive in a head sketch and I've often make a point of retaining the sketch for its own value, without painting over it. On the first day, I frequently capture something I'm afraid of losing later, so I may start over again, painting on a new canvas and retaining my initial sketch. When I paint from a sketch, I simply place the sketch on an easel and paint from it as if I were painting from a model.

Incidentally, don't be discouraged if you get a fine statement and then destroy it in painting. Portrait painters are continually losing and finding and restating their portrait as they work. This is simply part of the challenge!

Toned Canvas

On some portraits I paint directly on the white primed canvas. On others I prefer to tone the canvas first, painting into the tone. This decision depends on the mood of the painting. On a white canvas, I use the whites for highlights, much as a watercolorist does with the white of his paper. In the toned canvas, the tone becomes a halftone color in the painting. Therefore, when I'm looking for bright color, I use a white canvas; in a low-key, dramatic picture, I use a toned canvas.

To tone the canvas, I use a neutral color—umber or a bluish-gray tone diluted in turpentine—which I wash over the entire surface of the canvas with a rag. Since the surface of the toned canvas must be bone dry before using it, I am sure to have a supply of stretched toned canvas in my studio, in all sizes, so that if I decide to use one I have it on hand.

Dr. John Richard Craft 34" x 33" *I painted this in Columbia, South Carolina, where Dr. Craft is the director of the city's museum of art and where the portrait was to hang. I was eager to get a contemporary feeling into the painting, a degree of color and vitality that I felt was in keeping with the man and his profession. I painted the portrait in his home and included the horse, a piece of sculpture he was very fond of. It was fitting for a museum director's portrait. Collection, Columbia Museum of Art.*

Mrs. William H. Cheatham 28" x 23" *The painting was to fit over the subject's Virginia mantelpiece. I wanted to emphasize the refinement and beauty and suggest the bosom which is so attractive in a young woman. The white dress presented a good contrast to her dark beauty and the tonal background complemented this effect considerably. Collection, Mr. William Henry Cheatham.*

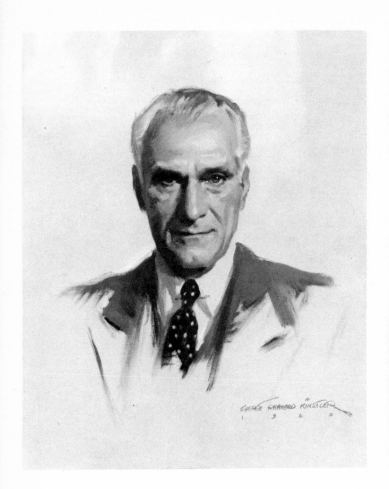

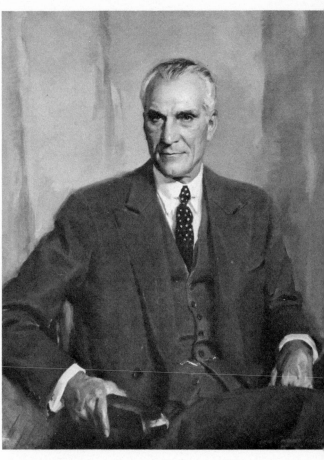

William H. Colvin, Jr., *Former President, Crucible Steel Corp. 36" x 30" Since Mr. Colvin could only come to the studio once a month, I found it easier to make an oil head sketch (20" x 24") and work from the sketch rather than from the model. (In doing sketches such as these, always consider the shape of the vignette as you leave it unfinished.) For the painting, I turned the head slightly, kept the light from the same angle, and completed the portrait. Collection, Crucible Steel Corp.*

Making Adjustments

It's impossible to do too much work. In my work, I attempt to be decisive at the outset, but I never commit myself so completely that I can't change my mind when a new idea occurs to me. I allow for the possibility of adjustments. For example, I leave extra canvas around the stretcher—as I've already mentioned in Chapter 1. Because of the extra inches, I can jockey the canvas back and forth. Sometimes I find that moving the canvas to the left or right an inch—which means adding an inch on one side and taking one inch away from the other—can do very desirable things to my composition.

On occasion I sense that I've made a wrong color choice. I have a feeling that another color, say in the background, would improve the composition, but I'm not altogether sure. I take out a box of pastels and find the color I think might improve the background and rub the pastel over that dry area. Then I stand back and study the color. Afterwards, I can easily erase all traces of the pastel with a rag, and then paint over the area in oil if I feel the color *is* an improvement.

I'm completely in favor of committing yourself at the earliest possible stage, but I'm not embarrassed about changing my mind after I've begun. I really feel you've got to be self-centered about the painting. Start over if it's not what you want. I can't allow myself to get distracted by petty inconveniences, even if it involves extra sittings. My subjects never remember that I've inconvenienced them; they only remember the final result. Sometimes I've started paintings over and over again, only to return to the first one in the end. Above all, I think you should be an artist painting portraits, not simply a portrait painter. And if it takes repeated attempts to get what you want, keep right at it until you're satisfied.

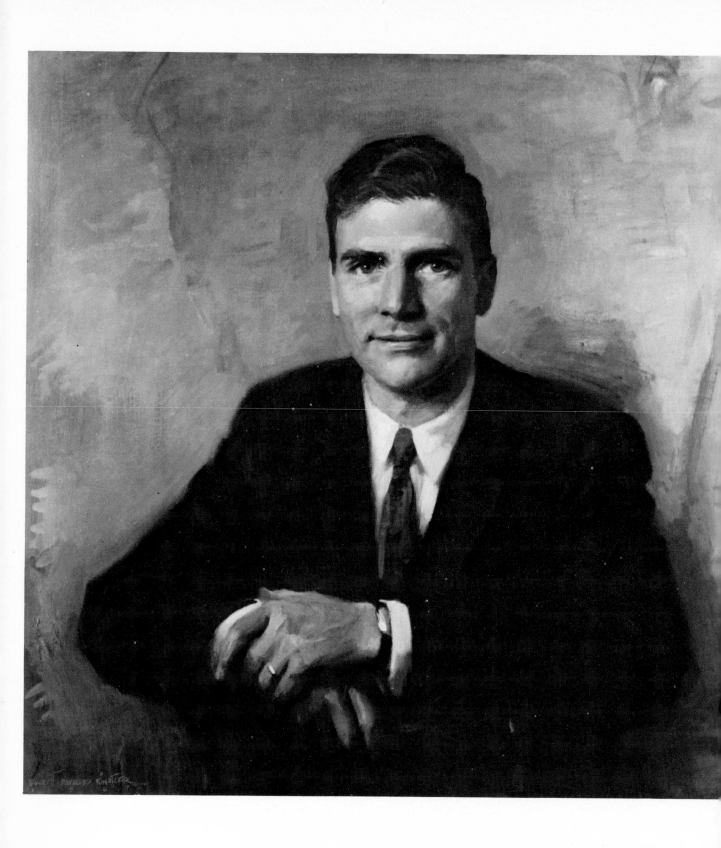

Lammot duPont Copeland, Jr. 30" x 30" Having the subject straddle a chair is not a pose you can use too often. It should, however, be considered occasionally, since it is so expressive of the vigorous and easy manner of a young man. I had the model place his left hand over the right one so that I could take advantage of painting the ring and watch. Collection, Mr. and Mrs. Lammot duPont Copeland, Jr.

Getting a Likeness

Many students are fascinated with the idea of getting a likeness, as if there is some extraordinary process taking place that enables the artist to make a portrait of John Smith look just like John Smith. Actually, a likeness is a very elusive thing. It's not simply a question of the correct proportions and precise measurements; it's also an emotional quality. *Selecting* what makes a person identifiable means looking for what is characteristic of that person, and this is not merely a matter of inches. How can I suggest and express in the most simple terms what John Smith *is*?

Looking for Characteristics

Strange as it may seem, I'm never concerned about likeness when I start to paint, except in a general way. I think only about big shapes; about the movement I want to get in a painting. As I talk to the subject in the first meeting, I watch for characteristics: how he sits in a chair; whether he appears to be a nervous man, vigorous or easy-going. This will give me the feeling of the person: a general impression that will affect the way in which I paint him. If the sitter is relaxed—and this is largely the responsibility of the painter—you enhance the possibility of getting closer to that character. Basically, the likeness becomes a question of catching certain gestures. If you first get the feeling of the way the head moves, you will come closer to getting a likeness than if you concentrate on the mouth or eyes. You're painting the whole tree, not just the individual leaves.

You notice that I keep returning to the idea of characteristics, of over-all

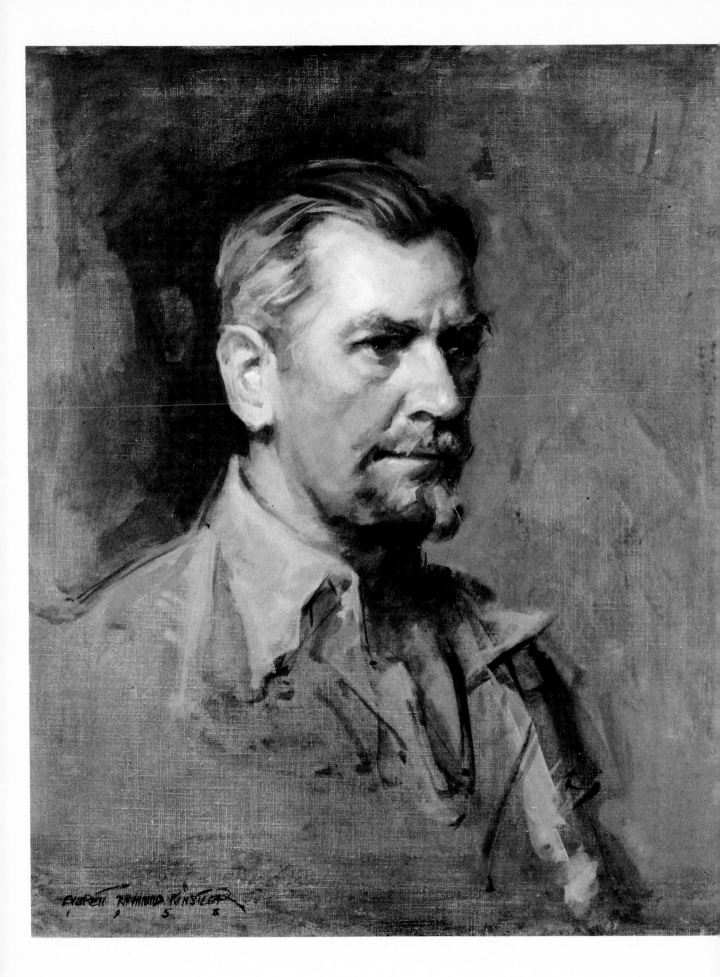

qualities that distinguish the person. Remember, I'm trying to achieve a likeness that will be recognizable from a distance of seven or eight feet, or even more. When a painting is viewed from that distance, the details are not what carry the likeness. In fact, this carrying quality is the crucial part of a likeness; it's got to hold in space, particularly if it's hung in poor light.

When I paint, I first block in the subject, then I go for greater detail. As the subject talks, I watch what happens to his mouth, lips, and related areas. It's like looking at him through binoculars: first the over-all shape comes into view, then as you focus, specific details begin to sharpen. Later I ask myself how I can best suggest this or that feature with less detail, and I begin to return to simplicity. With great economy of line, form, and color, I eliminate whatever I think interfered with the impression. Even when I am working for greater detail, I tend to stay with a larger brush so that I'm not tempted to "noodle" or "tickle" for detail. I attempt to block in all the forms in a large, rough fashion, yet striving for accuracy of tone and color, so that at a proper distance the portrait emerges in a total effect.

The Question of Flattery

I've spoken to people who've spurned the profession of portrait painting because they considered it an obligation to flatter the sitter. Frankly, I don't see this as part of my work. There is a distinction between flattery and looking for characteristics. If a woman has a certain glint in her eyes, prominent cheekbones, and warm, golden hair, and also tends toward being too plump, perhaps having a double chin, I'd be apt to select in my painting those qualities that express my response to her. I might place her in the light in such a way that her double chin won't interfere with my statement. This is not making her thin and I don't consider this flattery. Perhaps it is finding what is best in a person and using that for the portrait, but this does not mean falsifying.

Years ago an elderly man came to see me about painting his portrait. His left eye had been damaged by buckshot when he was a boy and in referring to this he stated: "Don't make this a pretty picture; I don't want to be flattered. I've had this eye all my life and I don't want the portrait to pretend it never existed." With that in mind, I began to paint his portrait. I painted the left side of his face in full light, feeling that I was working according to his wishes. When I looked at the canvas the next morning I was disturbed by the direction the painting was moving: the eye was distracting. In my eagerness not to hide the eye, I had focused on it, to the detriment of the portrait. I had drawn attention to the eye, giving it more importance

Stuart Cloete 24" x 20" I was commissioned to paint the portrait of this South African novelist for the jacket of his forthcoming novel. I wanted to retain a sketchy quality in the painting, in keeping with generous outdoor feeling of the man. The open collar was indicative of his colorful and lusty character. Collection, Mr. and Mrs. Stuart Cloete.

than I had seen in his character. I wouldn't put the face in profile to avoid the problem, but by reversing the light—so that the bad eye would be on the shadow side of the head—I could emphasize characteristics that I thought more vital to the man.

I mention this story because I think it makes my point clear: to select characteristics you find appealing is not to say that you flatter the sitter. Flattery implies falsifying, and I don't recommend that a portrait painter violate the integrity of his work to make someone look other than he is.

Lighting the Subject

A very important aspect of achieving a likeness is how you light the model. The lighting has two important functions: it complements the mood of the person and its direction emphasizes certain structures in the face and hands. During the subject's first sitting, I shift the lights around, raise and lower the window shade, until I find a light that heightens what I feel is appealing. There are no rules about how to use lighting, in what combinations for what kind of people, but if I give you some specific examples, perhaps you can draw your own conclusions.

With a man, I generally make a stronger lighting effect than I do with a woman, either by raising my window shade to produce longer shadows or by placing artificial light higher in a more intense, concentrated way. With a woman, I tend to use a more gentle, diffused lighting, facing her into the light. I find that the delicacy of a woman can be lost with a light that's too strong, but a strong light tends to heighten a man's character.

If I'm painting a man who has no striking characteristics—no heavy eyebrows or distinctive hair, for example—or who is rather egglike in appearance, I can strengthen his character with a stronger light. If I used a light background, placed him in front lighting, his head might be lost against the dark suit. I would perhaps give him a stronger lighting by pulling up the window shade or supplementing the natural light with artificial light to make the atmosphere more dramatic. The stronger you make the contrast, the more dramatic it's going to look.

When the light is placed higher, the shadows are deeper. I can use the light to accentuate certain areas of the head. Where the light meets the shadow you create an accent on the face. If you want to accentuate the line of a high cheekbone, a light placed above the face will produce a hollow in the shadow of the cheek, giving that bone a sculptural, almost angular effect. If a man's dimples are particularly striking, I tend to use a side lighting to pick up the dimple. Again, the shadow creates the hollow.

When I painted the astronaut Scott Carpenter, his space suit—with its paraphernalia, strings, reflective details, mirror, dials, etc.—threatened to overwhelm the portrait. Since I was painting the man, not the suit, I had to strengthen his face so that the suit would not distract from the portrait. I did this with lighting: I concentrated the light and shadow on the head.

Light is what enables you to create the effect of three dimensions on your canvas. If you take a photograph with a flash bulb placed head on, you will

A

B

C

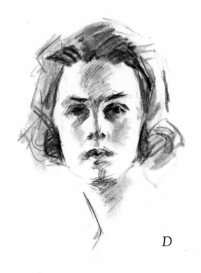

D

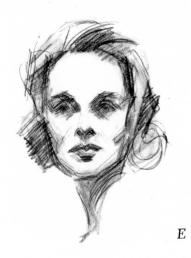

E

(A) With a flat even lighting, the head will register primarily features, not planes. This is similar to a flash bulb photo, with absence of shadows or dramatic effect. (B) By directing the light from one source, side and above, planes, and halftones edges, and shapes of light are brought out, emphasizing the characteristics of the head. (C) By using a dark background, such as velvet, the effect of light on the hair will be reversed. Try to consider all possibilities when posing your subject. (D) Light coming from both sides can create interesting effects and give a crisp series of edges through the middle of the head. This was a light favored by the Swedish portraitist Zorn. (E) This effect is created by a strong overhead light, generally artificial. It is usually too extreme for female sitters and the shadows, rather than appearing luminous, appear as holes.

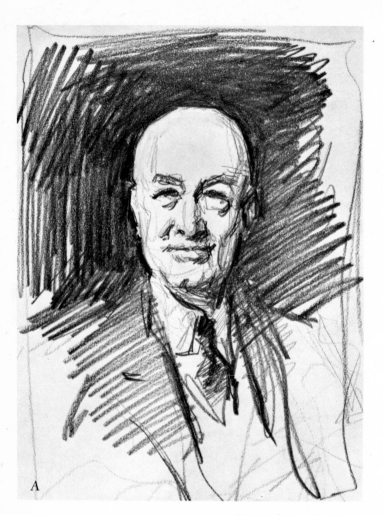

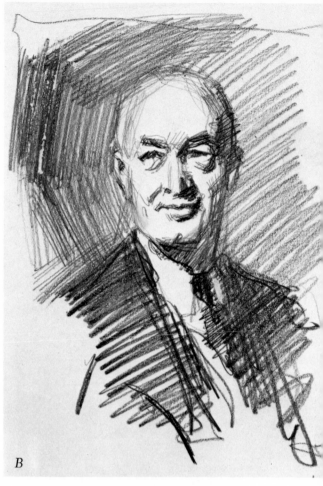

(A) *Lighting the head. If your subject has an egg-like forehead, don't give a cut-out impression to that area. (B) A softer background that "moves" more harmoniously will also help to achieve a more satisfying canvas. Don't flatter; but use artistic judgment.*

see the features, but the light will flatten the face, diminishing any sculptural effect. Experiment with light and see what effects it will give you.

Highlights and Accents

Light produces highlights and shadows, extremes which give the illusion of depth to your canvas. I consider highlights as planes, *extensions of the light planes of the face.* If you think of highlights in the literal sense of the word, you're apt to make them isolated spots on the painting. But highlights should be a lighter version of the color of the light plane: a light plane in the hair is a different color from a light plane at the tip of the nose.

An accent is the darkest part of the shadow area, just as the highlight is the lightest part of the lighted area. Accents are not dabs of dark paint—they are continuations of the shaded planes. If you place them incorrectly you get holes in the shadows, just as you get spots from improperly painted highlights. You want depth in the shadow areas.

Selecting the Angle of the Head

When I study the face of a sitter, I generally get an impression about which side of his face will best carry his character in the portrait. Once again, this is a question of feeling. A subject may be much more distinctive in three-quarter or profile than in full face, perhaps because he has a sharp expressive nose. The full depth of the eyes may be more penetrating in full face. These are decisions you have to make based on how you react to the sitter.

I really don't understand why the profile has become so rare. Generally, I find it difficult to convince a sitter that I'd like to paint him in profile. I do feel that some people are more distinctive in that angle, perhaps because a profile can strengthen a jaw and give a face real character. The profile suggests characteristics more quickly because the contour of the face is most prominent against the background. The full face or three-quarter is more involved with three-dimensional, sculptural effects, but the emphasis on the

Try to avoid this pose. It is monotonous and devoid of creative thinking. Here is the same size canvas. By moving the figure off center and achieving a relaxed pose, the possibilities of an interesting portrait are increased.

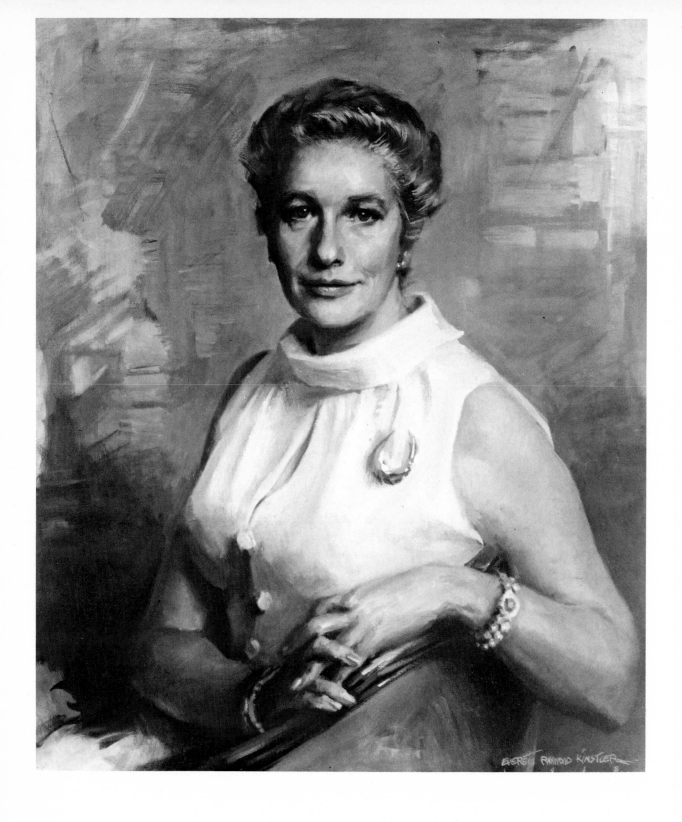

Mrs. Dan S. Mortensen 32" x 28" Again, notice how the body is at an angle compared to the head. This helps achieve movement in the painting. I asked Mrs. Mortensen to move her brooch from one side to the other to make use of the space and to heighten the line of the breast which is so attractive. The bracelet in the shadow helped me with the foreshortening of the arm. Collection, Mr. and Mrs. Dan S. Mortensen.

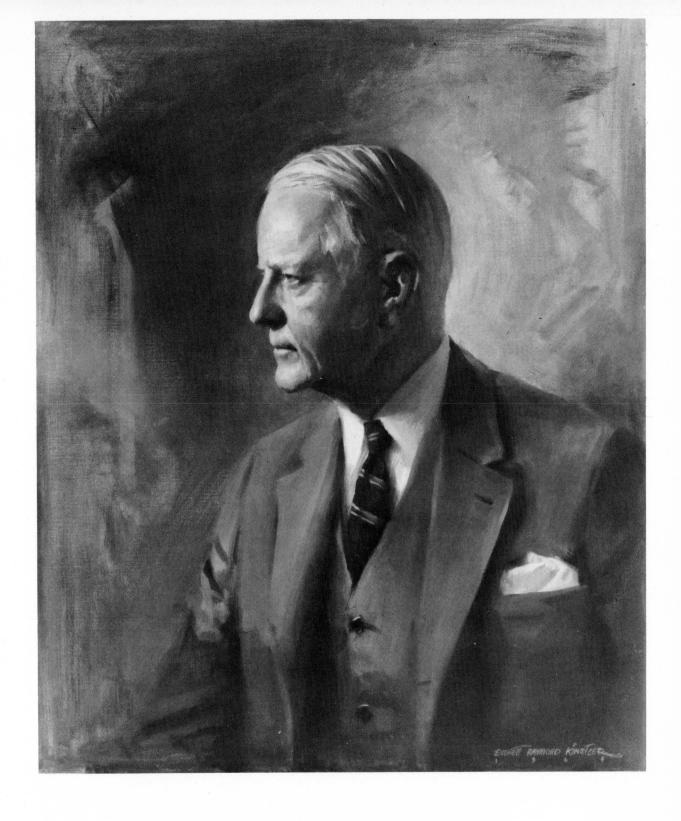

George Emlen Roosevelt, *Chairman, Board of Trustees, N.Y. University. 30″ x 25″ Here is a case where the profile was selected as the angle most suggestive of the man's characteristics. His crisp features were desirable for the life-size portrait painting. Notice that the body is turned toward the viewer, not in the direction of the profile, an angle that gives action and dash to the portrait. Collection, N.Y. University.*

Forrest E. Mars, Sr. 36″ x 30″ The sidelighting in this portrait was an accident, a discovery I made when painting Mr. Mars on location. I took advantage of it because it picked up distinctive lines of character in his face. Each morning after an early breakfast, I painted him in his Virginia home while he posed in his stocking feet. The vest and accessories were all personal characteristics of the man. Collection, Mr. and Mrs. Forrest E. Mars, Sr.

Mrs. A. Mason Gibbes 24″ x 20″ The size of this painting was pre-determined: it was to hang over a mantelpiece in a modest dining room of the Gibbes' home. In a small portrait, simplicity of dress is very important, so I chose this outfit from several because it was simple and because the gold fabric contrasted nicely with the hair. I liked the crisp effect on the dress in the light, and I felt the pearls added a note of refinement. Collection, Mr. and Mrs. A. Mason Gibbes. 3/2 and 3/2

Mrs. E. F. Herrlinger III 30″ x 30″ This painting was commissioned as a 25″ x 30″ canvas, but I made it exactly square in shape because I thought it improved the composition. I started to paint her in a white blouse, but the sweater—which had more flair over her shoulders than completely on—helped vary the white area. The jewelry gives a note of style and adds another texture. When you make a decision about clothing, consider the background as well. Collection, Mr. and Mrs. E. F. Herrlinger III.

profile is in the contour. It's more difficult to convey expression—a smile, for example—in profile. A full face or three-quarter tends to be more arresting, probably because the eyes are looking directly out at the viewer, a quality that creates a sense of immediacy.

Even when I do paint or draw a profile, it's never totally without dimension. I always show the line of the brow on the other side because this suggests the other side of the face. Without the other eye or brow, the profile is flat, a cameo rather than a portrait with dimension.

You should be able to paint a portrait from any angle, simply because one person may be more interesting from one angle than from the others. For this reason, I strongly recommend that you experiment as much as possible, painting and drawing portraits from every conceivable view, so that when the occasion arises, you'll be able to handle it easily.

Incidentally, directly related to the angle of the head is the way in which the subject is seated. Bear in mind that greater contrast gives greater interest. Two straight lines or two curved ones are never as interesting as a straight line contrasted with a curve, and vice-versa. Try to achieve a feeling of movement through dynamic planning of angles and shapes. If you have a figure facing to the front, shift his shoulders slightly so that they are at an angle. That way, you avoid the static feeling of a totally head-on pose. Similarly, in a profile, keep the body turned frontwards so that the slight twist from body to head will create movement. A lifted arm may help in enforcing this movement as well.

For a portrait head, it is wise to paint and suggest collar, tie, and shoulder. By turning the head at an angle to the body, you will add movement.

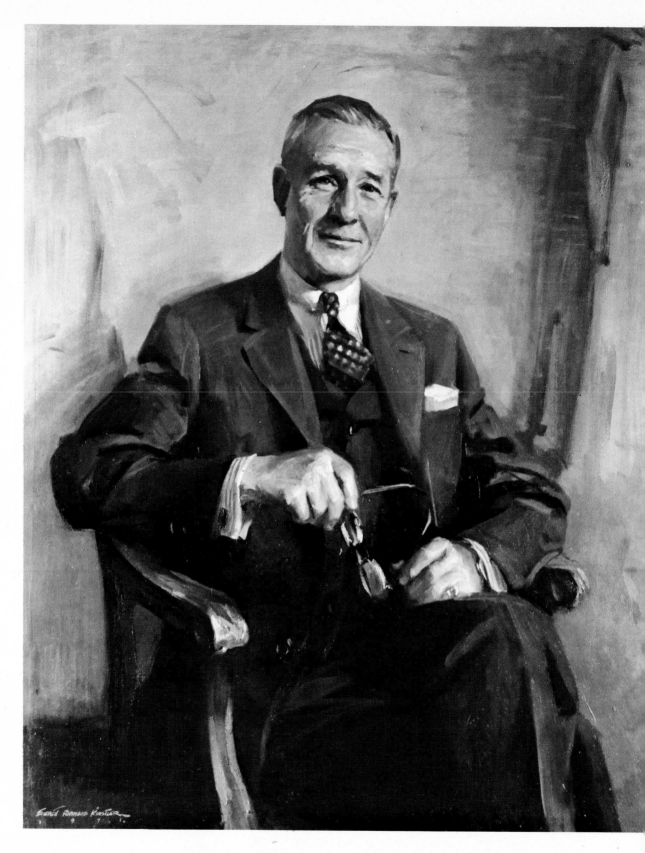

William C. Miller, Trustee, Rutgers University. 34″ x 42″ The subject
here had an animated, relaxed manner which I attempted to capture
in the portrait. The tilt of his head was characteristic, and he fingered
his eyeglasses naturally. Collection, Rutgers University.

CHAPTER 6
Hands

The portrait painter who can master the portrayal of hands in his painting is far ahead of the one who can't. Hands help to convey so much of the sitter's personality, their gesture being a key aspect of his character. Moreover, the hands are a vital element in the composition of a portrait painting. If you have a canvas over 25″ x 30″ you're really obliged to do something with the hands, if only to put them in the pockets.

Catching the Gesture of the Hands

The human head is only about 10″ long, and ¹⁄₁₆″ at the tip of the nose or at the end of the chin can make the difference between getting a fine likeness and not quite "catching" it. However, if you make the hands a bit smaller or larger than they really are, it doesn't make too much difference so long as you retain the gesture. As a matter of fact, I tend to make a man's hands slightly larger than life size and a woman's hands slightly smaller. The larger hands emphasize masculinity and the smaller hands suggest refinement and delicacy. The size of the hands is not so important as their gesture. I don't see a palm with five fingers, but a gesture, the way the hand rests on the knee, the particular quality of a subject's hands. This takes careful observation.

Once I understand the function of a subject's hands, how he moves them and holds things, I may get someone else to pose for me, placing the model's hands in just the same way my subject had placed his. It is the function and character—the gesture—of hands that make people say, "You've caught John's hands so well," even if John didn't pose for those hands at all. The fact is, I knew what John's hands were like, what they did, and that is what distinguished them, not their precise form.

I strongly advise against giving the hands busy work to do, activities to keep them occupied. The gesture is the way in which the hands fall when they are relaxed, not what they do to keep busy. This is not to say that you can't place a cigarette or pipe in the hand; but I do this only if the subject is associated with his smoking. You don't want gimmicks.

Rev. Dr. Richard Baker, Bishop of North Carolina, 46″ x 35″ *I chose a standing pose for this portrait because I felt it expressed the dignity of the office, and the Bible was a natural complement for this conception. This is what I mean when I say that the glint of a ring can help establish the whole hand. The papers also add interest to the hand and alleviate a dark area. Before arriving at this treatment, I made an oil sketch shown above. Collection, Episcopal Diocese of North Carolina.*

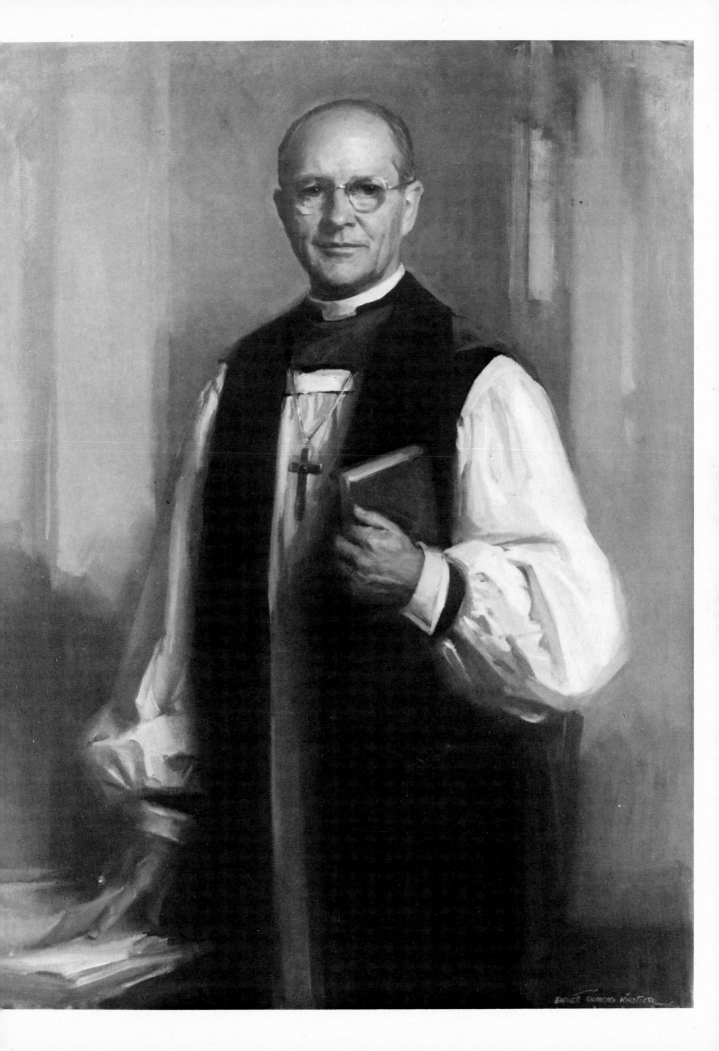

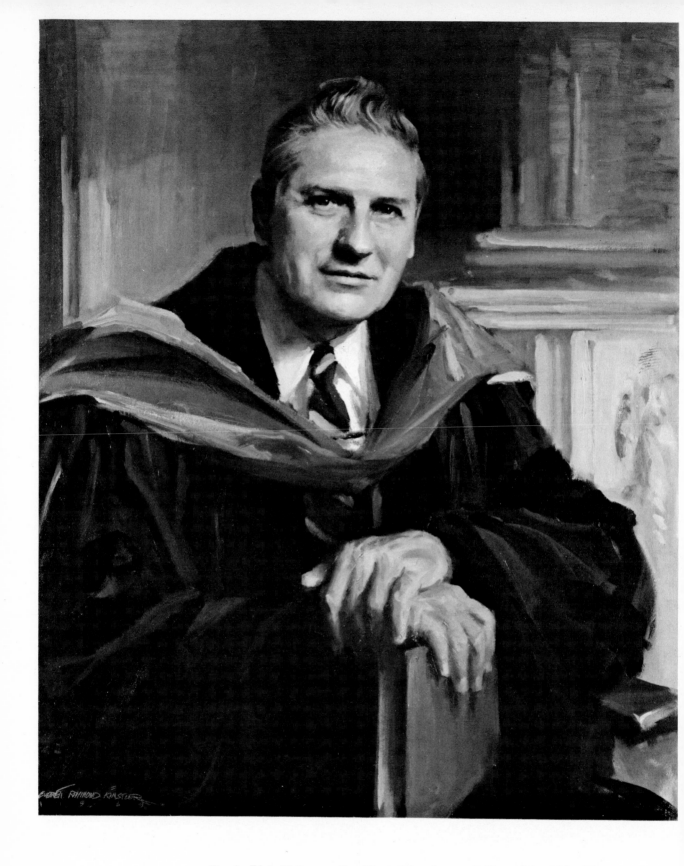

Dr. A. Blair Helman, President, Manchester College. 36″ x 30″ This college president was youthful and I wanted a natural pose. The books related to his profession and atmosphere, and gave me an opportunity for another compositional shape in the space below. I experimented with the hands in reverse, but preferred the left over the right. Collection, Manchester College.

Composing the Hands

Hands serve an important function in the composition of the painting. They can give interest to a dark space on the canvas; they can offset the head placed well to one side of the painting. In Chapter 4 I've drawn some diagrams describing ways in which you can consider placing the hands within the total composition of the painting and I urge you to consider that chapter again.

What may surprise you about painting hands is that you don't have to paint all five fingers to suggest the total structure. In getting the function of the hand, you may need only to paint one or two fingers and barely suggest the rest with a few brushstrokes. You need some degree of light and shadow to fall on them to give the feeling of structure, but many students mistakenly feel that they must convey every finger, every knuckle, which simply isn't true.

An item on or near the hand may help greatly in suggesting the gesture and placement of that hand. For example, if you've painted a hand in shadow, a glint of light striking a ring can establish the volume of the entire hand, without your having to paint the hand in detail.

I look for what's around the fingers. Hands can make the fabric of clothing more interesting, especially a woman's dress. A hand placed on a knee can suggest the quality of the fabric below, and also establishes the weight of the hand by the way it makes the folds spill out from beneath it. Holding a handkerchief can give a feeling of the whole hand. A man's cuff can be helpful in arranging the space in your painting. If a man is wearing dark trousers and his hand is placed nearby, the dark can isolate the light hand, producing a distracting spot in the composition. The cuff of his shirt can bridge the effect and prevents the hand from seeming cut off. A cufflink catching the light can also enliven the space.

What you place in the hand may help compositionally as well. A hand that seems to be falling off into space can be "anchored" by placing a cigarette between the fingers, a handkerchief in the hand, folds catching the light beneath the weight of the hand. Conversely, if the hand is *too* distracting, I tone it down. I don't want the hands to distract in any way from the head.

Hand Studies

I do a great many hand studies. I make sketches in whatever material I have available—pencil, charcoal, oils—because I know that these studies may be valuable to me for a future painting. These hand studies extend my range so that when something arises in a painting I know I can handle it because I've already worked out something similar in my sketches. I recommend that you paint and sketch hands, too. There is no better way to increase the number of situations you can meet.

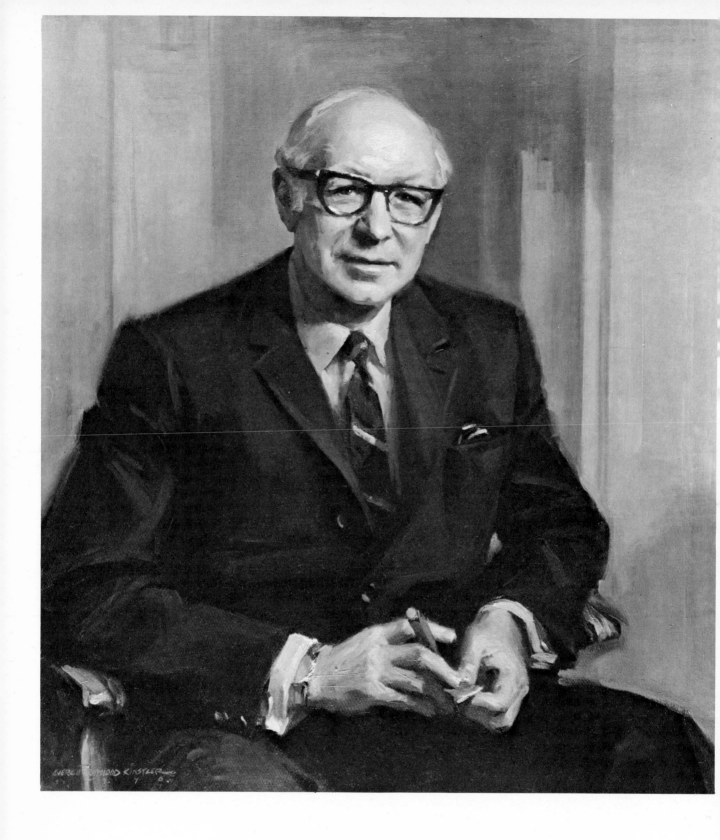

Raymond H. Lapin, Former Chairman, Federal National Mortgage Association. 36″ x 30″ As he posed, the subject smoked his cigar. I felt this added interest to the portrait, and I portrayed the moment when he fingered his matches. I did not paint any studies of this gesture, but just blocked it in directly on the canvas. Once I've decided what the hands are doing, I prefer to paint them all in one go. Collection, Federal National Mortgage Association.

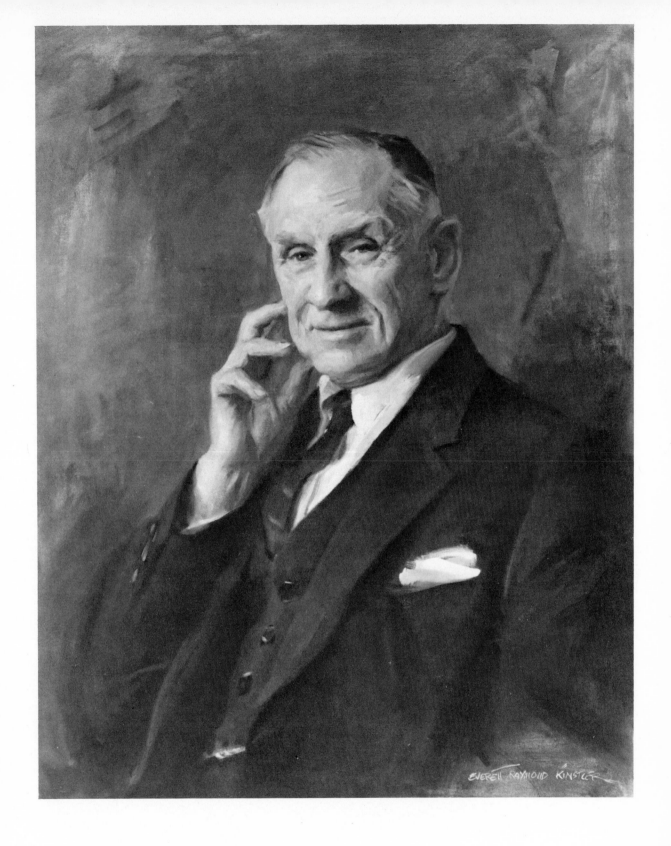

Robert Lee Kerr 30" x 25" This is one of the few times I've included the hand in a small canvas by placing it near the face. The pose was characteristic of Mr. Kerr and his hand had great individuality. However, this is not the kind of treatment you can use often; it can look affected. Collection, William Bird Co.

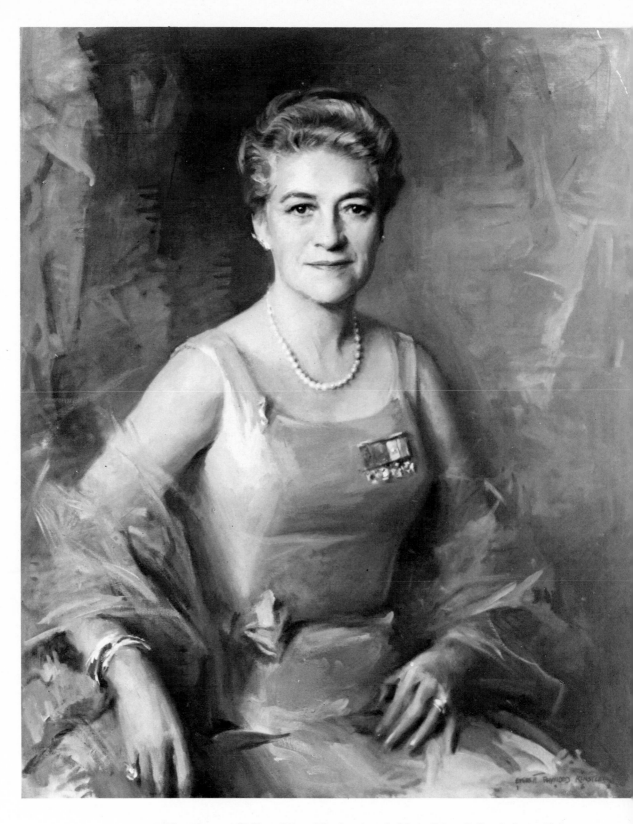

Mrs. George Callery 36″ x 30″ *I painted this in Mrs. Callery's beautiful Wilmington home in January when the trees were bare, which afforded more daylight in the house. The medals were awarded to her for unique contributions and represented part of her formal silk evening gown. The tulle added a note of sparkle. Collection, Mr. and Mrs. George Callery.*

CHAPTER 7

Clothing

In talking about portraiture, I constantly return to the idea of painting what is characteristic of the subject. This is the key in portrait painting and it affects the choice and painting of the subject's attire as well.

General Considerations

The reason the portrait has been commissioned and the place where it will hang largely determine the *kind* of dress required. If a portrait is going to hang in an office or boardroom, the attire should suit the occasion: white shirt, blue suit perhaps. An informal portrait, on the other hand, is more suited to a painting that will hang in the home. (I've painted business executives wearing a sweater thrown over the shoulders, but the paintings were going into homes, not offices!) Wherever possible, I lean toward the more informal. People have a feeling that a portrait is a once-in-a-lifetime thing and they should look their Sunday best. But I prefer to paint people as they appear every day of the week. I feel this better represents them as they are.

The clothing should suit the personality. If a man is accustomed to wearing his jacket unbuttoned, then it would be a mistake to paint him with his jacket buttoned. People dress in the way they feel most comfortable, and getting them at their best really means to me painting them when they're most comfortable.

When I was commissioned to paint Tom Hoyt, president of the New York Athletic Club, I anticipated an informal portrait in keeping with the athletic environment and atmosphere of the club. But Mr. Hoyt told me (almost apologetically) that he never felt comfortable in colorful, informal clothes. He said he would feel unnatural and ill at ease if he wore anything but his blue suit and white shirt. Painting him in character, then, meant painting him in his favorite attire. I would not have done otherwise.

As a general rule, I stay on the side of simplicity. If the costume is too elaborate, it detracts from the face and overwhelms the painting. What a

person wears is only one aspect of his character and should not tell the whole story. As I've said before, you want the man, not the trimmings.

Before our first sitting, I discuss clothing with the subject. If possible, I go to his home and we go over various alternatives. This is particularly important in selecting an outfit for a woman. In general, the sitter looks toward you for guidance and you should have a fairly good idea of what you're after. Holding up a dress in the livingroom light may not have the same effect as seeing her dressed in the outfit in my studio light. If I'm in doubt, I ask her to bring more than one outfit to her first sitting.

Uniforms

Painting a person in uniform can offer many interesting possibilities and can also be terribly restrictive. For instance, a scholar's robes may call for painting large areas of open color, which is enormously rewarding and fun. On a number of occasions I have painted men in military uniforms, which can also be an interesting experience, despite its limitations.

When I speak of limitations I mean, of course, that the painting has a specific purpose; it will hang in a certain place along with paintings of other officers. Medals and awards take on an importance, and I really have to work at not losing the man within the uniform. Even within these limitations I have, on occasion, held out for something slightly different from what was planned.

Once I painted the head of the Department of Navy, Admiral David McDonald. When I walked into his office, he was wearing his tans. At the time, I didn't yet know how I was going to paint him, so I began to sketch freely in his office. I photographed him in the same light I had sketched him. When I finished the oil sketch, he said, in passing, "Of course, you're going to paint me in the blues, not in the tans." I quickly responded that I would prefer him in the outfit he was wearing. He was a good-looking man, youthful, with crisp features, and his manner lent itself to a certain airiness and informality. I felt the darker uniform would inhibit these characteristics.

Admiral McDonald hesitated, saying that all the previous heads of the Navy had been painted in their blues. He had a preconceived idea that the blues were in keeping with tradition. I asked him which *he* preferred and he admitted that he felt more comfortable in the tans. Since he wore the tans five days a week during the warmer months, I knew he would present a more relaxed feeling wearing them for the portrait. He agreed, and I painted him in his tans.

I was commissioned to do another portrait of General Wallace Greene, Commandant, U.S. Marine Corps. I wanted to paint him in his casual uniform rather than in the dress blues. However, there was a reason for the blues which I had not considered. The uniform, recently designed, had never before been painted, and this portrait was to have a historical purpose. I had a similar situation when I painted the astronauts, whose space outfits certainly had historical significance, even though I had to struggle against letting the suits overwhelm the men inside!

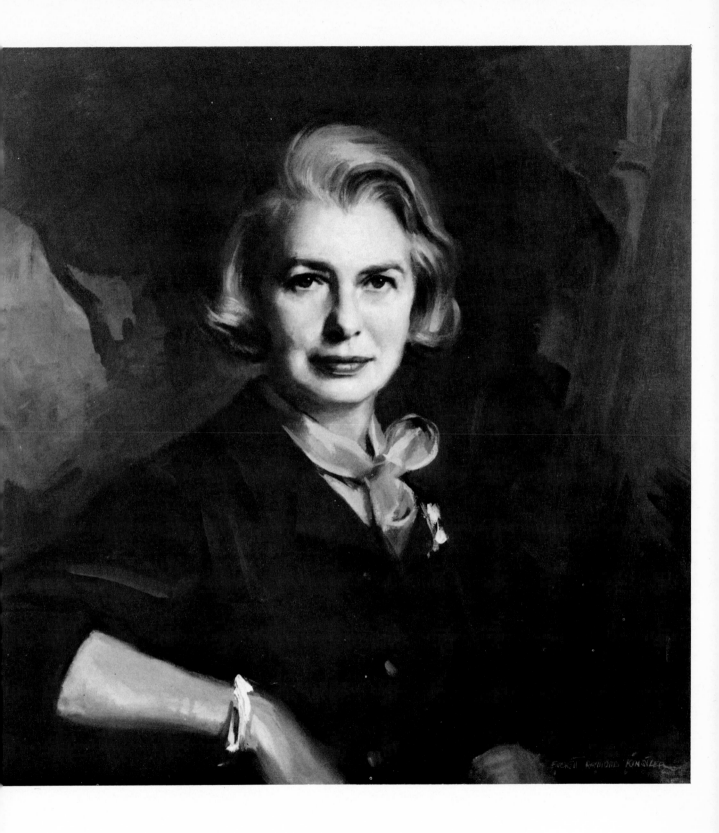

Mrs. Frederick Kingsbury 30″ x 30″ When I decided on the pose, I realized I had the bracelet and brooch on the left side of the picture. So I changed the brooch to the other shoulder. If I hadn't, the composition would have been off balance, so this proved a satisfactory compromise. Collection, Mr. and Mrs. Frederick Kingsbury.

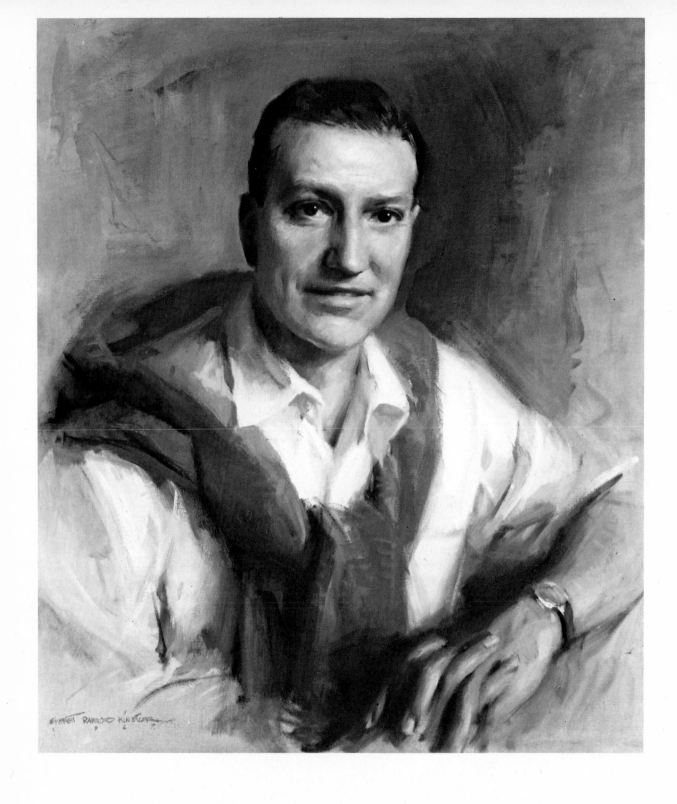

James A. Fisher 30″ x 25″ Although the subject was a business executive, the painting was going into his attractive home and could reflect the informal surroundings. Mr. Fisher was an outdoor man—loved to sail—and we decided that he pose in an open collar shirt with his sleeves rolled up. Once I started painting, I felt the white shirt was too stark, so I asked him to throw a sweater over his shoulders—which was in keeping with the informality and gave variety to the white. Jim had great animation, hence the smile. The wrist watch helped in the foreshortening of the arm. Collection, Mr. and Mrs. James A. Fisher.

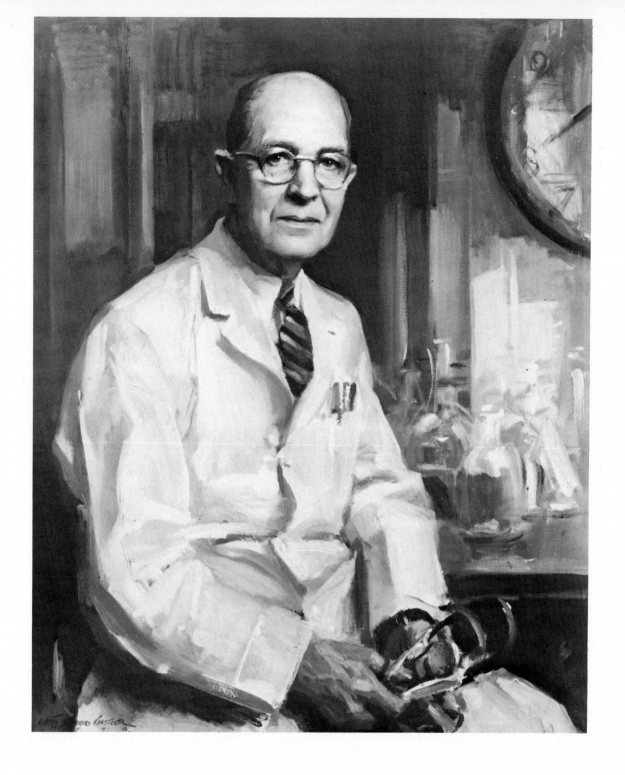

Dr. James Bordley III Director Emeritus, Mary Imogene Bassett Hospital. 44″ x 34″ Before our sitting, I chatted with the physician. He told me the white coat was part of his daily attire and since the portrait would hang in the hospital, this seemed an appropriate garment. He brought the white jacket and left it at the studio for me to study. I included the stethescope because it was appropriate—even the pens and pencils in his pocket were typical. For the background, I made use of various pictures I had in my files of bottles, vials, glassware, etc., which were part of a hospital surrounding. And the clock furnished an interesting shape. Collection, Mary Imogene Bassett Hospital.

I mention these incidents because I think they illustrate the kind of considerations you have to make in regard to painting uniforms. The uniform may be an emblem of a man's profession, but it shouldn't stand in the way of getting to the man himself. The same holds true if I'm painting a portrait of an artist in his smock, or a doctor in his white outfit.

Women's Attire

Men's clothing remains fairly simple, whether formal or informal. With women's clothing, however, there are many more things to take into consideration. Clothing takes on more importance in a woman because the portraits tend to be personal, rather than institutional. Certain outfits have a sentimental value—"This was the dress we loved Mother in"—and that may be the reason for the selection of an outfit.

Because women's fashions can change so drastically, I think it is especially important here to lean toward simplicity. There is less likelihood that a simple, classic style will change over the years than will a particular line that is in style for the season. You don't want your painting to look dated in five years. If the outfit is simple, the painting is not too affected by style.

With women there are many variations not possible with men. Considerations such as neckline, sleeves, fabric, color, pattern, and accessories make an enormous range of possibilities. There are no rules here: a low neckline can be as effective as a turtleneck sweater, a sleeveless dress as interesting as one with sleeves. (Incidentally, I would avoid a bare, low neckline for an older woman. It comes across as if you're trying to make her look younger and may touch on poor taste.)

I always ask the subject if there is some outfit she particularly likes and feels comfortable wearing. Once a young woman brought a cocktail dress she was especially partial to, a dress of purple taffeta, which picked up the light as she moved. The dress was very feminine, had a simple neckline, and she looked attractive wearing it. But as I began to paint, I noticed that the style of the dress didn't succeed on the canvas. The dress had style only in movement, but didn't convey this on the canvas. For one sitting she arrived in a yellow summer dress with matching headband, and I asked her if she would mind wearing that summer outfit for her portrait rather than the purple taffeta dress. She agreed. And I think changing the dress greatly improved the portrait.

The size of the canvas may determine the outfit. If the painting is to be head and shoulders, no hands, you may not want bare arms because they look cut off from the hands. Bare knees are not particularly desirable in a three-quarter portrait, so I suggest an evening or cocktail dress here. (Occasionally I suggest that the woman bring along a filmy tulle stole. This fabric can add style and movement to the portrait and prevents bare arms from being stark and distracting.) An evening dress in a head-and-shoulders canvas might look like a simple summer dress, defeating the purpose of elegance in style. A print dress or too many accessories on a small canvas are very distracting.

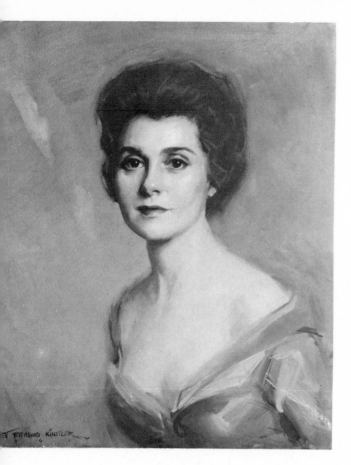

Mrs. Thomas Russell Price 24" x 20" The portrait left is reworked
from the painting right. Mrs. Price had come to New York City from
Memphis to pose, and months later (when I was painting other
portraits in Memphis) we talked about the completed painting hanging
in her home. She reminded me that I originally wanted to paint her
in another dress, and that she had come to realize that I was right.
It involved very little for me to simplify the style of the dress and I
felt it helped the painting. The first dress looked matronly, which
was a far cry from her character. I left the head unchanged, except for
a slight softening in her hair and suggestion of her ear. I signed my
name on the opposite side of the canvas to balance the compositional
change. Collection, Mr. and Mrs. Thomas Russell Price.

As I've said before, I don't necessarily adhere to what I see before me. I always have my painting in mind, and if adding sleeves to a sleeveless dress will improve the composition, I take the liberty to do so.

Painting Hair

Hair is a particularly distinctive feature in getting a likeness. With women in particular, hair is a singular characteristic. I ask that the sitter style her hair in her accustomed way, and I make a point of telling her not to have it too set. I'm not a tight painter, and I like hair to have movement and grace. Because her hair may change so much from one sitting to the next, I take Polaroid photographs the first two or three meetings. I may find the way it falls more appealing the third sitting than I did the first, and I change it to suit the painting.

I'm after movement in the hair, a feeling of abundance, pleasing shapes. I look at the edges: are they crisp here, diffused there? And then, with generous brushes, I follow the direction of the hair as if I were combing it. Hair is not a solid structure and the brushstrokes should follow its movement. This is the key to painting hair.

Accessories

I like a note of jewelry if it's in good taste and not distracting. A pearl necklace can set off a black dress very well. A bracelet can help in foreshortening an arm, in filling a large, bare area. A hand in shadow can be more interesting if a bracelet or ring picks up a flicker of light. Accessories stress femininity and style, and can add some sparkle to the painting. However, I don't ask a woman to put them on if she's not accustomed to wearing them. And if she wears too many, I ask her to remove them, because they can be a distraction.

Here again, I can take liberties. I may ask the sitter to change the brooch from the left to the right side if I feel it will make a passage more interesting. I arrange them the way I want them. Naturally, I wouldn't ask her to change a wedding ring from the left to the right hand, because in this case the accessory has a special meaning and I wouldn't impose the needs of the painting onto that emotional association.

Dr. Thomas Pitts 37" x 32" When I met Dr. Pitts, I asked many of the same questions I had asked Dr. Bordley, since they both were doctors and both paintings were going into hospitals. He told me he never wore his white jacket at work. Yet I didn't want to make it like a business portrait, as he was a doctor, and I wanted to suggest his profession. To insist he wear the white jacket would be painting him in a way unnatural to him. I resolved this by placing the jacket over the chair to suggest the medical atmosphere, without at the same time betraying the attire he ordinarily wore. Collection, Columbia Baptist Hospital.

Painting Eyeglasses

While I'm on the subject of accessories, I should say a word about eyeglasses. I ask the subject how often he wears his glasses, whether, for example, he puts them on first thing in the morning and wears them all day. If his family and business associates know him only with his glasses, it is best to include them in the painting. However, if the glasses are incidental, if he wears them only for reading, their inclusion in the painting is really optional. I learned this from one distressing experience.

Years ago, I painted a portrait of Charles Stewart, a bank chairman, who wore very heavy eyeglasses that enlarged the size of his pupils. After the first sitting, I received a phone call from Mr. Stewart asking if he could be painted without his glasses, so that we could avoid the distortion they created. Since I'd just begun to paint, it didn't make much difference whether I removed the glasses or not, and I went along with his request. After I finished the portrait, the president of the bank came by to see the painting. His reaction was unexpected. He felt that I had missed the likeness, but he couldn't explain why. I showed him several photographs I had taken during the course of the portrait, hoping that he might notice some characteristic I had missed. Among the photographs I showed him were a few shots from the first morning when the subject had worn his glasses. That was it; he had never seen Mr. Stewart without glasses. The character of the eyes had been quite altered and had affected the likeness.

Painting eyeglasses can be quite tricky unless you bear in mind some basic principles. It's rather like painting a bracelet: you don't want every pearl, but the *impression* of the object. Eyeglasses are not outlines placed over the eyes, as so many students think; they are suggested with only one or two highlights and a cast shadow. The light reflected on the lens brings the plane forward. These highlights are generally linear, crisp reflections, painted in the lightest color you have on your palette. I may have to adjust the angle of the light or the position of the head so that the reflection doesn't interfere with the eye itself. This is important.

Just as the highlight brings the glass forward, so the cast shadow suggests the space behind. The shadow of the eyeglasses falling on the plane of the head will suggest the form of the glasses.

Bishop Walter M. Higley 32" x 28" It's always appealing to paint clothing other than a suit, and clerical robes offer a fine opportunity. The difficult part here was in painting the voluminous white robes because of the subtle variations in color. First I considered the action of the fabric. There is no such thing as pure white; warm and cool variations make it possible to play one tone against the other—and give life to cool whites and warm luminous shadows in the folds. I kept the robes in the studio, having someone pose for me, so that I could experiment and resolve their treatment. Collection, Trinity Memorial Church.

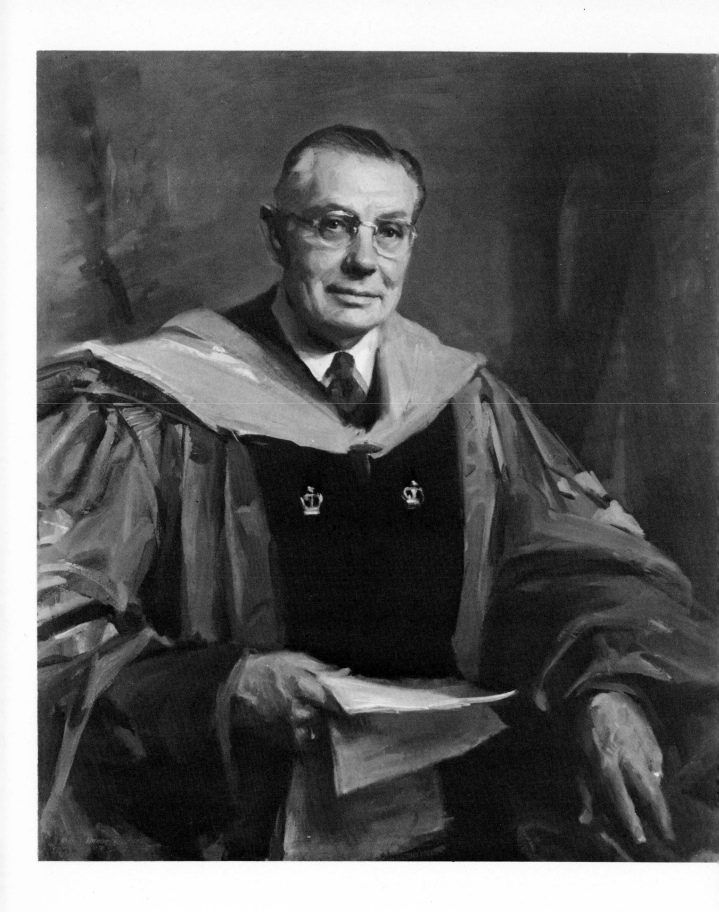

Color of Clothing

Although I don't think about painting a bluish portrait to go in a bluish room, I do consider the colors of a portrait in relation to the setting in which it will hang. If a room is particularly subdued in color, I would not paint the person wearing a brilliant red outfit. The painting would overwhelm the room. On the other hand, if a room is bright and colorful, a red headband may be just the touch I need to make the painting part of its setting.

I consider my painting in terms of values—how light or dark I want my colors—not just in terms of hues. In this sense, I have a certain latitude in painting. If a person is wearing a red dress, I can change it to a soft orange dress by lightening the value of the red. However, I never alter the color radically. I won't, for example, change a red dress to a black dress; doing this means altering all the values of my painting—the background, the highlights, the over-all tone of the painting. I never change drastically from a rough scale of values.

Bear in mind that you can cut the strength of a color by breaking it up. For example, a suit in heavy black can be brightened with a white handkerchief in the pocket, or a bright blouse can be subdued if you throw a neutral sweater over the shoulders.

Folds

Painting folds is not nearly as complex as students tend to think. First I study the function of a fold. After all, folds are simply draperies around three-dimensional objects. The arm is bending and the folds drape around the arm. If you look for what the body is doing beneath the folds, you will come closer to seeing the function of those folds.

Here again, the kind of fabric in a costume will determine the kind of folds it produces as it drapes over the body. If the texture of the clothing is appealing, that texture should be conveyed in the folds. How do the folds respond when the model crosses his legs? Do they bunch up? A tweed suit, for instance, will tend to bunch, and you have to modify this in the painting, without losing the feeling of the tweedy texture.

I modify folds by eliminating them whenever I feel they are unnecessary. How can I suggest these folds with a minimum of detail so that they will carry from the distance? Here is an instance where you really don't want more detail than necessary; folds can be terribly distracting if they are overworked.

Dr. John Fischer 42" x 35" I painted this college president in his light blue academic robes. The blue of the fabric was so dominant that I subdued the background elements. Too much would have distracted from the portrait. Originally I had a book in his hands, but this evolved to papers instead. Collection, Teachers' College, N.Y.C.

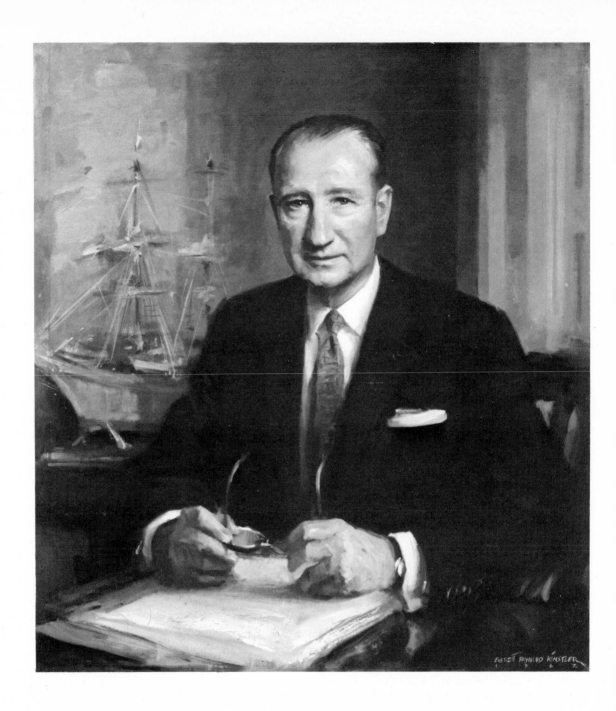

Andrew Neilson, Chairman, American Bureau of Shipping. 34″ x 37″
When young, the subject had sailed on a clipper ship and the model
of the ship seemed a natural background. I didn't paint it in detail or
it would have distracted from the head. I had to compensate for the
clipper ship in the composition, so I placed the light area on the right
for balance. Cover up the right side and you'll see that your eye moves
over to the left without this light area to pull it back. If you cover
the left side the same won't happen because the background on the
right is more abstract and doesn't balance in the same way. Even the
spaces through the chair—which weren't actually there—help balance
the clipper ship. Breaking up the space behind the chair also helps
in creating space in the background. Cover up those areas and you'll
see what I mean. Collection, American Bureau of Shipping.

CHAPTER 8

Backgrounds

Backgrounds should be nothing more than the word implies; they should stay back! A scenic designer once told me that if a set is repeatedly applauded by the audience, the designer is doing a disservice to the playwright. And creating a background is like laying the scene for the play. The background sets the atmosphere of the portrait, but is not the whole story. I seem to be starting this chapter with negative advice, but I do feel that this warning may help you conceptualize the function of the background.

I like to think of the background not only as the space directly behind the sitter, but also as consisting of the things that surround him from all sides: the chair he sits in, what he holds in his hands, the desk he's leaning on. These, to me, are all part of the background, and I'd like to discuss them all in this chapter.

General Considerations

From the very beginning of my painting, I consider the background simply as a complement to the sitter. It is an atmosphere and a mood which works in harmony with the expression of the sitter, the pose of the sitter, the way I see the sitter. If the man is dramatic, I may want a dramatic background; if quiet, I would probably prefer a subdued background.

The size of the canvas has something to do with my vision of the background. In a small canvas, the background is generally nothing more than a tone, because any clutter would distract greatly from the head. If your subject is wearing robes which are generous and flowing, the fabric fills a large part of the background, reducing the area you need to cover. On the other hand, a full-length standing portrait means that there is a considerable amount of space to fill.

Basically, I return to the same idea: how simply can I say this? How much can I eliminate and still retain the necessary atmosphere? A background should be like a tree a bird can fly through, as someone once said.

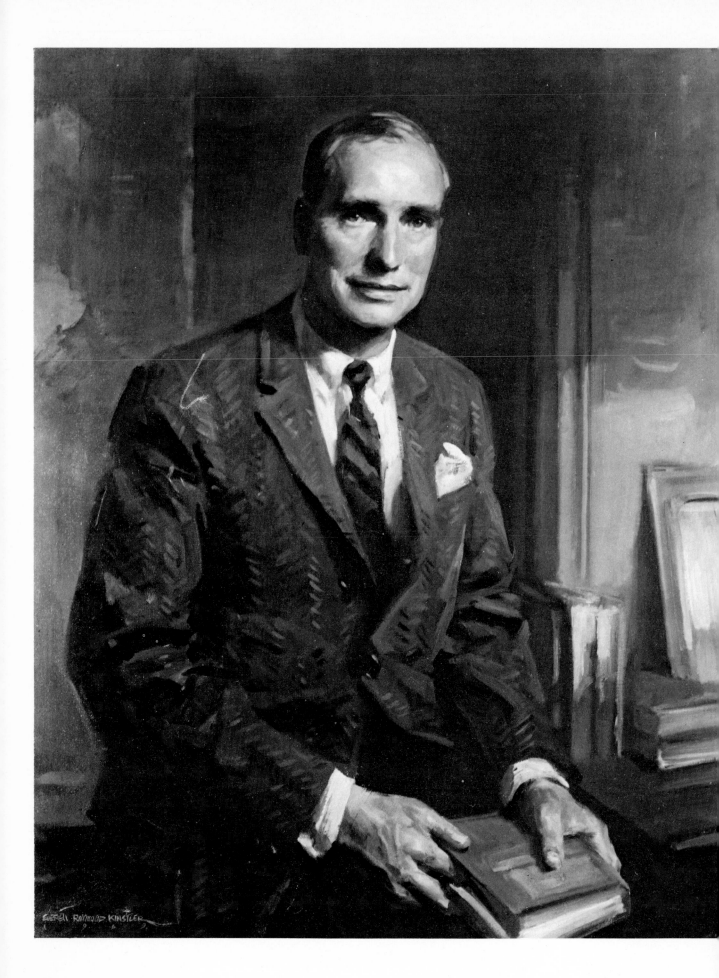

Laying in the Tone

In the first sitting, I decide on the tone and color I feel is in keeping with the model. Generally, I have no preconceptions when I start. I take several draperies and place them on the screen behind the sitter, step back and look for what I feel is most harmonious. One may appeal to me, another not. Later, I can transform that curtain into a molding, but for the time being I am looking for a tone.

I generally choose a middle tone, one that relates to the tones of the face. Changing a middle-tone green to a middle-tone red later is a simple process. But I avoid changing a middle tone to a. lighter or darker tone because this will alter all my other color relationships, such as the highlights on the face.

What tones I choose also are related to the outfit the sitter is wearing. When I painted a woman wearing a full-length white dress, I wanted to bring out the contour of the line and the whiteness of the fabric. Here I made the background darker. The reverse may not be true, however. Someone in a dark suit, if set against a light background, might look cut out, as though he were pasted onto the background. So here, I would stay with the middle tone. This is not a question of rules, but of appeal and taste. In fact, I do experiment, changing from a light background to a dark background if I feel I'm beginning to repeat myself. And I think you should experiment too.

Very bright colors should be used cautiously in the background, because they can detract from the head. Your first consideration is in making that person come to life in space, and extreme colors can compete dangerously with the subject.

Shapes and Light in the Composition

I look at my canvas abstractly, in terms of large shapes and areas, and I compose the shapes in the background in a way that enhances the movement on the canvas. If you have a vertical figure, for example, it might be wise to introduce a horizontal line in the background. A curtain is more than just a piece of fabric: its shadows are arranged and composed in shapes that work into the total composition.

Cast shadows are a great aid in creating shapes in the background. A strong light can throw an interesting pattern of shadows against the screen,

Bruce McClellan, Headmaster, Lawrenceville School. 42" x 35" To convey the relaxed, informal manner of Mr. McClellan—a school headmaster—I had him sit on the bridge table. Working with basic light and dark shapes, I decided to transform the light area behind him into books. The shapes appealed to me, and I painted them in horizontal and diagonal lines. I felt books were part of his life and their shapes in the background were appealing. Collection, Lawrenceville School.

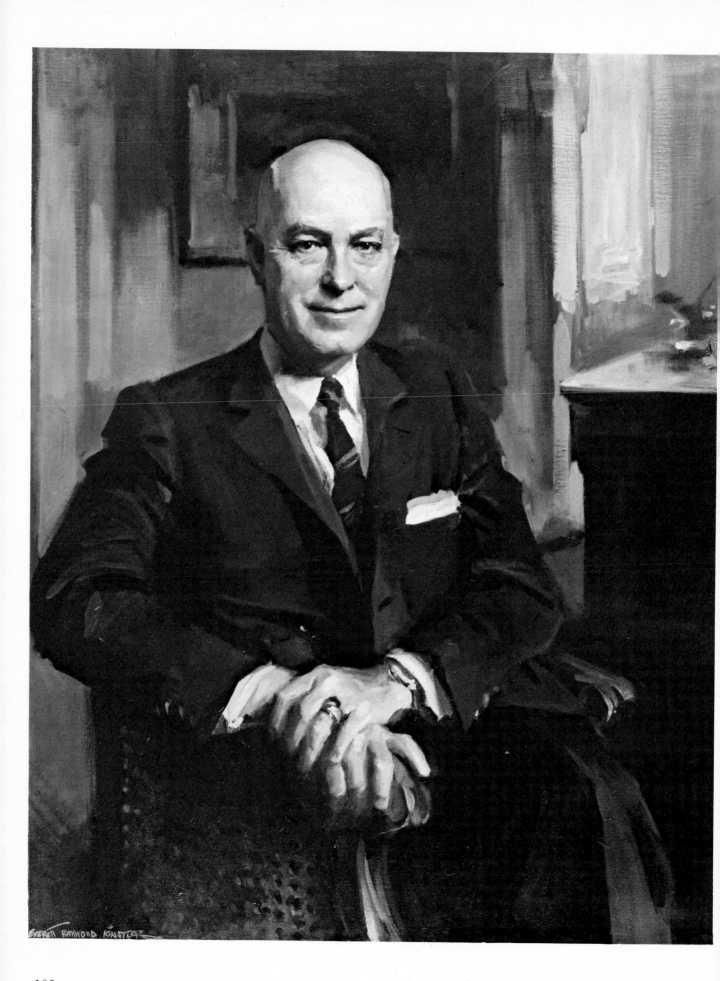

for example. Or the way the sunlight falls from a window can produce an interesting pattern across the floor and up the wall as well. Here again, I don't just paint what's before me; I take liberties, changing shapes into what I want them to be in the composition. I also may convert a shape into a detail, such as a molding or bookcase. (One word of advice: if you transform a shape into a specific object, be sure to paint it in the same light as the model. If the light is coming from the right, be sure that the light hits the object from the right as well.)

While I'm on this question of light, let me also add that the space behind should not be converted into an outdoor scene—such as a sky with patterns of clouds—if the portrait has been painted indoors. The light is very different outdoors from what it is inside, and if you want your subject to be in an outdoor setting, paint him there. Pasting a background behind him will not give him an atmosphere.

Texture

I keep the texture of my paint to a minimum in the background. My application here tends to be flat: I apply my paint thickly in the light areas that I want brought forward, and thinly in the dark areas that I want to recede. If a dark area has too much brushwork, the light will reflect those particular strokes and bring that area forward. But a thinly painted background, viewed from a distance, looks more like space and atmosphere and doesn't have the opaque quality created by thick paint.

I once encountered a real problem with texture in the background when I painted a portrait of a man in his home. He was part of an old era of affluence, breeding, and culture, and his appearance—with his vest and pince-nez—was very much in harmony with the estate he'd grown up in. To catch that harmony, I decided to use one of the wall tapestries in his home for the background of the portrait, but I had quite a time conveying the texture of the fabric without making the background come forward to compete with the head. I solved the problem by keeping the background colors reasonably subdued and simplifying the detail.

Putting the Bridge Table to Use

I find many uses for my collapsible card table, converting it into whatever I may need for the background. For example, I can seat my model alongside

Robert B. Pamplin, President, Georgia-Pacific Corp. 39″ x 34″ Lately I've experimented with the idea of raising the horizon. Notice that here the horizon line is above the subject's elbow, creating greater space and atmosphere. John Johansen, whom John Singer Sargent called our finest American portrait painter, helped me see that space and light move horizontally, rather than vertically. Consider space as moving across the canvas, rather than moving down. Raising the horizon is a logical result of this kind of thinking. Collection, Georgia-Pacific Corp.

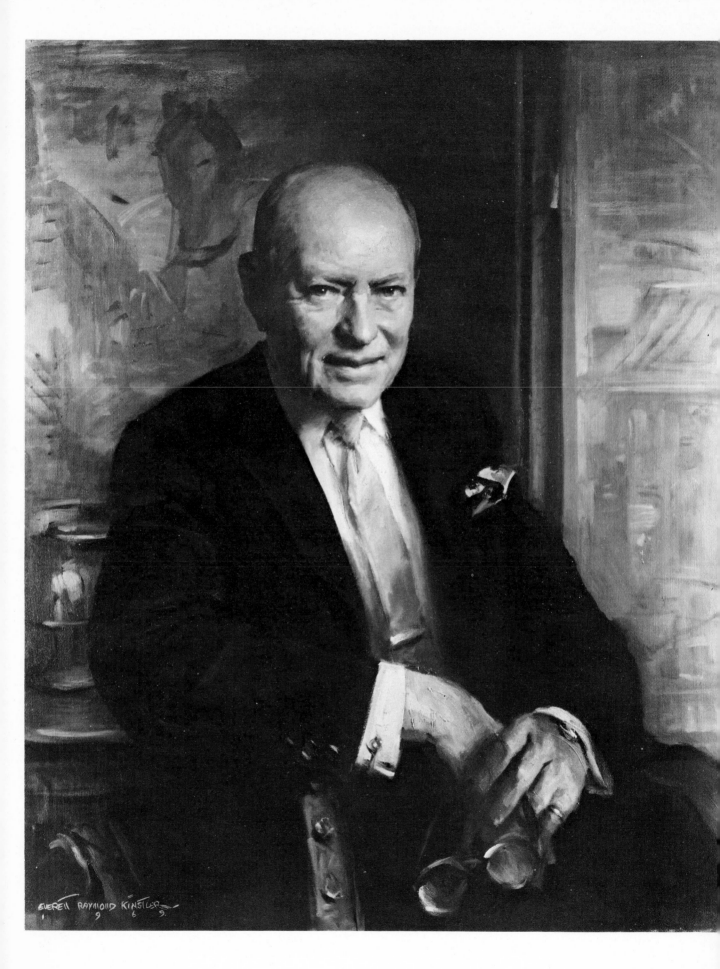

the table and paint him as if he were posed behind a desk or elegant table. And it can always help in creating a mantelpiece! Since I sometimes can't include the arms comfortably in the composition because of the size of the canvas, I find that placing a hand or an arm on a mantelpiece can resolve the problem, so I pile books on the card table until they reach mantelpiece height, and I have the model lean on the books. In my painting, I transform the books into a mantelpiece.

Using the bridge table is an excellent example of how I can make the shape and height work for my painting. First you must know what you want, then you make the thing happen. The bridge table functions as a conceptual tool. I improvise the picture to make it what I want it to be. Perhaps this is because of my orientation as an illustrator.

I use the bridge table idea when I'm on location as well. Once I had to paint a portrait of an executive in a boardroom. Seating him at the long conference table was uncomfortable. I tried putting him at a desk in the room but I couldn't get near enough to paint him. So I took him all the way to the corner of the large room and seated him at a small telephone table, where he looked much more comfortable and where I could work easily. Later, I transformed the telephone table into a desk in my painting.

Chairs

I have five or six chairs in my studio, in various styles. I use a chair when the model's hands are part of the portrait, and I choose the chair that I feel relates to his character. This, I feel, is part of the background too. I probably wouldn't want a young woman sitting in a heavy period chair. Not only is the chair expressive of the model's character, but I want the sitter to feel comfortable in the chair, because I know that if the sitter is relaxed, the chances of doing a good portrait are greatly enhanced.

Details and Props in the Background

The portrait is a total picture, not a collection of details. What I bring into focus is what I see with my eyes. When you look someone in the face you're not focusing on the details around him, but on his head. I keep this in mind when I paint. If you put a statue in the background, you suggest it with a minimum of detail to keep it subdued, so that it does not compete with the head.

Benjamin Flint 36″ x 30″ Mr. Flint was an art collector and I wanted the background to reflect his interests. My screen seemed too bare for a man who moved in his particular atmosphere; I went through books of antiques and interiors to find screens that would be appropriate. From these references I was able to indicate a pattern on the screen that would reflect his interests. Notice that here, too, the light moves horizontally across the canvas. Collection, St. Lawrence University.

Whenever I include a detail in the painting, I'm careful that it has a function. I don't care to paint symbols—a crest or emblem—to identify a man, but I prefer to create an atmosphere that captures him. If I turn a shape into a certain architectural molding, I may consult books in the library to get the design I need and refer to photographs to reproduce that molding in my painting. But I put in these details only if they have a function, never for the sake of having them there. Robert Henri once said, "In painting a laughing child, every brushstroke should contribute to that laughing child. Anything that doesn't is wrong."

The detail I put in the background relates to the character. It would be a mistake to take a young woman in a sophisticated dress and suggest the pillars of a building behind her. Likewise, a masculine portrait of a man with a bouquet of flowers behind him would also conflict, unless perhaps he happened to be an avid flower arranger or horticulturalist!

This brings me to the question of props, which is related to detail. I use props when they contribute to the character of the sitter, but I don't depend on them. I'm more interested in the gesture than in the item itself. For example, the wife of one sitter told me that her husband never sat without something in his hands. So I painted him holding his eyeglasses. Or if a cigarette is truly part of a model's character, I may paint him with a cigarette. If a man has the habit of fiddling with his glasses or is an inveterate smoker, the prop is part of his character, but I don't depend on the prop to tell the story. It is only the background.

Likewise, if I think there are some objects that are a particular part of the person, I may introduce them in the painting without making them gimmicky. I painted a man once, for example, who was the head of a shipping firm and who'd been a sailor as a young man, having traveled on one of the last clipper ships. He had a model of the ship, which held great meaning for him. I made several sketches of the ship in the same light I was to paint him in. I posed him and made use of the sketches. I placed the ship behind him as part of the atmosphere of his office.

I think by now I have emphasized often enough the importance of subduing anything that conflicts with the portrait of the man. If the detail takes on too much importance, reduce its impact or eliminate it!

James M. Bovard 39″ x 34″ *The subject was Chairman of the Board, Carnegie Mellon Institute, and his office was in the museum. He was surrounded by tradition and objets d'art. I felt it would be appropriate to include something in the background that would suggest this atmosphere, so I made notes and sketches of art objects whose shapes appealed to me, and used this one for the painting. I had sketched it in the same light I was painting the model. Collection, Carnegie Mellon Institute.*

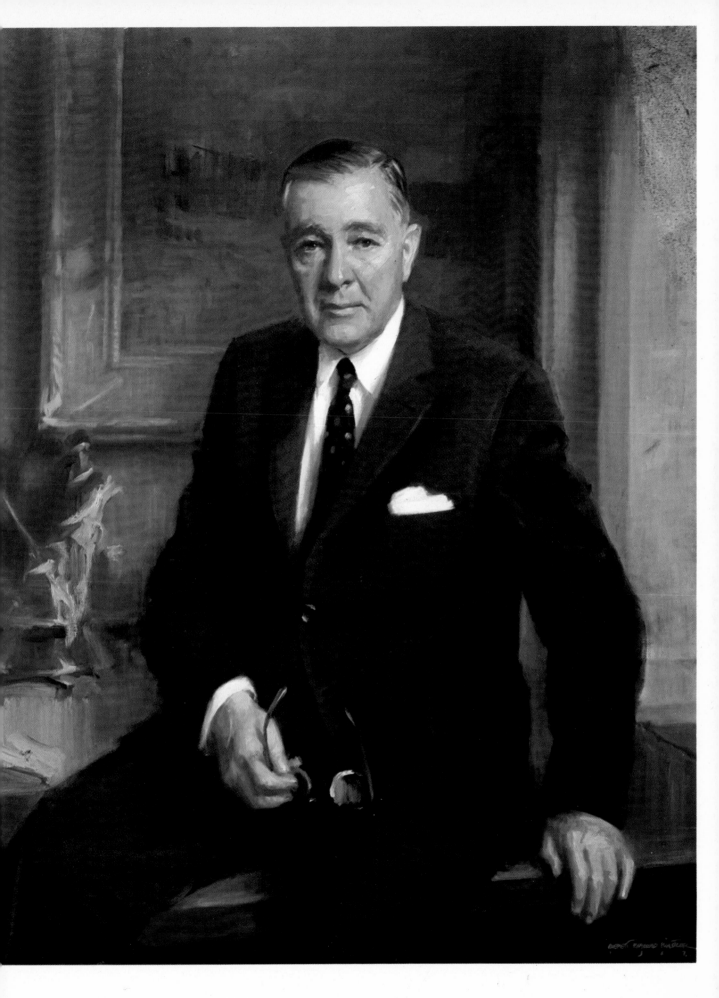

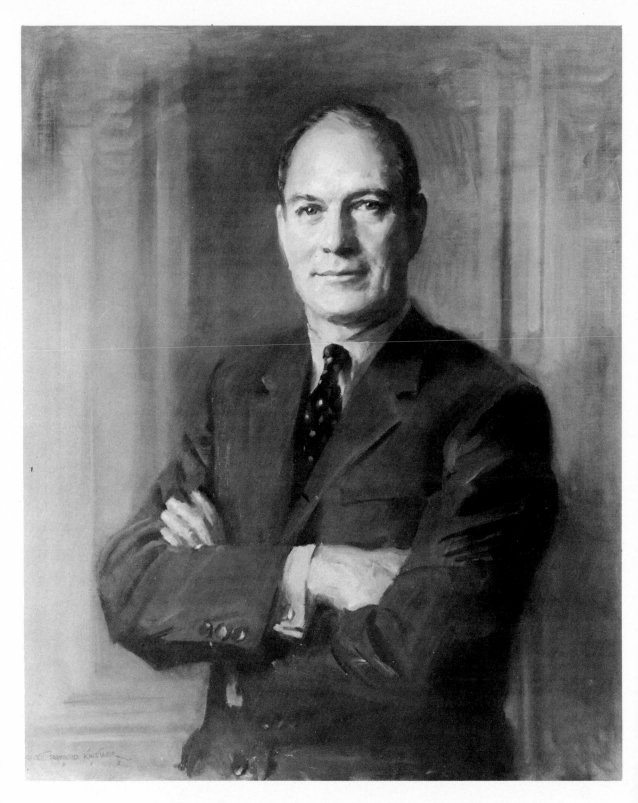

Alan S. Boyd, Secretary of Transportation, 1967–1969. Originally, I was commissioned to do a head-and-shoulders portrait, but I felt that the subject—being well over six feet tall—would be cramped in such a small composition, so I made a larger portrait. I painted this in Mr. Boyd's office. There was a north light in the office, but the ceiling was very low. With a low light it's an advantage not to have the subject on a model stand. Collection, U.S. Department of Transportation.

CHAPTER 9

Painting on Location

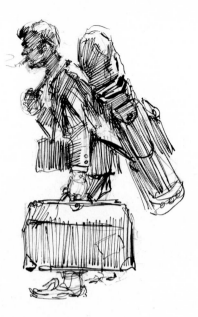

There may be occasions when your subject will not agree to sit at your studio. Sometimes, for reasons of health, or because of self-consciousness, the subject prefers not to travel. Frequently, a person agrees to sit at the insistence of someone else—an executive for his corporation, for instance—but only on the understanding that his life will not be interrupted. On these occasions, if the artist doesn't agree to go out of town, he may lose the commission altogether.

Painting on location has many appealing features. First you have the opportunity to travel. I know some portrait painters who maintain no studio at all—they just travel all the time! Painting away from the routine of the studio also means that there will be certain challenges you have to face— accidents of light, a different atmosphere, for example—challenges which often make for a better portrait and stimulate growth in your own work.

In painting on location, however, you probably will encounter many unforeseeable problems which this chapter may help you avoid.

Carrying Your Equipment

Since no model I have ever painted has had an easel, paints, and canvas waiting for me, my studio has to travel with me. While it's true that a number of items might be available at a local art supply shop, I can't chance relying on that simply for the sake of lightening my baggage. Traveling with my equipment had always presented a great problem for me. Added to a suitcase of clothing, I'd cart my camera and related equipment; a paintbox with brushes and mediums; stretchers and a roll of canvas; and an easel—large enough to support a good-sized canvas—which I could fold into a fairly tidy package. Now, when you consider that 90 percent of my travel is by air, you can see why I grew so perturbed every time I had to carry this armful of equipment.

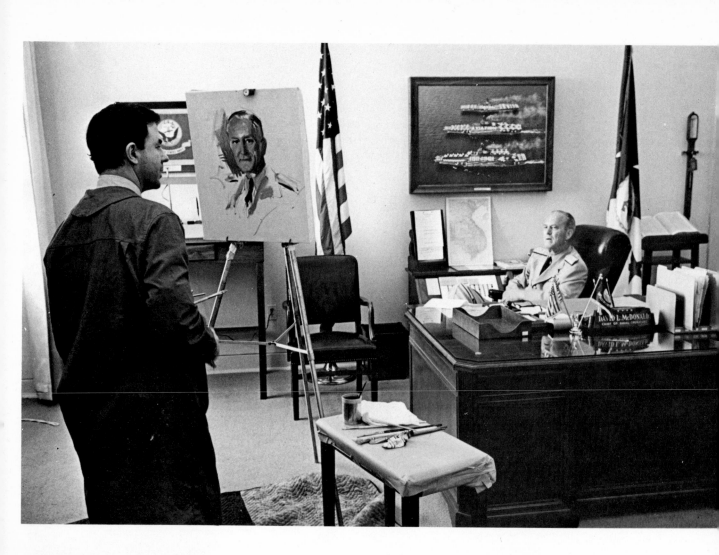

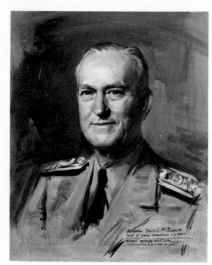

Admiral David McDonald, Chief of Naval Operations, U. S. Navy, 1965–1967. (left) 24″ x 20″ I painted this subject on location under less than ideal circumstances. Although the Admiral's office was very light, it was diffused and created a lighting difficult to control. I maneuvered the light the best I could to get light on him and the canvas, but I couldn't get any closer to him than the photograph shows. I covered the floor with a cloth and set up a taboret, working in this way for an hour and a half. You can see how distracting the background can be. I eliminated most of the details, and used the dark of the chair to dramatize the head in the background. The final painting is reproduced on the opposite page. Courtesy, U. S. Navy Combat Art Collection.

Admiral David McDonald, Chief of Naval Operations, U.S.N. 46″ x 35″ (right) After sketching and photographing the Admiral in his office, I felt this uniform—the tans—were more youthful and contemporary than the formal blues. This was a departure from the other official portraits lining the halls of the Pentagon, and Adm. McDonald had no serious objections to changing the precedence. He questioned my painting him with his hand in his pocket—saying it was against Navy regulations—until I showed him several photographs taken of him in exactly this position. Courtesy, United States Navy Combat Art Collection.

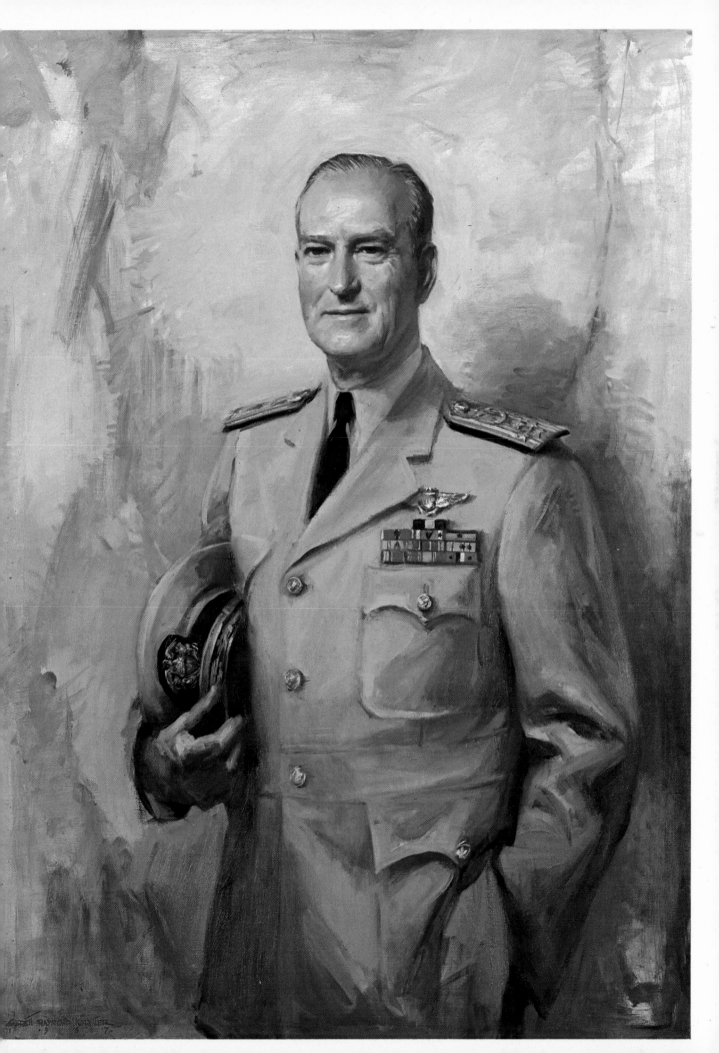

One evening in my studio I mentioned my problem to a friend of mine, a painter who had been on the scene longer than I had. I told him about it because another portrait commission trip was looming and I dreaded playing the burro role again.

"A golf bag," he said, "get a golf bag." His advice at first didn't register on me, and I began to think that he might be older than I thought. But then suddenly I saw the light. The golf bad *did* solve the problem of transporting my gear. I could consolidate my easel, stretchers, and canvas roll into one neat package. In addition, there were a number of unexpected surprises. Previously, I'd been hard-pressed to find a skycap at the air terminals or a bellman at the hotels who would want to mess with my bulky paraphernalia. Besides, I'm sure they felt that an artist was an "excellent bad tip risk," because everyone *knows* that artists starve. Now I have my pick of people climbing over each other to help me.

My golf bag studio has introduced some bizarre incidents to my career as a painter. One of them occurred in Grand Forks, North Dakota, where the temperature was 7 degrees when I checked into the hotel with my golf bag on the bellman's shoulder. I don't have to tell you how the guests in the lobby and the clerk at the desk reacted to this sight. As much as I felt there should have been an explanation, I must admit I couldn't think of a thing to say. My bellman said it for me: "Going south for a tournament, sir?"

I try to anticipate my needs by bringing along everything for the portrait. I don't want to rely on buying anything after I've arrived, for fear of wasting good time in hunting down an item. I always carry extra canvas to carry me through in case I have to start the painting again. I also carry larger stretcher strips than called for so that I can adjust the composition when I get home.

Carrying the painted canvas home can be a problem. At the very last moment, just before I leave, I roll the dry painted canvas onto a broom handle. I carry it with me, separate from the luggage, because I feel I can always afford to lose the materials on the return trip, but not the canvas. (I'm definitely fidgety in this regard!) The first thing I do when I return home is to unroll the canvas and restretch it.

Studio away from Home

If a portrait is to be painted in a location near your home, take a trip out in advance to assess the situation in order to get a better idea of what to

W. Willard Wirtz, Secretary of Labor, 1962–1969. 42" x 34" Painting this final cabinet portrait, I can't resist the pun: I went from Boyd to Wirtz! This was a very good room for painting: a boardroom with a high ceiling. This light was west. I started to paint at 9 o'clock in the morning and about an hour later the sun crept in. The lower part of the French doors had to be blocked off with cardboards to force the light higher. Collection, U.S. Department of Labor.

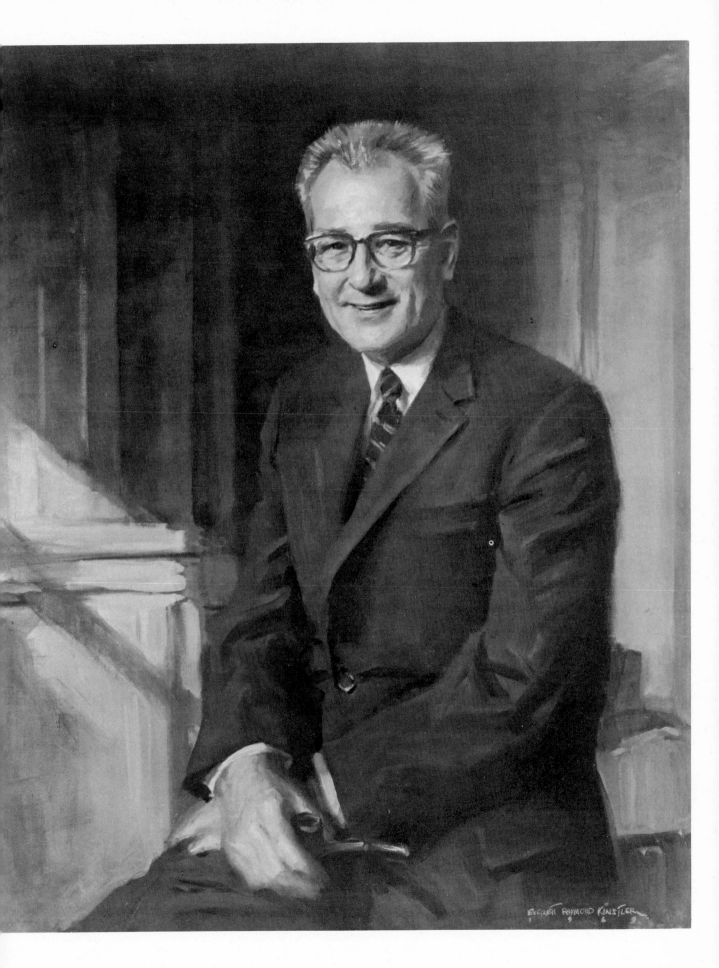

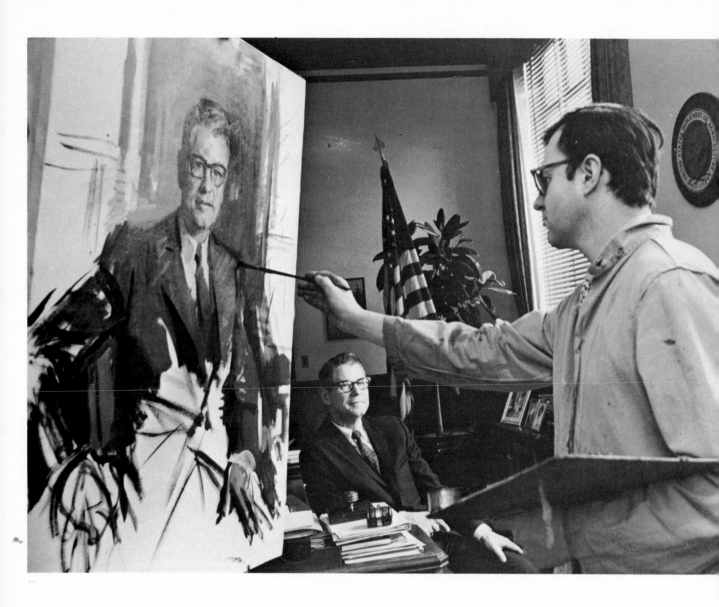

Painting Orville L. Freeman (above) *I had the advantage of much better light here than I had with Admiral McDonald. I was able to get closer to him and still have the light on my canvas. The window over my shoulder—not shown in the photograph—was the main light. I closed the blinds of one window to darken the background. This photograph was taken on the second morning. The doorway behind the subject was used in the background. I concentrated on the head in the sketch, and the final painting opposite.*

Orville L. Freeman, *Secretary of Agriculture, 1961–1969. 46" x 36" (right) I altered Secretary Freeman's environment considerably from the way it appeared on location. I made use of the doorway behind him in the painting, but I eliminated the desk in the foreground—placing it in the background—in order not to distract from the portrait. I also went further with the pose, altering it somewhat from the original. Collection, U. S. Department of Agriculture.*

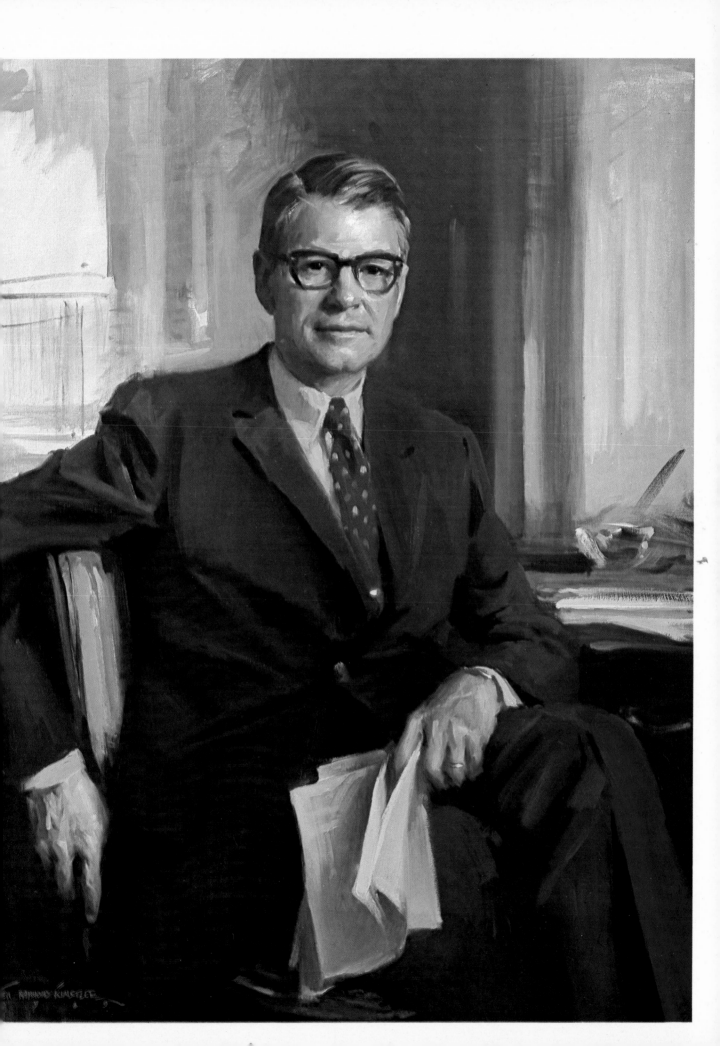

bring and what problems to anticipate. The chances are, however, that making a trip in advance will not be convenient or possible, and you will have to rely on good preparation and all your wits once you arrive.

Setting up a studio is going to be your first consideration. Naturally, you want to get as close to the studio conditions you're accustomed to working in, but this is not always possible to achieve. When I'm going to a place that's near or in a city, I'll try to use my hotel room as a studio. In Columbia South Carolina, for example, I've painted fifteen or sixteen portraits and I'm pretty well known by now at a particular hotel there. I reserve a room with a north light at the top floor, and have as many things moved out of the room as I can to improvise a studio.

But using a hotel is not always so convenient. When your commission calls you to a suburb or small town, you may well have to work in an office or in someone's home. If this is the case, write to your client beforehand, describing the kind of working area you need, and requesting a room with a north light if it's at all available, with some degree of space. Since you'll be working with paint in someone's home or office, it's a good idea to forewarn them of possible damage that can be done with paint or turpentine. Request something to cover and protect the floor. I also request a folding card table for placing my palette, brushes, and turpentine.

Hopefully, your client will have a spare room which you can use as your studio. As it is, you will be working in someone's home and won't have the freedom you would in your own studio. If they have a room to spare, you can at least leave your materials there from one day to the next or continue to work after the sitter leaves.

Adapting the Studio to Your Needs

Now you've made all your preparations in advance. You arrive on location, step into your studio away from home, and find a situation quite different from the one you had imagined. Every place has a different problem and as long as you operate with your wits and maintain your sense of humor, you'll never be overcome by frustration.

Light is the most important problem. Your client may have reassured you in advance that he had a room with a good deal of light. You arrive and discover that, yes, there is light, but too much coming from too many different sources. It's best to find one source of light, even if you have to block off the other windows to get it.

Invariably, I find a location that is good for seeing the sitter, but I can't see my canvas, or the easel won't fit in the space I need. Or I can see the canvas, but not the sitter. If faced with the choice, I'd rather have good light on my canvas than on the model, because it's the canvas that's the final result. I may ask for a piece of cardboard or some tarpaulin from the garage to cover the window in order to block the light.

I can avoid some problems with light by picking the best time of year to paint, if I can possibly arrange it. In the summer, the trees block the light, create peculiar shadows, and cast their green reflection throughout

the room. For this reason, I prefer painting in the winter when the trees are bare and the light unobstructed. I remember once painting a woman in Wilmington, Delaware, who had an enormous house. I chose the most unlikely room to paint, one corner of a drawing room where the light was superb. I painted the portrait in the winter and returned in the spring to make some minor corrections. When I returned to the room, I was dismayed: the trees were blocking the light, making the whole room dim, and green was reflected off the ceiling. The entire room was transformed.

Painting the Portrait on Location

If at all possible, I set up regular sittings with my model, preferably in the morning. The sitter is more responsive in the morning and you have time to continue working after the sitting while the portrait is still fresh in your mind. Also, arranging the sittings at the same hour each day means that you get the same type of light, particularly if you are not painting in north light.

In the studio you're in your own domain. When you're painting on location, you're at the disposition of your clients. You will have to adjust a bit more to the person out of town than you would in your own studio. Your relationship will be much more concentrated, and there is very little time between meetings to gain some perspective. Be prepared to be adaptable, avoiding a situation that makes you appear as an intruder. However, although you have to adapt to the environment in which you are working, it should be made clear that your primary goal is in getting a good portrait. You cannot afford to compromise in your painting.

I'm forced to work more quickly on location. I use more cobalt drier than I ordinarily do so that my paint dries rapidly between sittings. Because the sittings are so frequent, from one day to the next, you don't have the time to reflect on the canvas for very long between sittings as you can in the studio when the portrait is painted over a period of weeks. There is a feeling of concentration and immediacy in painting on location.

After about five sittings I feel that I'm ready to return home. I rarely finish painting on location. By the time I'm ready to leave, I feel I have everything I need to finish the painting in my studio. I have made good use of my Polaroid and 35mm cameras, so that I have several records of my subject's appearance if I should need them for reference when I return. After five sittings, my composition is completely planned and the head is near completion. This, along with the photographs—which I try to have developed while I'm there so that I know I have what I need before I leave—furnishes me with enough to finish the portrait at home.

Sometimes, for a larger painting, I don't commit myself to the composition until I return home. On location, I may paint one or two studies of the head, take photographs in various poses, make several drawings, and then assemble them all in my studio. Then I make my choice, repaint the head, and have someone pose for the figure.

If I have planned everything carefully, there should be no need for further sittings. The idea of going back to location is not only an inconvenience for

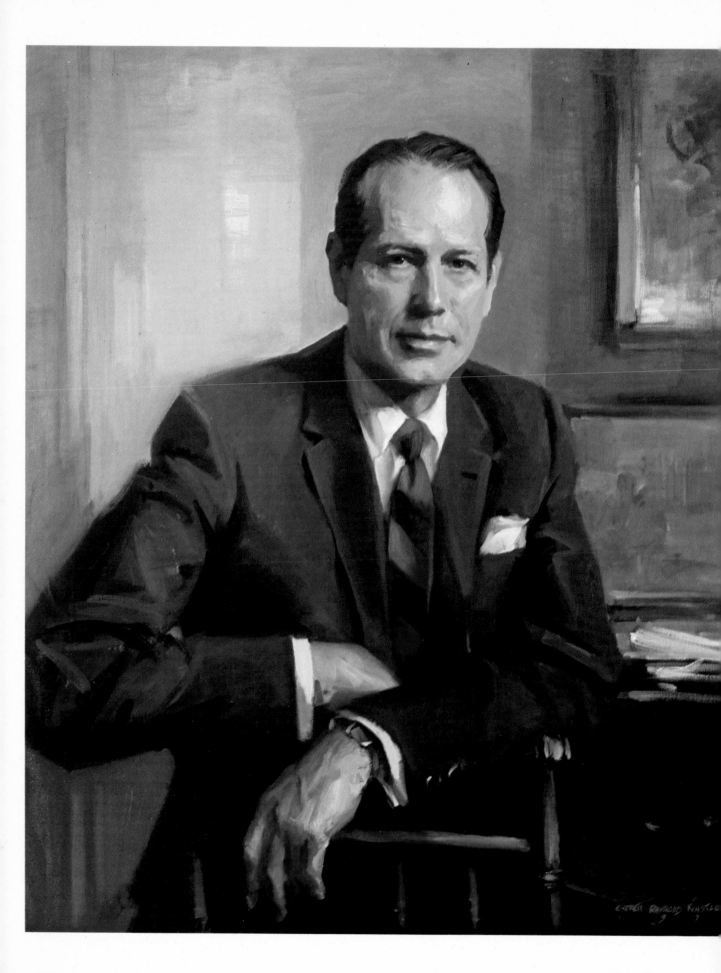

me, but entails greater expense to the client. On occasion, a sitter who originally had refused to sit for me in my studio in New York will change his mind after I've begun to paint him on location. I find my subject generally becomes involved in the development of the portrait and is willing to make the trip later when he wouldn't have done so initially.

The work I do back in the studio is critical. Once I'm under the familiar lighting, I find that my colors from working on location may have been much pinker or colder than I thought. If I had been working solely under artificial light, the colors may not look as fresh as they did. This is all the more reason to finish the painting in the studio.

But as I study the painting in my studio, I generally notice an interesting quality, something new in my work. In fact, some of my most successful have been started on location. The challenges of the new environment stimulated me, and that stimulation is, I think, evident in the results I achieved.

Robert T. H. Davidson, former Chairman Board of Trustees, The Brooklyn Hospital. 36″ x 30″ This was originally commissioned as a head-and-shoulders portrait. Bob is a relaxed, lanky person about 6′4″. He even conveys this when sitting. We arrived at this pose almost immediately while getting acquainted, and we pursued it to the finish. Collection, The Brooklyn Hospital.

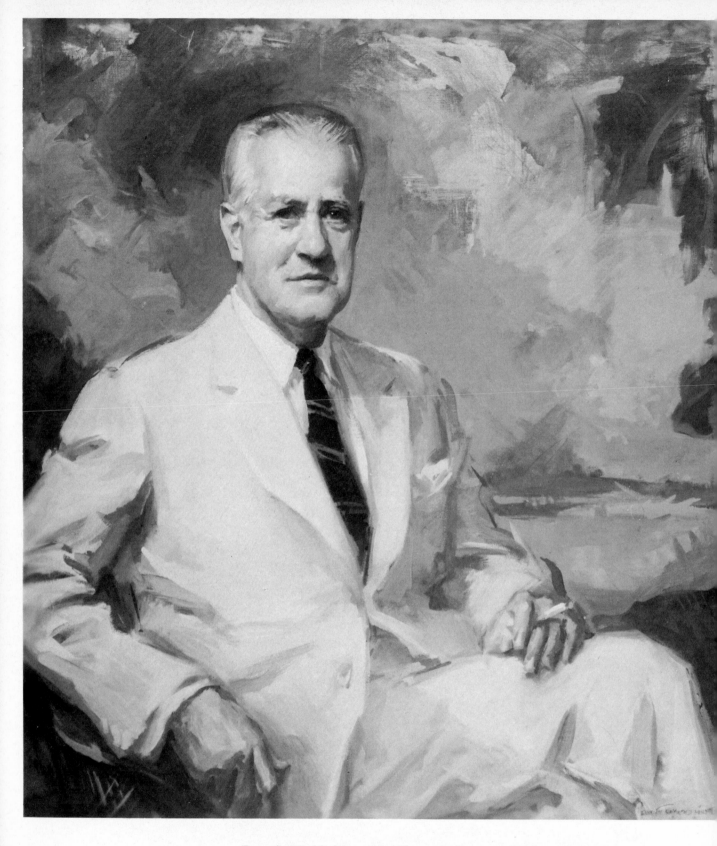

Perry J. Walsh 37" x 34" The portrait was painted outdoors in Connecticut during the summer. The light is not nearly as extreme in Connecticut as it is in Portugal. It's much milder. At first, I painted what was literally in the background—trees, water, etc.,—but later I felt these details conflicted with the portrait of the man and I obscured them when I finished the painting in the studio. Collection, Mr. and Mrs. Perry J. Walsh.

CHAPTER 10

Painting the Portrait Outdoors

It may seem absurd to leave the comfort of your studio and venture forth into the unpredictable outdoors, simply to paint a portrait. Painting indoors is tough enough! And yet, for the portrait painter, painting outdoors is an extremely valuable experience and its benefits may surprise you.

What Happens Outdoors

Painting a portrait outdoors is like painting a landscape. If you study what happens to color outdoors you'll find that there are many more extremes than you see in your studio: colors are more intense; violets are more violet; shadows have more color. Outdoor light will sharpen your observation of color and if you're like me you'll delight in its richness.

In painting outdoors, you have the opportunity to include in a portrait the sky, a tree, or other landscape detail, which should stimulate your inventiveness. It also may be the best way to paint your subject in an environment that is characteristic—a gardener in his garden, a sportsman outdoors. You can also take this occasion to paint costumes that are unsuitable indoors: wide-brimmed sun hats, overcoats, bathing suits, clothes that bring variation to your work.

And, like painting landscape, you'll have all the hazards to consider as well: what do you do about wind blowing at your subject's hair—or at your canvas, for that matter? How will you place the subject so that he's not squinting at the sun, and how will you place your canvas so that you're not seeing spots from the glare?

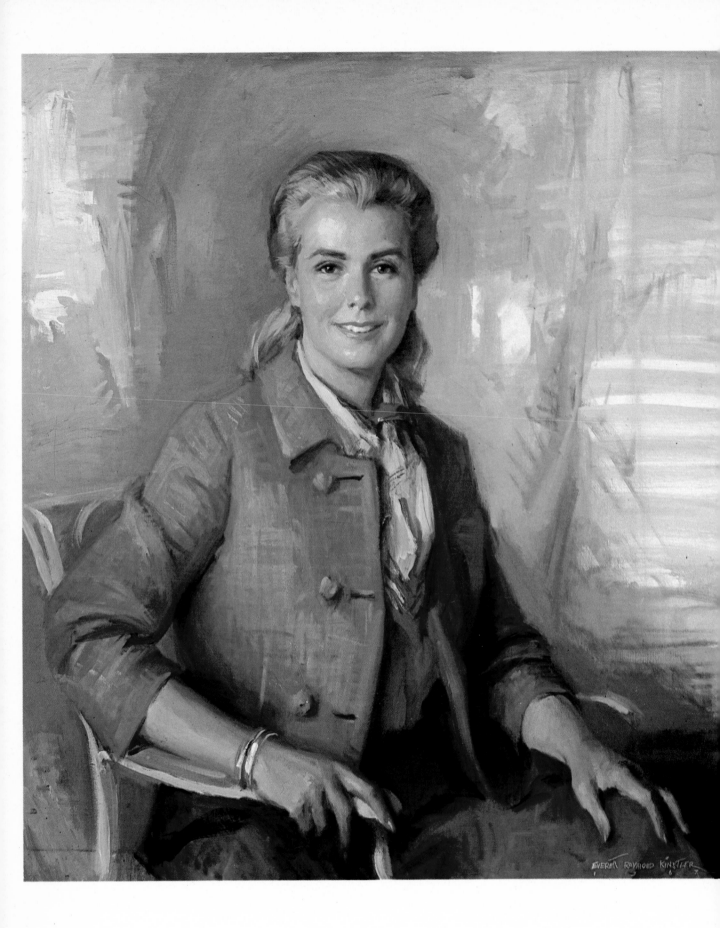

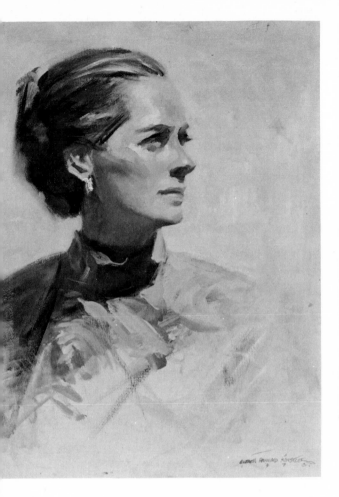

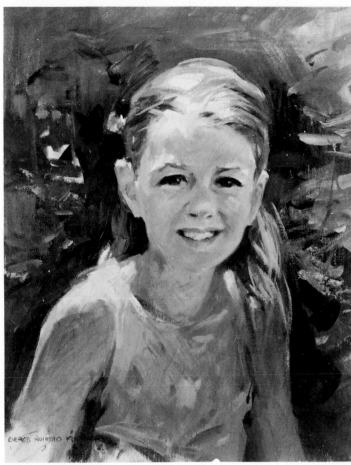

Lea (above left) 24″ x 20″ This painting of my wife was completed in about one hour outdoors. I painted it in Portugal where the light is extraordinary, very appealing for outdoor work. The head is quite strong, but the background is light, unlike my outdoor portrait of Kate. It may be interesting to note there is no attempt to detail the eyes which were squinting due to the intense light. I stressed their shape and luminosity instead.

Kate (above right) 20″ x 16″ I painted this portrait of my daughter outdoors in one sitting. The main light was concentrated on the top of her head and the shoulders and the face were in a diffused tone. The colors are more extreme and intense.

Mrs. Franklin Starks (left) 37″ x 33″ I went to Louisville, Kentucky to paint this young lady in her mother's home. Most of the rooms were dark, and the most appealing place to paint was a porch. However, there was a good deal of reflecting light on the porch and I spent the whole day setting up before I started to paint. I borrowed all kinds of tarpaulins and cardboards which I used to cover up the windows, until I finally established a single source of light. The room was filled with plants and flowers which I used as abstract shapes and colors in the background. Collection, Mr. and Mrs. Starks.

Setting Up to Work

When I prepare to paint a portrait outdoors, it's as if I'm going to paint on location. I bring my portable easel, my canvas, and perhaps a board to slip behind my canvas to prevent the strong sunlight from shining through. I wear a hat with a wide brim to keep the sun out of my eyes. (Incidentally, I would avoid wearing sunglasses under any circumstances. The tinted lenses play havoc with your color sense!) And, of course, I musn't forget the insect repellent.

Since I can't control the light the way I can in the studio, I try to keep the risks to a minimum, painting at the same time every morning or afternoon so that at least the direction of light is the same each sitting. In choosing a spot to paint, I avoid the direct sunlight. I don't want the subject feeling uncomfortable and squinting against the sun, and I don't want the sun shining down on my canvas. So I hunt for a cast shadow.

I once painted a three-quarter portrait of a man outdoors. In the only spot I could find which cast a good light on him and where I could work at the same time, I couldn't get the background I wanted. I had planned to suggest a part of his house that I associated with him, but the house was not within my range of vision. So I made a sketch of the house from a desirable angle and I made use of it as a background.

Sketching the Portrait

After I've found the spot where both the model and I are comfortable, I make a head sketch in oil which I use as a color guide for painting later indoors. Or I paint the portrait directly on the canvas, carrying it as far as I can, but not necessarily all the way to the end. I tend to get much better results when I complete the portrait in my studio, because the indoor light gives me a better sense of how the colors will look when the picture is hanging indoors. I can study the painting more objectively indoors. The colors outside may seem somewhat washed out because of the glare. I use the head sketch as a color guide to refresh me as I take the painting further. This helps me as I attempt to restate the effect I'm trying to paint.

I might also add that the character of outdoor light is very different from one area to another: my paintings in Vermont are very different from my paintings in Bermuda. And the light changes the character of the painting. I only wish I had more occasion to do portraits outdoors; I am very enthusiastic about the opportunities and challenges it offers.

Colonel Irvine Furman Belser 40" x 34" I painted Colonel Belser as he was sitting in front of his South Carolina home in his hunting coat with his favorite dog and rifle. We experimented with several poses, the dog and rifle in different positions. The house was actually closer behind him, but I took the liberty of painting it impressionistically and further in the distance so as not to distract from the portrait. Collection, Mrs. Caroline McKissick Belser.

Chen Chi 46" x 21" For this portrait of the accomplished Chinese artist, I was aided by Chi's suggestion of this shape which was appropriate and unusual. I toned the canvas with primarily raw sienna and you can see the tone as I used it and left it, particularly in the lower part of the canvas.

CHAPTER 11

Using Reference Materials

Throughout this book, I've stressed that I try to seek out what is characteristic of my subject. But frequently I'm unable to rely exclusively on the model. Possibly because I'm trying to capture a fleeting moment that vanishes with a gesture, or because I'm painting a posthumous portrait, it may be necessary to find additional sources of information.

In this chapter I'd like to describe the ways in which I use reference materials, extracting from them the information needed to create the painting I feel states exactly what I want. I'm going to stress particularly the way in which I use photographs, since it's a well-known—but little described (or admitted)—fact that many painters use photographs in thier work. To what extent they use them and in what situations they turn to them is very individual; no two painters regard photographs in exactly the same way.

However, before I proceed with my thoughts on using photographs, I want to make one point very clear. I do not intend to recommend my methods indiscriminately. There's no substitute for working from life. My working habits have evolved out of a very personal training and I still regard painting from life the most essential part of my work. I don't want to give the impression that I paint photographs, or that I even paint *from* photographs. I rely on my experience of painting from life. I try to interpret photographs, to use them creatively when I need them, for the very specific purposes they fill. I select and edit from the photographs the details I need for my painting, but I never slavishly copy them.

My early training was as an illustrator, and as such I believe I developed habits which have helped me enormously in my painting. I learned to work from my imagination. What was my illustration to describe and convey

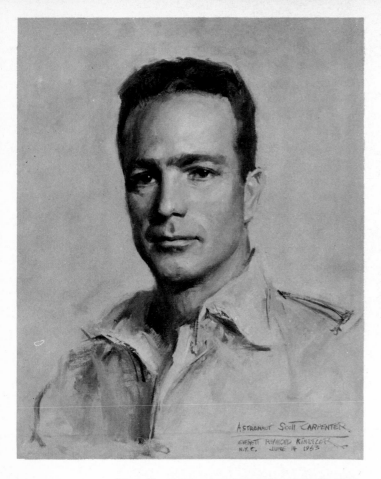

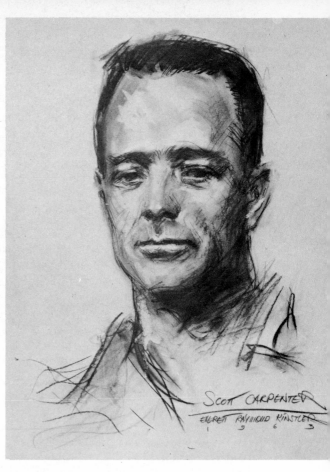

First I made a head sketch of Scott Carpenter on a 22″ x 18″ canvas. I used this to study the character of the head. Notice that with the light coming from the right, most of his head is illuminated.

With this 20″ x 16″ charcoal sketch I was able to study Carpenter's head as it was affected by shadow. Collection, The Metropolitan Museum of Art.

With the Polaroid, I could study the character and structure of the head as it was affected by light.

By reversing the light, photographing the head from another vantage point, I could quickly see the head in a different lighting situation.

and how best to achieve it? If it meant using models, making dozens of rough sketches and drawings, or going to the library to find photographs, I would do so. This training—to think conceptually to communicate—has been an important factor in painting portraits. If I use reference materials creatively, I owe this to my background as an illustrator.

There are two different occasions when photographs may be necessary in painting a portrait: to supplement information when you're painting from life and when photographs are the only source of information you have—in a posthumous portrait, for example. First I want to describe using photographs for supplementary information, then discuss them as a single source of reference.

Using the Camera

If a painting is particularly complex, I take photographs and use them as supplementary aids. I make use of two cameras: the Polaroid and the 35mm. I use the Polaroid for larger portraits where there are several compositional elements to be included in the painting. By reducing the area immediately to a flat, two-dimensional surface, the Polaroid tells me quickly if I'm on the right track. When I've decided the angle and lighting for the painting, I take a few Polaroid shots to see how it registers compositionally. The photographs suggest quickly if I'm encountering a foreshortening problem or whether the lighting is too harsh, and I may reverse myself entirely if the photographs indicate problems. These decisions are esthetic judgments on my part. The Polaroid is not as sensitive to tones as the 35mm camera—it tends to drop out blues and distorts the blacks, whites, and halftones—but it suits my purposes very well for pose and compositional decisions.

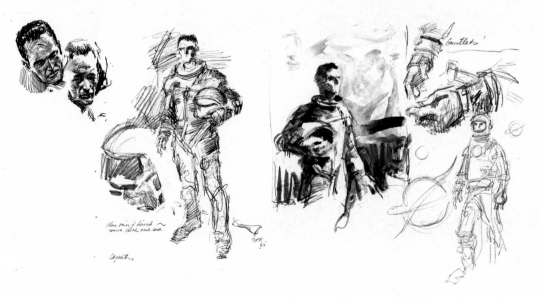

These small sketches were made in a variety of media: pencil, pen and ink, and watercolor. With these studies, I could further explore problems of composition, head structure, and pose. I made notations on the sketches which helped my recall.

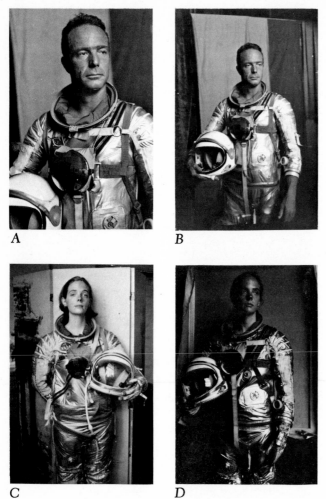

A

B

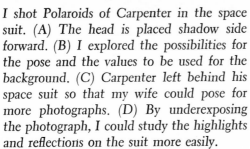

C

D

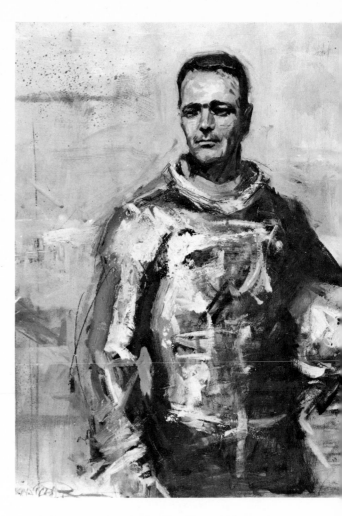

I shot Polaroids of Carpenter in the space suit. (A) The head is placed shadow side forward. (B) I explored the possibilities for the pose and the values to be used for the background. (C) Carpenter left behind his space suit so that my wife could pose for more photographs. (D) By underexposing the photograph, I could study the highlights and reflections on the suit more easily.

I made a rough oil sketch, 22″ x 16″ on cardboard. From this I could make certain decisions about color and pose. I ultimately changed the helmet from Carpenter's left to his right hand.

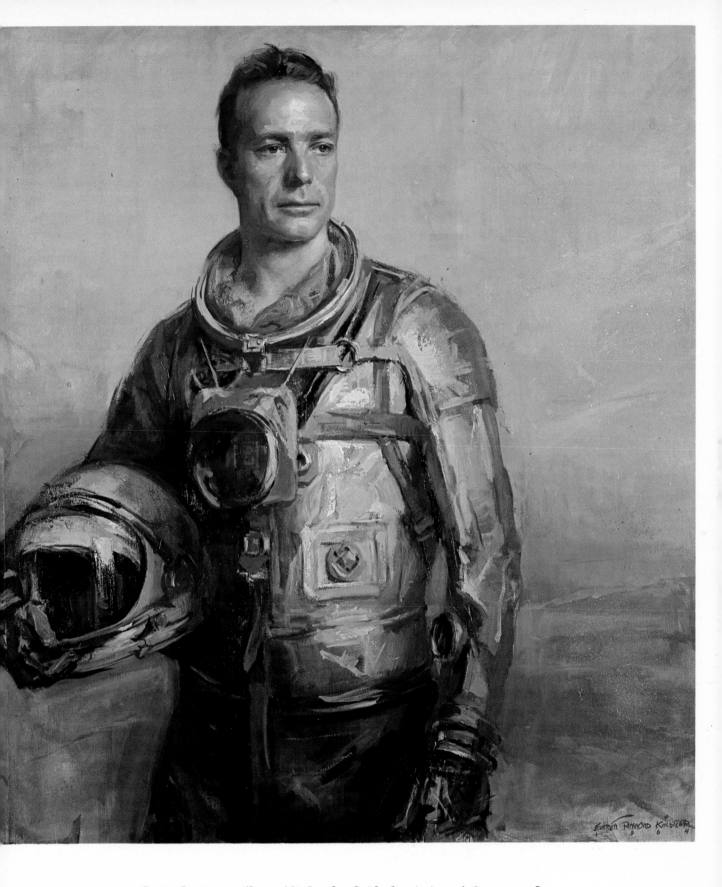

Scott Carpenter *53" x 45"* In the finished painting of Carpenter, I retained a suggestion of the paraphernalia in the uniform in order not to allow the suit to compete with the head. I painted the head from the shadow side to dramatize it. This was one more way I attempted to keep the suit secondary. Courtesy, U.S. Navy Combat Art Collection.

I use the 35mm camera for quite another reason: to record the structure and expression of the face. In the course of 30 seconds I may snap 30 pictures—generally from the same angle I've chosen to paint—and use these for reference at a later time, not to paint from, but for reference and study. When I'm working without a model I may unintentionally paint into or over an ear or shoulder, when painting in the background, and I refer to these photographs to correct the shape. The 35mm camera can also catch something characteristic which I may incorporate in my painting: a gesture of the hands captured in a split second or a subtle expression that may have gone unnoticed.

To avoid generalities, let me give you specific examples of how I use the camera—in combination with drawings. From these examples you can see how they help me arrive at decisions involving pose, lighting, expression, and over-all composition.

Scott Carpenter's Portrait

I was commissioned to paint a portrait of astronaut Scott Carpenter and was informed that for the first sitting he could stay in my studio for less than two hours. There were no limitations as to the size of the canvas, and while this could only be decided after meeting him, I felt I wanted the portrait to be larger than head and shoulders. I couldn't spend an hour chatting with the subject, as I generally do to create a relaxed atmosphere. I had to work fast. When Scott Carpenter appeared, I proceeded to paint a head-and-shoulders oil sketch. This enabled me to study and observe his facial expressions and characteristics closely and intensively. I used the remaining half hour to photograph him from every possible angle, in every kind of light, and I made quick charcoal sketches of his head. For the head sketch, I painted him in a light coming from over my right shoulder, the major part of his head in light. In the charcoal sketch, I reversed the light to experiment further.

After studying my drawings, studies, and photographs, I decided it would be appropriate and appealing to paint the astronaut in his space suit. Consequently, for our second sitting, I asked Carpenter to bring his space outfit. After he arrived, he climbed into the complicated and heavy suit. He could wear it only for five or ten minutes because of the uncomfortable heat generated inside the rubberized skintight fabric. (In space the suit was air conditioned.) I quickly photographed him, using a screen behind him that had been draped with a light and dark fabric. From these photographs I could determine the effect of the light on his silver suit in relation to the value of the background tones.

After this second sitting, I explored further, and made many thumbnail sketches in pencil, watercolor, pen and ink, groping for a concept. Carpenter's space suit—with its paraphernalia, strings, reflective details, mirror, dials, etc.—presented problems. As I was painting the man, not the suit, I decided to dramatize his face. I did this with lighting, by concentrating on the shadow side of the head.

Since Carpenter agreed to leave the suit behind (for several weeks it hung in my studio!) I took full advantage of this time to study the garment in detail. I photographed my wife in the suit (it was much looser on her than it had been on the astronaut, making it more comfortable for longer posing) so that I could study the interplay of light and shadow. By underexposing the Polaroid shots, I was able to see at a glance how the highlights fell on the suit. I made a rough oil sketch of Carpenter, here deciding that I wanted a light background. Finally, I reversed the composition entirely so that he was carrying his helmet in his right hand. With all these compositional aids, I was able to arrive at a final arrangement.

Sometimes I photograph my painting in progress with the 35mm camera. When I feel I'm not getting something and I can't exactly locate the error, a photograph can often point it out to me: a nose too short, forehead not broad enough, etc. I may get so close to a painting that I can't see I've neglected certain proportions, which become obvious in the photographs.

Robert Goelet's Portrait

The example I've described of the Carpenter portrait is not the only way I use photographs for painting from life. There have been times when I've decided to paint a subject from life but at a different age. Here's what I mean.

About ten years ago, I was commissioned to paint Robert Goelet. At the time, he was in his seventies, and age had taken its toll: he used two canes to walk, and had very thick lenses in his eyeglasses, which magnified his pupils. Because of his frail health, he could not pose for numerous sessions. I requested earlier photographs of him. From these I could tell that he had been a handsome man, vigorous, white-haired, generally wearing a dapper double-breasted vest. He had represented Newport society in an

These two photographs of John Johansen wearing Robert Goelet's clothing helped me resolve the question of pose and lighting.

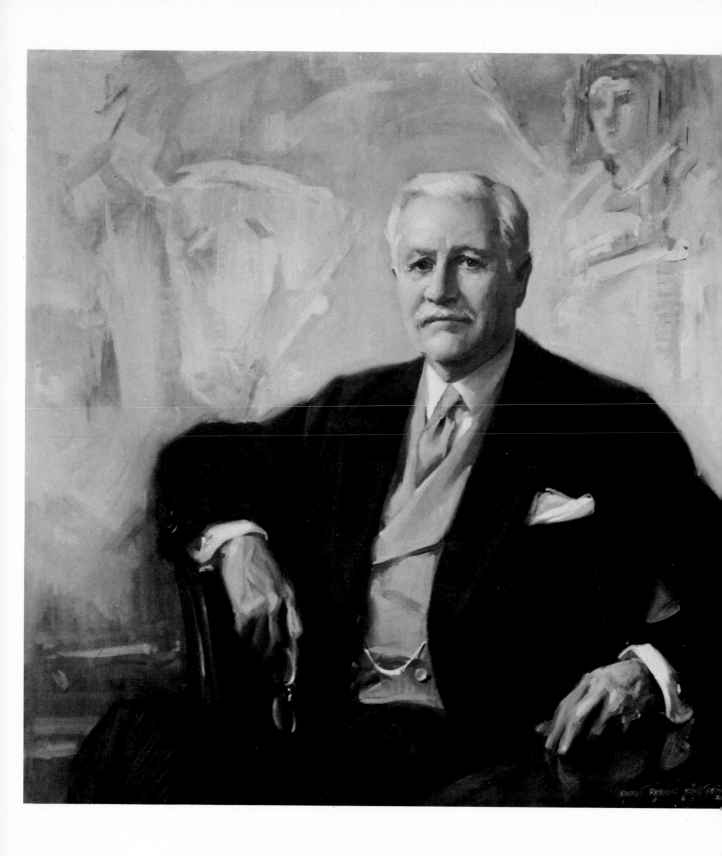

Robert Goelet 35″ x 39″ Here's the final result of my efforts with the Goelet portrait. I wanted to retain the vigor of a man whose life had been colorful. I painted the suggestion of tapestries in his Newport home. Very little detail was necessary to give the feeling of the historic atmosphere in which he lived. Collection, Salve Regina College.

era in this country that has passed, and evident in the earlier photographs.

I decided that Robert Goelet should be depicted as he was before his health began to fail. This was not a question of flattering him. The photographs showed him when he was more vital and I preferred to represent him this way. Moreover, the portrait was to hang in his home—an estate in Newport—and would be more in keeping with the atmosphere.

I selected some photographs that had been taken ten years earlier, photographs that showed the structure of his head. The structure of the head does not change with age. The chins may double, the hair becomes thinner, but the bone structure remains the same. I went to his ancestral home in Newport—which I used for the background of the painting—and made sketches of Mr. Goelet from life in the same light as the photographs. When I returned home, my friend, the artist John Johansen, posed for me in the double-breasted vest Mr. Goelet had been so fond of and in poses characteristic of Mr. Goelet. I photographed him several times, concentrating on the draping of the outfit and the qualities in the hands.

Here again I decided what I wanted from the portrait, and used whatever resources I could find to make it what I felt it should be. I think this process is helpful in making an interesting painting.

The Posthumous Portrait

Now that I've described some examples of using the camera in painting from life, I'll discuss what I do when photographs are all I have to paint from. When you're painting a posthumous portrait you have no choice; photographs are all you have. Getting the best material for these portraits is essential. I like to have as many photographs as possible in as many stages of the subject's life I can get: How does his face move and change? How does his head look in different kinds of light? What kind of clothing did he wear? I can study his facial characteristics—a sharp nose, a prominent chin perhaps. These photographs will give me the impression of the man.

In a posthumous portrait I try to find out something about the man from the people who knew him well: What were his characteristics? How was he remembered? In a business portrait there may be greater latitude in how the subject is depicted. In a personal portrait I'm dealing with the sentiments of the people closest to him, and they want a portrait of the man as they remember him. This brings in a very delicate emotional question, and for this reason I talk at great length about him with a close member of the family. We go over the photographs and I listen and consider their suggestions: "This is a bad photograph of my husband because it shows him after his illness, and you can't see the humor in his face that I remember so well." "I remember my father looking stronger than this photograph shows."

Bearing in mind where the portrait will hang and what kind of painting it should be, I try to pin down the client to some specific photographs that best capture the man. On the basis of personal recollections we can generally zero in on one or two that portray the subject best. I don't take the eyes from here, the mouth from there, but base my painting on one or two that

A

B

C

D

In painting a posthumous portrait of Dag Hammar-skjöld, I chose one photograph (A) out of the hundreds I had seen because I felt it was most characteristic of the man. I knew that I would alter the photograph considerably. So I posed and had a friend pose for some Polaroid shots which would enable me to see other possibilities for the position of the legs and arms (B, C). I made an 18″ x 14″ oil sketch of Hammar-skjöld's hand (D) before I finally decided to use it for the portrait.

Dag Hammarskjold 34″ x 46″ You can see that the original photograph has been very much altered in the final painting, yet I retained the expression and feeling I felt the photograph had captured. I replaced the cigar for the pipe because other photographs had made me realize this was more characteristic. Collection, School of International Affairs, Columbia University.

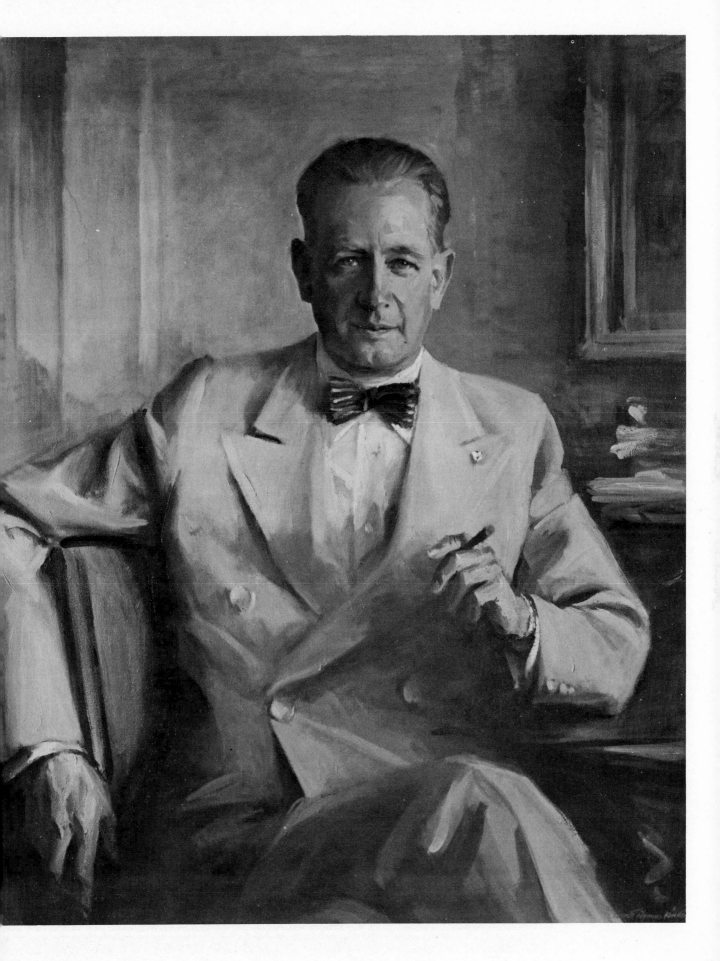

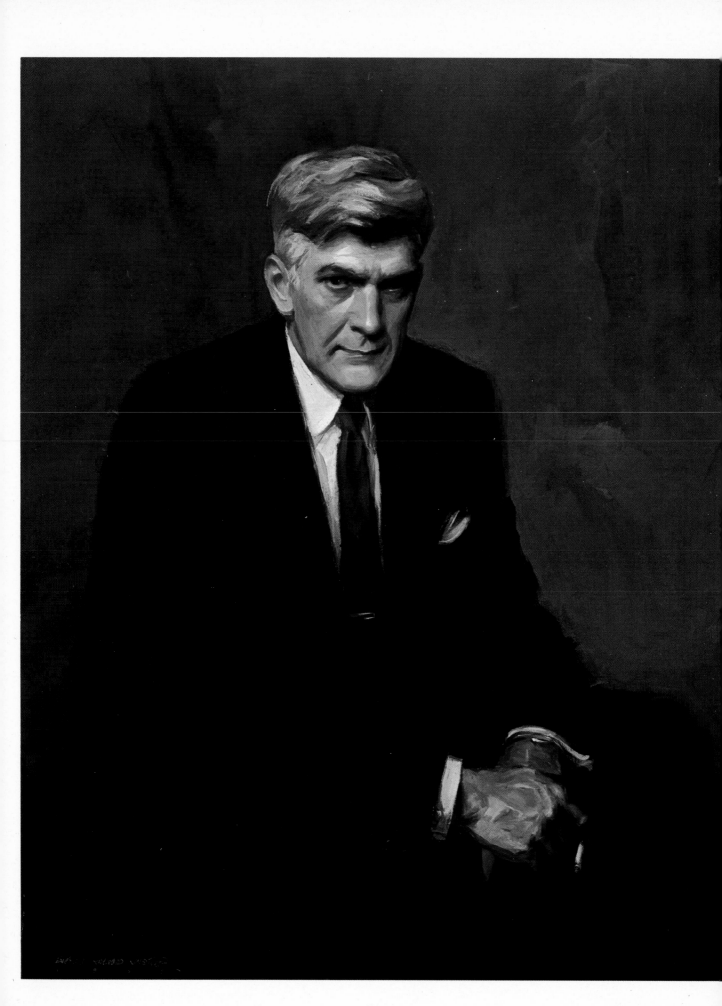

best describe the man. You can't work from pieces, but you can study them for a general feeling of the person.

Selecting a photograph can be a problem if there's too much material on hand. When I painted the late Dag Hammarskjöld's portrait, I discovered that there were files of photographs and slides at my disposal because of his prominence. Selecting the best photograph was quite a job! I feel very strongly about finding the photograph that best describes the subject and is appealing to paint, even if it means altering the pose or environment in the painting, which—in fact—is just what I did in the Hammarskjöld portrait. Polaroid photographs helped me change the pose, and studies of details enabled me to vary the position of the hands and environment.

The reverse of having too much material is having too little. I have turned down commissions when I felt that the photographic material was inadequate. After all, no one remembers the limitations a painter worked under; they only remember the final result. And if I feel that the material is so faulty that my painting will suffer, I'd rather refuse the commission.

Professional portrait photographers have a dreadful tendency to retouch the photographs, to remove the lines of character, the signs of individuality in the face. Often I've found that the photographer has retouched or altered exactly what I would like most to see. Once I was asked to do a portrait of a man's deceased mother. She had been rather plain-looking and, because she was self-conscious, had not encouraged photographs of herself. The only photograph her son had on hand was a professional portrait taken when she was about thirty years old. It had been taken in a very soft light and was extensively retouched.

After showing me the photograph, the client told me that he would like his mother painted in the way she looked when she was in her fifties, when he best remembered her. He suggested all I had to do was to use the photograph as reference and add "a few lines here and there to age her." I explained to him that shifting a line an eighth of an inch here or there could totally alter the character and resemblance of the woman; what age would do to my face is not necessarily what it would do to hers. Fortunately, he was able to locate some photographs of her at a later age which enabled me to do the portrait as he desired.

The quality of a photograph can play an enormous role in the success of a painting. So many photographs tend to be out of focus, gray, or grainy, interfering with my perception of the subject. As I look at a photograph, I imagine how it would look greatly enlarged, hanging from a distance of 8 or 10 feet. What may be acceptable as a snapshot may be all wrong for a portrait painting.

Joseph H. Ball, U.S. Senator, Minnesota, 1940–1948. 39" x 32" Senator Ball is a handsome, rangy man whose features seemed hacked out of stone, part Abe Lincoln, part Gary Cooper. His premature gray hair and strength are characteristics I wanted to include in the portrait. A cigarette in his strong hands was natural. Notice how the cuffs bridge the areas of light and dark, preventing his hands from being two cut-out spots at the bottom of the canvas. Courtesy, Portraits, Inc.

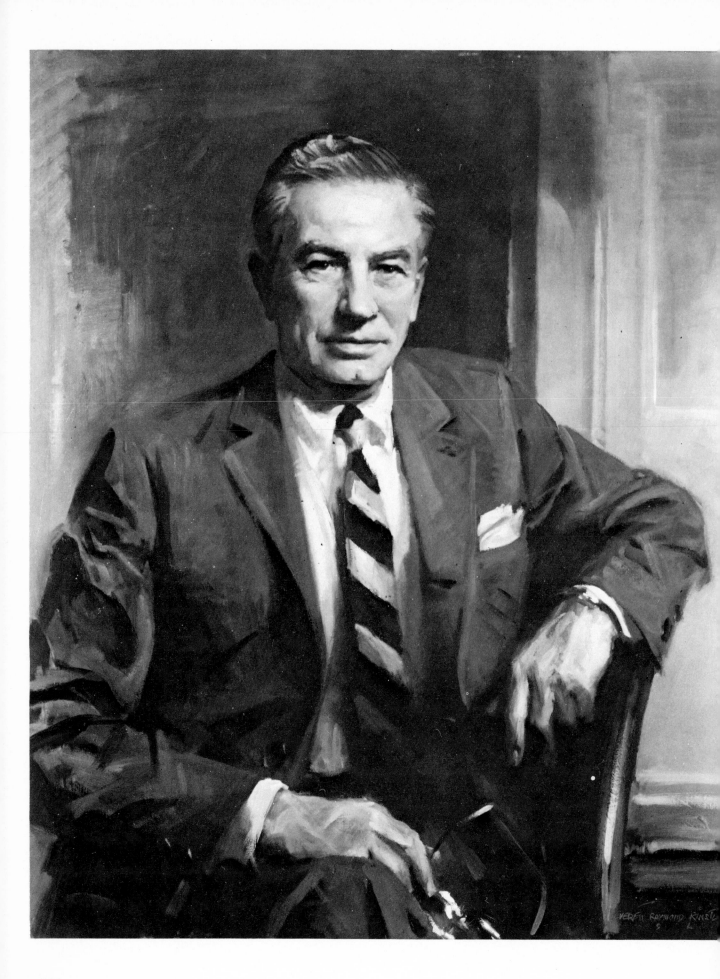

Painting from the Photograph

I paint from the photograph as freely and as directly as if I were painting from life. I take the picture and tack it to an easel, tripod, or any upright support, and paint from it as if it were a live model. This helps give breadth and vitality to my painting. If the photograph is small, I have it enlarged to about 8" x 10" so that I can view it from a three or four foot distance.

I strongly advise covering the photograph with a sheet of acetate for protection. By handling the picture, you can destroy it with fingerprints of oil paint. (Incidentally, I've discovered, from bad experience, that turpentine will remove oil paint from the photograph without destroying the surface of the photo, but I don't think it's worth the risk to put this experiment to the test.) The client may be very partial to the photograph and it may be the only one he has, so I make every effort to protect it from damage.

Whenever possible, I paint from black-and-white photographs, not from color. Color photos tend to distort colors, suggesting hues that are not true to life: someone who is pale may look ruddy in a color photograph. In black and white, the values are truer to actuality. I ask the client to give me the specific colors of the subject's eyes and hair, and from this information I can generally arrive at the color of the complexion. When I'm near completion, I call in the client to check the colors. It's really no trouble to darken the eyes or lighten them if I haven't quite gotten them. These are small details and simple to correct.

As I paint I do everything possible to keep the painting looking as if it were a fresh painting from life. There's nothing to be gained by making the portrait look as if it were a photograph; otherwise, there'd be no point in painting it. The important thing is to concentrate on achieving a good painting. The likeness follows.

As a final word on photography, I maintain that there's a definite danger in relying on pictures too heavily. It's vital to develop a knowledge and ability in painting from life so that you can select intelligently from the photographs. (Remember, the camera flattens out things, whereas your eye will take in planes and depth. For example, edges, transitions, and perspective—so vital to your painting—can be deceptive and downright distorted in the photograph.) Only when you have a sound basis in painting from life can you interpret these distortions into a meaningful and creative painting that no camera could ever have taken. Using photographs can be fun and challenging, if used intelligently and creatively. Consider using the camera so that you can control it—not the reverse!

J. Preston Peters 36" x 30" Due to reasons of health, Mr. Peters was unable to sit for lengthy sessions, so I painted his head, sketched his pose on the canvas, and had a model pose in my studio for the figure. I began to paint on location (in his office) and I shut out the too-strong natural light and worked with artificial. I hung a cloth over a picture hanging behind him to get a dark area behind the head. Collection, Peters, Griffin, Woodward, Inc.

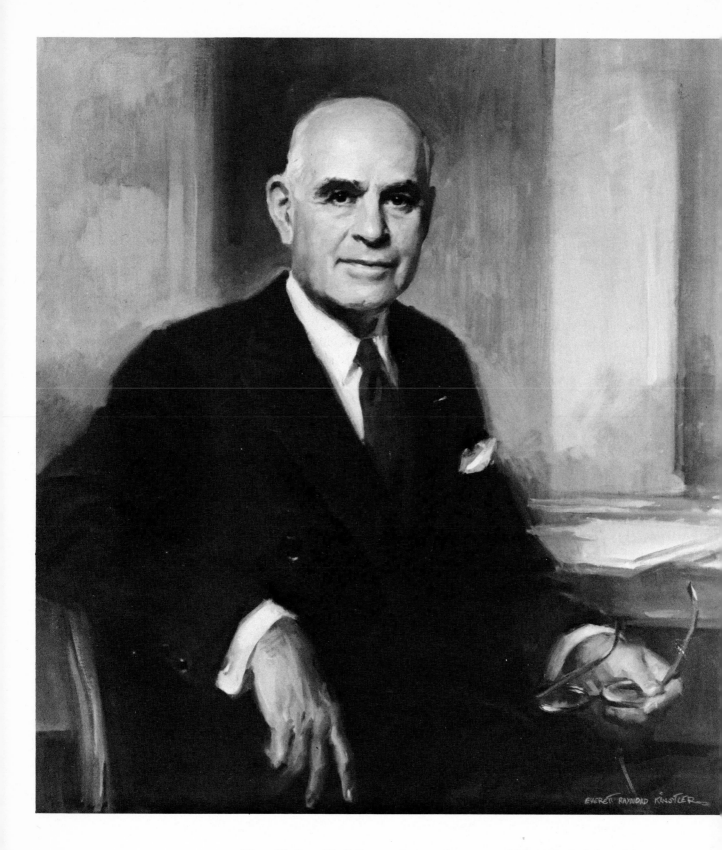

Hon. Herbert H. Lehman, former Governor of New York. 36″ x 34″
This is a replica of a portrait I had painted of the Governor several
years before. I changed this only slightly from the original, making it
brighter, higher in key. It's more stimulating to alter the copy than to
make an exact duplicate. Collection, Mrs. Herbert H. Lehman.

Copies and Replicas

There is a difference between a copy and a replica. If Gilbert Stuart duplicates his portrait of Washington, he is making a replica. If another artist makes a duplicate of Stuart's Washington portrait, no matter how close it is to the original, it is a copy.

I have painted both copies and replicas. Many years ago, I was commissioned to make a copy of a portrait by Ellen Emmet Rand, a very fine painter. Neither the artist nor the subject were living, and the portrait was in the subject's home. Columbia University wanted the portrait because the subject had been the founder of their School for Social Research. You may ask, why not paint a new portrait from photographs? It may happen, as it did in this case, that the portrait captured something that the family liked very much, so that rather than commission an entirely new work, they preferred a copy of the original. I made the copy and signed it with my name, followed by "after a portrait by Ellen Emmett Rand."

For the most part, I prefer to copy my own work. I can study my painting objectively for mistakes I made the first time. It's very rare that a client has insisted on an exact duplicate of my portrait. I had painted the portrait of New York State's Governor Herbert Lehman, which hangs in the Lehman home. The School for International Affairs at Columbia University was making a duplicate of Lehman's study and wanted the painting to hang in the room. Mrs. Lehman did not want to give up the original, so she asked me to make a replica of it, but suggested it didn't have to be exactly the same.

Copies are frequently necessary when a person is prominent and more than one portrait is desired. There are about 27 portraits of Dwight D. Eisenhower, painted by Thomas Stephens. These were painted over a 10-year period so that Eisenhower's portrait could be represented in many different institutions, from West Point to Abilene, Kansas. I know Eisenhower didn't pose for all 27.

A client may also want a large painting for one reason and a smaller one for another reason. When I say smaller, remember that I only paint the head life size or slightly larger, so that a smaller painting actually includes less of the body. But the head is still the same size.

Copying portraits is a very fine way to develop discipline in your work, and I recommend it highly for the student. But I realize that copying doesn't have the same stimulus as starting out freshly on your own. I think this is because the end result is always in sight, and there isn't the same feeling of discovery. Some artists refuse to make copies of their work. And then there are several talented painters who do nothing *but* make copies. In some cases, a portrait painter may send out his portrait to a specialist for copying and then may carry it to the final stages himself.

Never attempt a copy without the original. Only the original will give you the exact proportions, colors, and textures. A photograph will not come close enough!

The Practical Method of Copying

I'm going to start out by describing what I have discovered to be the most practical way of copying a painting. Later I'll describe another way to copy that is less practical but more fun. In any event, I don't use fancy materials for copying—such as a projector or pantograph, because these methods are simply too mechanical for my taste.

To begin, I take a sheet of treated acetate the size of the canvas and tape or tack it over the original painting. Then I make an outline in India ink and trace the contours of the portrait. This is not a highly detailed rendering, but the placement of the lines is exact. When I've finished drawing in the contours of the head, features, body, and hands, I take the acetate and tape it onto a white illustration board so that I can better see my ink lines.

Then I lay a sheet of tracing paper over the acetate and trace the lines with a pen (or pencil if I'm working upright). In other words, I duplicate the entire line drawing on the tracing paper.

I remove the tracing paper from the acetate and turn it over. I take a soft pencil and darken all the lines on the opposite side of the tracing paper, spreading the graphite of the pencil where the lines show through. Placing the tracing paper onto the white canvas, I take a stylus or ballpoint pen that

Mrs. Walter Cheatham 36″ x 30″ *A Southern college had named a chair for Mrs. Cheatham and they commissioned me to do a posthumous portrait. I had only one source of reference for the painting: a handcolored tintype in miniature. I was furnished with more accurate descriptions by her daughter-in-law and son and they brought me a ring she wore, as well as the double strand pearl necklace and bracelet she favored. I had a model pose for the portrait, wearing tulle, which suggested a note of style to set off the characteristic black dress. Collection, Randolph Macon College.*

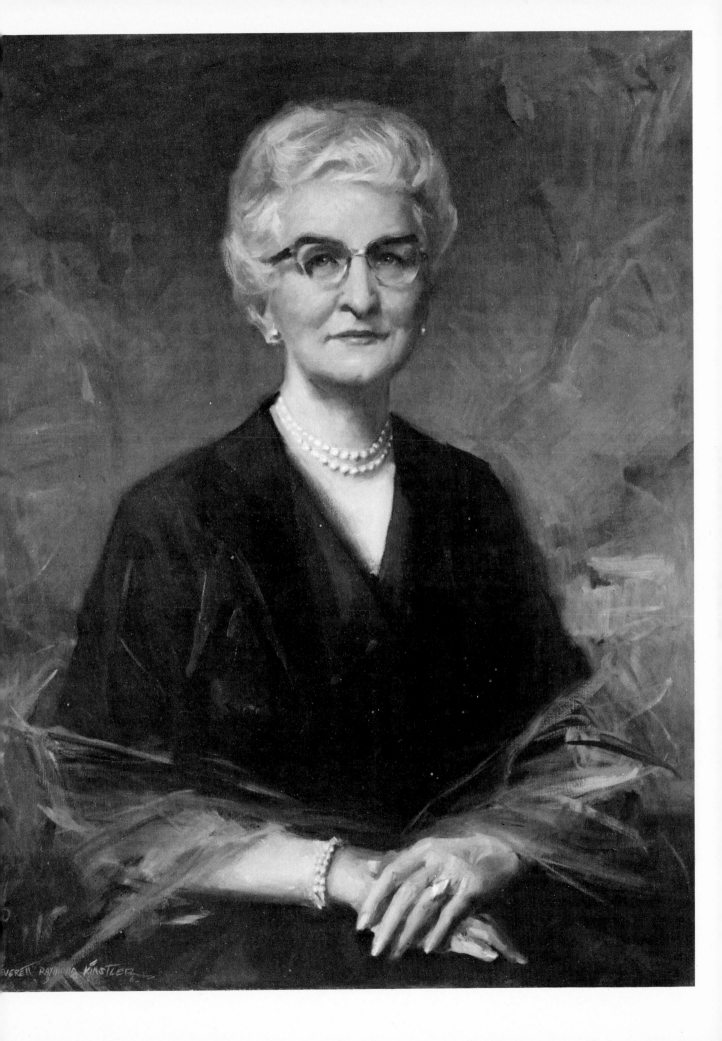

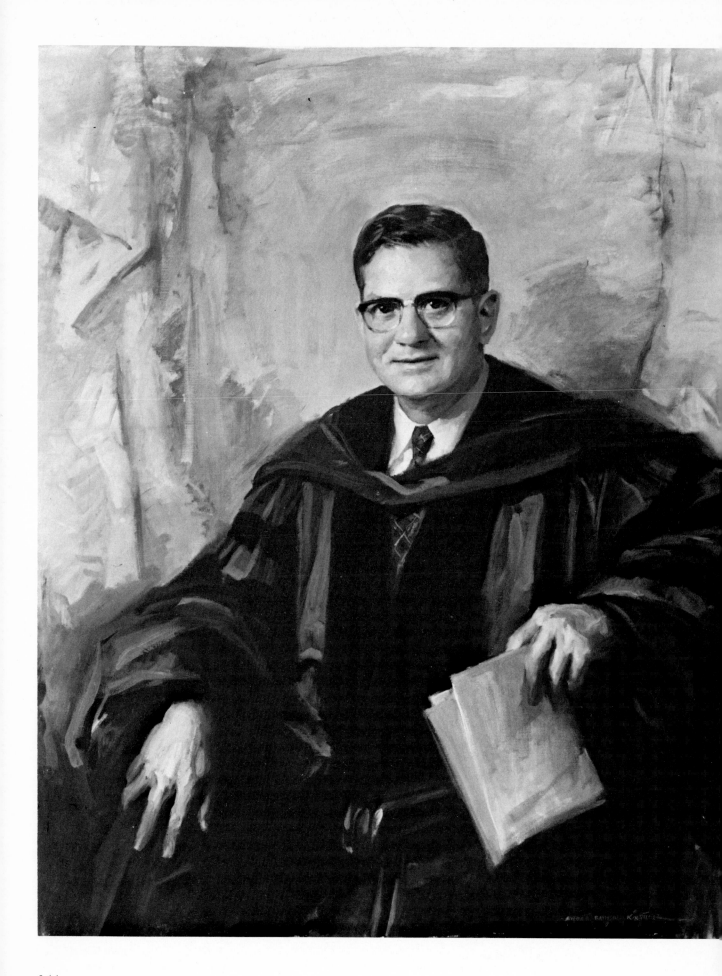

has run dry and go over the lines again. The pressure on the tracing paper transfers the graphite lines onto the canvas. The tracing paper is actually a kind of carbon paper.

For this process, you either need to lay an unstretched canvas onto the floor or table, or you need a backing for the stretched canvas so that you won't puncture the surface with the stylus. I wedge a piece of reasonably stiff illustration board into the frame behind the canvas for support.

Next I check the acetate drawing against the lines on the canvas to be sure I've got everything down and well placed. I spray retouch varnish over the canvas so that the graphite won't smear. I begin to paint now from the original which I've placed on an easel before me. As I paint over the lines, I refer back to my acetate drawing, placing it over the canvas from time to time to be sure I haven't gone off the track.

Less Practical But More Fun

Now I'd like to describe another way of copying that's more fun.

I make an outline drawing of the original on the sheet of acetate as I just explained. But I put it aside and begin to paint on the new canvas immediately. I place the original painting on an easel and work as if I were painting from a model. I carry the painting as far as I can go, then use the acetate as a means of checking my eye, to be sure I've come close to the original placement.

This method may sound risky to you, but I paint more freely, more spontaneously, and my final painting is generally fresher. I think I get these results because I don't have the end result so rigidly in mind. With the first method of copying, my painting tends to become too concerned with detail and if I start with a very tight picture, I find it more difficult to loosen it later. It's rather like painting from numbers. I prefer to correct details later, as if I were painting an original portrait, and go through the steps I find natural to me—from the over-all impression, to the more detailed rendering, then to simplification. I find this much more stimulating.

Matching the Painting

When I copy, I'm certain to place the original painting in the same light as my canvas so that the light hits each canvas equally. If you have the light

Dr. Val Wilson, Former President, Skidmore College. 40″ x 34″ The widow of Mr. Wilson furnished me with many photographs and indicated the likeness she found most characteristic. I was given the academic robes to paint from and experimented with several poses with a model. Although dark backgrounds tend to be simpler, light backgrounds offer a feeling of freshness and space. For centuries portraits were painted in dark backgrounds to give feeling of sobriety to the professional portrait, but I find the light background more contemporary. Collection, Skidmore College.

coming from the right side, obviously there are going to be certain brush-strokes that will pick up the light. This helps me see the direction of those strokes.

From there I approach the portrait as if I were painting from life. Matching the color and strokes is no problem if you really study the original, no more a problem than painting the portrait itself. I must admit, the most difficult task I've faced is copying an old painting where the colors have deepened, developed a patina of age. Here matching colors can be a problem because the new painting never looks quite the same as the older one. I explain to the client that the newer painting is closer to the way the original was when it was painted and that age will darken the copy as well.

Learning from Other Artists

The student can profit greatly by copying the work of an artist he admires. I don't recommend this as a constant practice, but for purposes of study and developing discipline, I think it's excellent.

When a problem arises in my work, I study the portraits of other painters, even though I don't copy their paintings. I go through books and museums, looking for the ways they have resolved similar problems. How should I handle space in a standing figure portrait? Or how do I compose a group of three people? How did Sargent handle it; how did Velasquez? Someone is bound to stimulate you, even if you only get a *negative* reaction to another painting.

Years ago, as an illustrator, I would use reference materials constantly to help me with unfamiliar problems. Albert Dorne once said to me, "Remember, to take from one is plagarism; to take from many is research." And to some extent you *are* a researcher. This doesn't mean that you copy, but that you use these materials to expand your own learning and interpretation.

Mrs. Jefferson Patterson 36" x 30" This portrait was painted to hang in Mrs. Patterson's handsome Washington home. We chose this dress (the simple cut was appealing), and Mrs. Patterson selected the accessories. I felt the need of something more, and after our first sitting I found this ermine wrap that I believe added a note of dash and style. This was painted in Washington, D.C. in four mornings. Collection, Mr. and Mrs. Jefferson Patterson.

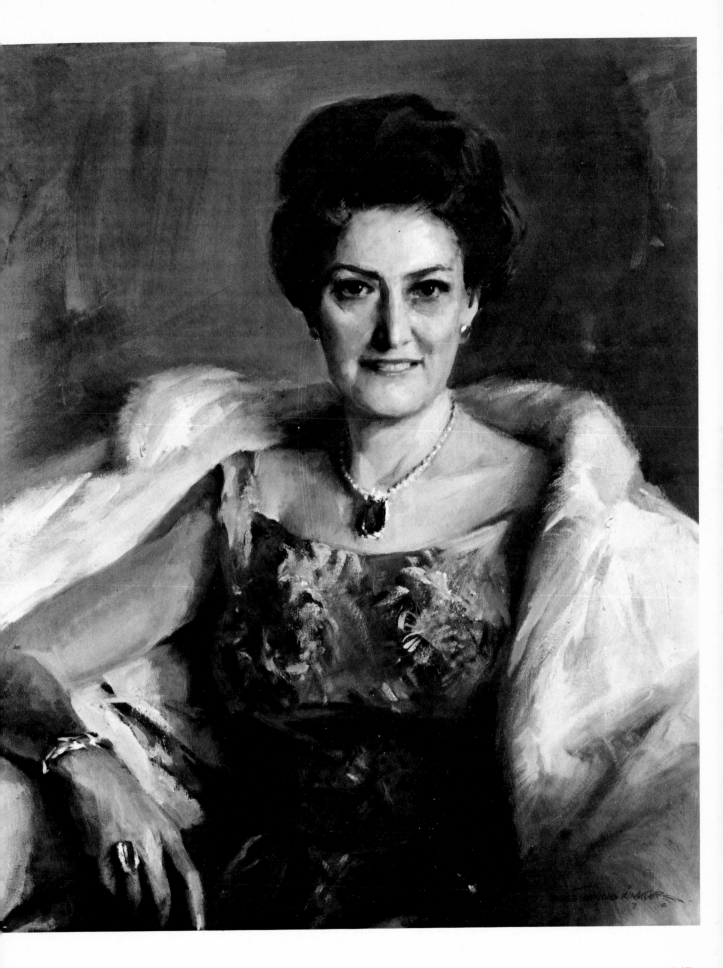

Demonstrations

Painting a Female Portrait

Mr. P. R. Mallory, whose portrait I had already painted, wanted me to paint a portrait of his wife, which was to hang in their New York City apartment. I went there to help Mrs. Mallory select an outfit. She showed me several generally formal dresses. I suggested she pose in the red suit she was wearing at the time, since the bright color was becoming to her vivacious and sophisticated personality. It looked smart and contrasted with her striking white hair. I asked her to bring a second outfit, so that I could judge it in the light of my studio, and also suggested she wear some jewelry, a necklace, brooch, and bracelet.

I seated her on the model stand and she relaxed into a comfortable position almost immediately. I suggested she change her brooch from the right to the left side, to give a note of interest to that side. I placed her head shadow side forward, using available north light, the background simple, using the dark of the doorway behind to offset her striking white hair.

I decided, in this case, to paint on a white canvas, rather than a toned one. It's hard to say why I prefer one to the other, but in recent years I've been doing much more work on the white surface. This painting was high in key and I felt the white canvas would bring forth the colors more vividly.

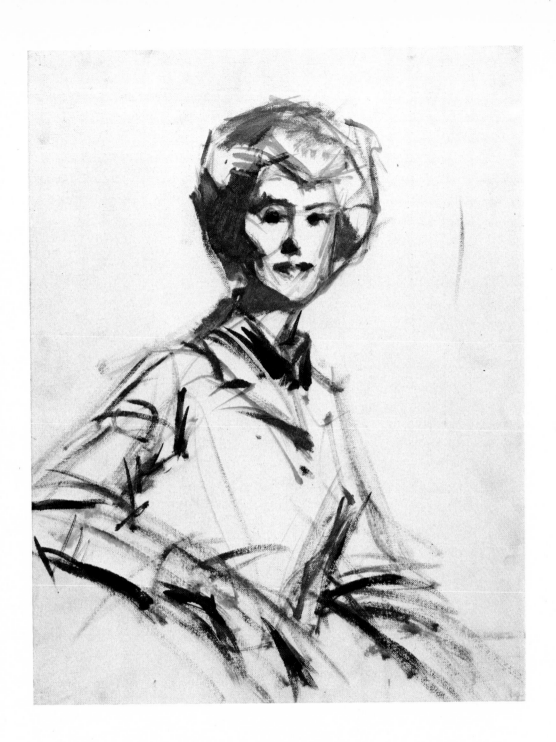

Stage One Working directly with a brush on the white canvas, I blocked in the pose in a bluish-gray monochrome. I established the over-all shapes first, using medium-sized filberts. My first thought is the movement of the model, the action of the body, and the placement on the canvas. Prior to this I may have taken an hour or an hour and a half to determine the angle and lighting, but this stage represents only about fifteen minutes of work. Once I'm committed to the pose, the blocking in comes quickly. I don't make a particular attempt to establish likeness, but I place only the general shapes and masses, the dark areas first.

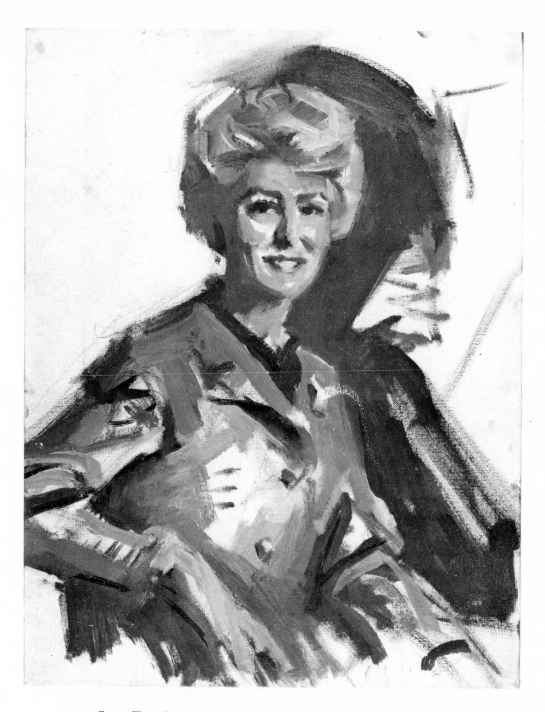

Stage Two Carrying the painting further, I reinforced and restated the shadow areas more precisely. I take the brush that approximates the shape and width of the area I'm painting and I follow the planes with the brushstrokes. I select the stroke, angle, and color that matches the particular form. This method of painting produces a sculptural effect that gives dimension and vitality to the painting. I'm still making no attempt to get detail, merely spotting the placement of shapes, such as the buttons and the darker tone against the head in the background. I used a richer cadmium palette than usual—cadmium red, red light, yellow, and orange—because the red suit established a bright, intense color key. I placed some of the colors in the jacket and in the background, going back and forth to establish the value relationships of the painting.

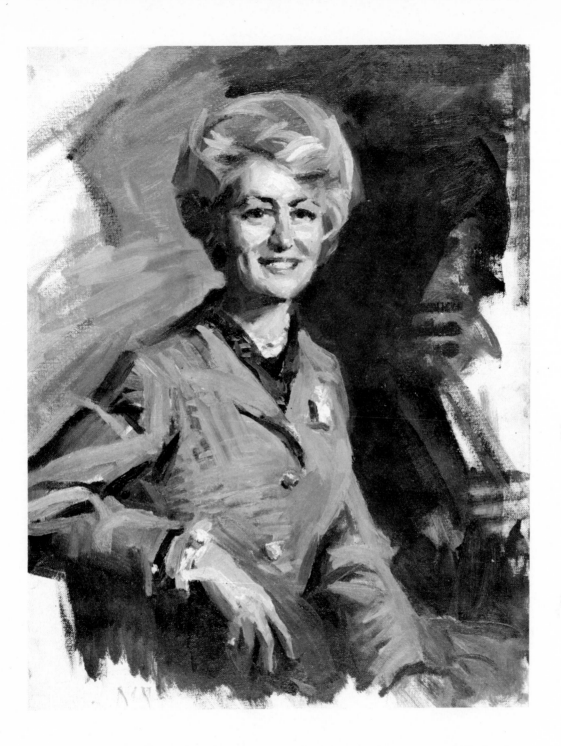

Stage Three The entire painting is further developed, not just the head. Some of the strokes that I made in earlier stages are still there; most have been reworked. As the model becomes more sharpened, it is reduced in size. I begin by painting the shapes—such as the hand— slightly oversize and with refinement they reduce. When I blend, I don't soften the edge, but select the brush and color to suit the particular areas of dark, light, and middle tone. Blending tends to make the painting too smooth, which is why I don't use sables. The dimple, for example, its shadow part is painted in raw umber, white, and a little chrome oxide; the light section is alizarin, raw sienna, and white; the halftone is a gray-green, three different mixtures placed in the proper locations.

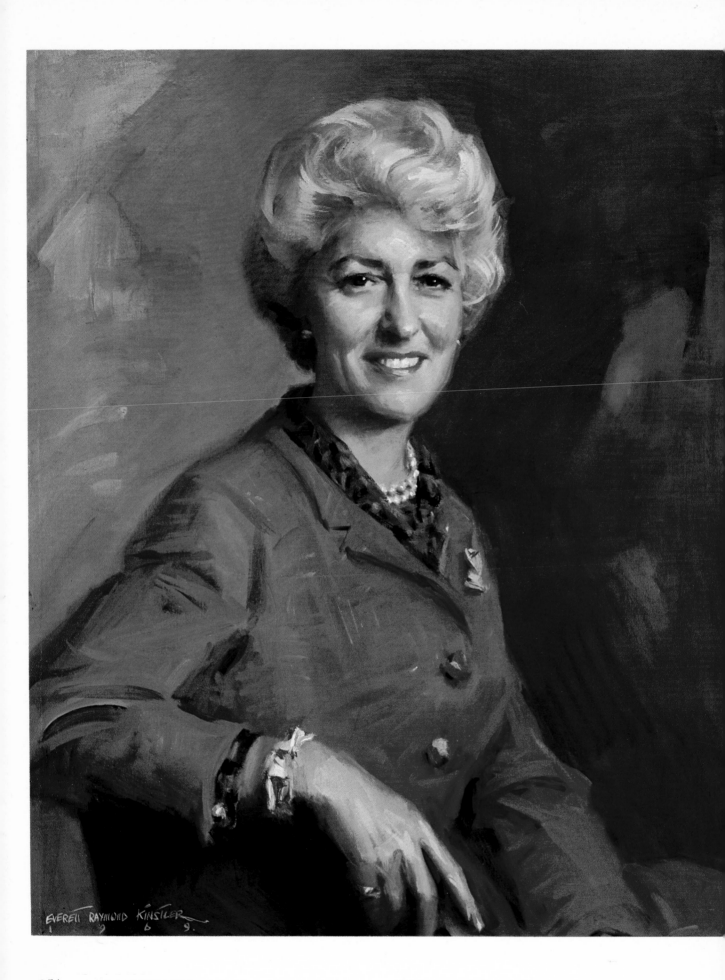

Painting a Child

The most important characteristic of a child is youth. In painting a child, if you don't get that feeling of youth, you've lost your portrait. The pose and expression should reflect the animation and spontaneity of the child. For this reason, it's worth considering a third party at the painting sessions, someone to help keep the child attentive. Their interest is worth retaining, so that you have an animated child to paint.

Mary Lois arrived at the studio wearing her favorite party dress. Wandering around the studio, at one point she relaxed and settled easily on the floor. This position formed a charming contrast to the formality of her party dress and I decided to paint it. Her lack of inhibition and reserve was the childlike quality I wanted to convey and this pose was most suitable in establishing that spirit.

An adult's head is about 10″ long and a child's about half that. Therefore, if you have a 25″ x 30″ canvas—as I had with Mrs. Mallory—you'd probably get both hands and her lap into the canvas if the painting is life size. In this 35″ x 41″ canvas, the entire body had to be considered: the legs, the folds in the dress, the entire movement of the body. With children, painting life size generally means getting more of the body into the canvas.

I decided to paint this on a toned canvas, since I wanted an over-all subdued color. Before the child arrived, I put a blue-gray wash over the canvas so that it was completely dry before the sitting. (A cool tone is always preferable for this purpose, because the halftones tend to be cool rather than warm.) She sat on the floor in front of my fireplace. I decided to eliminate the fireplace because it was too busy and distracted compositionally from the child.

Final Stage: Mrs. P. R. Mallory 30″ x 25″ Notice that I've cut off a piece of canvas along the bottom. I wanted a sharper square. Removing a couple of inches improved the composition, giving the head more dominance on the canvas. Although the painting is more in focus now, I continue using filberts—particularly the broad ones—right to the end, to prevent the picture from getting too precise. Even the highlight in the eye is placed at arm's length with a filbert. I reinforce the large, general approach, the bold impression. Collection, Mr. and Mrs. P. R. Mallory.

Stage One Even though I've blocked in very little of the canvas, the blue-gray tone establishes a certain feeling for the background. I started in with the light and shadow and the over-all movement of the composition, working almost totally in monochrome. I do spot in some color, indicating the approximate hue of the eyes, painting in a little white in other areas, such as the stockings. The middle tone, however, is predominant because of the prepared canvas.

Stage Two Here I began to lay in the color. Because this is a more subdued portrait than that of Mrs. Mallory, I didn't use much alizarin or much of the cadmiums. I did, however, use the cadmiums in the face because the intensity of these colors represents more youthfulness. Otherwise, I am using my normal palette. I carry everything further at the same time: if the face is more focused, so is the lace, the shoes, and the legs. Since the middle tone has been established by the toned canvas, the light areas must be suggested and placed. I also strengthened the shadow areas, indicating the pattern of light as it falls from the head down to the legs and stockings. If the painting looks rather tight here it's because reducing it to the page size of the book tends to make it appear so. Actually, it's still very sketchy.

Stage Three Until now—with the exception of the shadow—I allowed the tone of the canvas to act as a background tone. Now I begin to scrub in with a thinned color into the background. I used a thin dilution of paint because I wanted an impasto effect on the dress. I intended to reserve the character of the crisp brushstrokes for the areas of light and keep the rest of the painting subdued. If I had used a heavier application of paint for the background it would have distracted from the dress. Notice that the placement of the figure is the same; the areas have only been sharpened and refined.

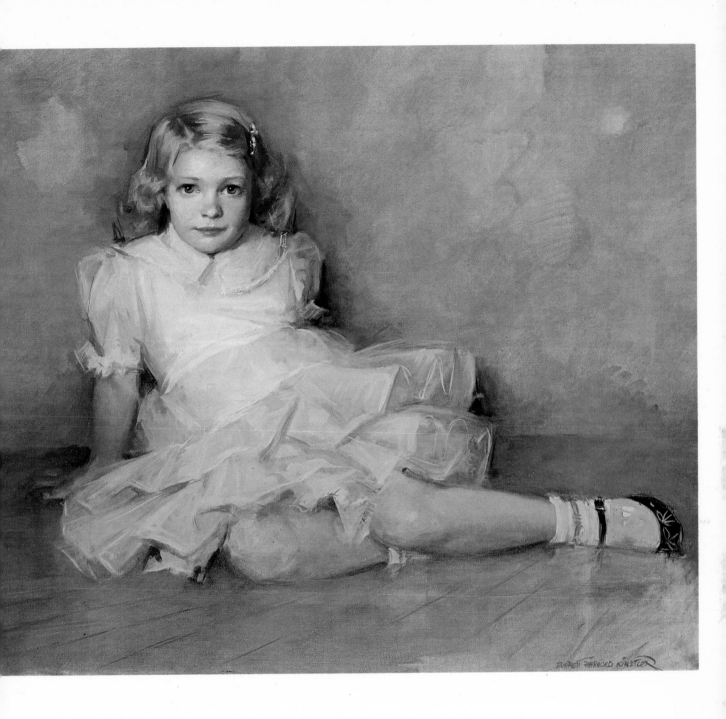

Final Stage: Mary Lois Murphy 34" x 40" The toned canvas is the blanket which unifies the painting. I can eliminate it or retain it wherever I feel it helps the painting and—as you can see—there are areas of the original tone still remaining in the final painting. Texture has been more sharply indicated: the impasto on the dress, the reflections on the floor, the soft, undefined quality of the background.

Painting a Male Portrait

I was commissioned to do a portrait of actor Dennis King, President of the Players Club. The club is an actors' organization and the painting was to hang in Gramercy Park clubhouse, in the historic home of Edwin Booth. The character of the building appealed to me enormously and I was proud to have my painting hang in the same building where three excellent portraits by John Singer Sargent are situated.

Dennis King spent fifty years of his life in the theater, and had a distinguished career, from the young leading man to character actor. I wanted to portray him and suggest "actor." The easy, obvious way to accomplish this was to paint him in costume. But I wanted to suggest his profession without using gimmicks, without the props. What could suggest theater? Here I had the opportunity to paint someone who had more color than I generally find in a boardroom portrait, and I wanted this portrait to be distinctly different.

The outfit Mr. King was wearing when he came to the studio settled the question: a blue blazer with the Players Club crest sewn onto the left pocket, a flash of pocket handkerchief, a yellow tattersall vest, and a blue shirt. This outfit had the color and flair I associated with an actor and, with this in mind, I began to paint him. First I made a life-size oil head sketch of him to study his head and his expressions. I was able to experiment here because Mr. King was available for extra sittings, since the Players Club—which he frequented—is next door to my studio.

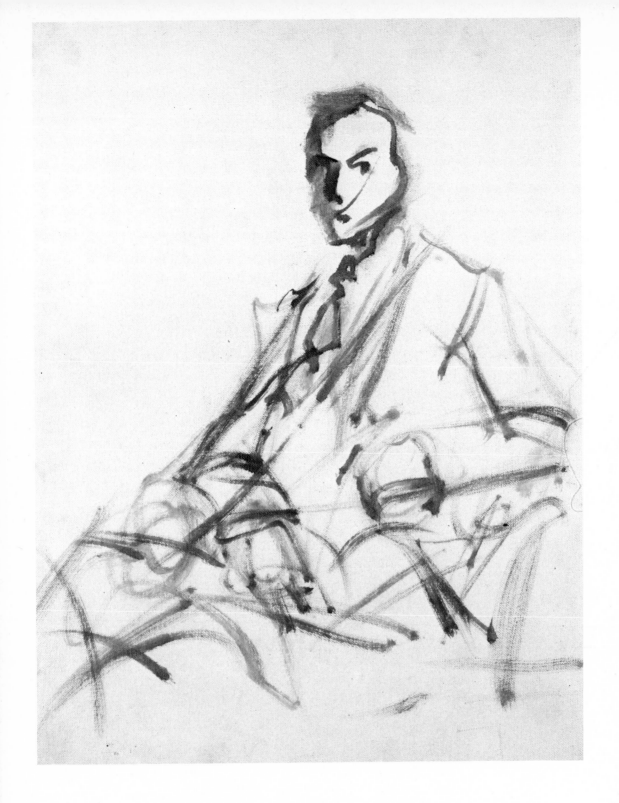

Stage One This is actually the second sitting. I had already made an oil head sketch of Mr. King and I felt ready here to block in the general pose, one which he fell into quite naturally. I had him sitting on this side because I wanted to take advantage of the crest beneath his handkerchief to suggest more individuality in the painting. Posing him in the reverse would have made the blazer look like an ordinary blue jacket. As I sketched on an untoned canvas, I noticed that he had a tendency to hook his finger into his vest pocket, and I painted this characteristic gesture. I placed the dark areas first as usual.

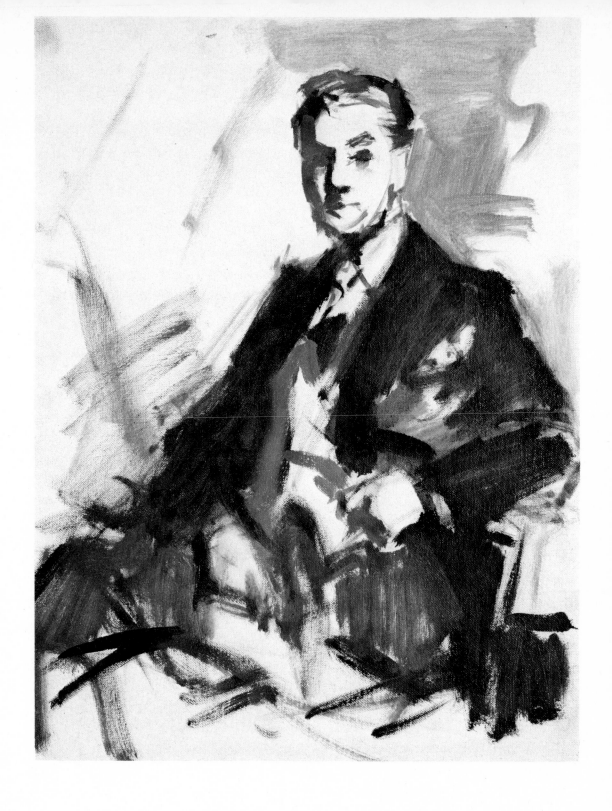

Stage Two Since I wanted no obvious theatrical props, I placed him in front of a simple screen background, turning the screen slightly to make a shadow behind the head. I had begun to paint him with one hand in his lap, and I continued to paint him in this way. Somewhere toward the end of this sitting, I felt I wasn't suggesting enough of the actor in him; it simply wasn't individual enough. I began to think about how I would resolve this.

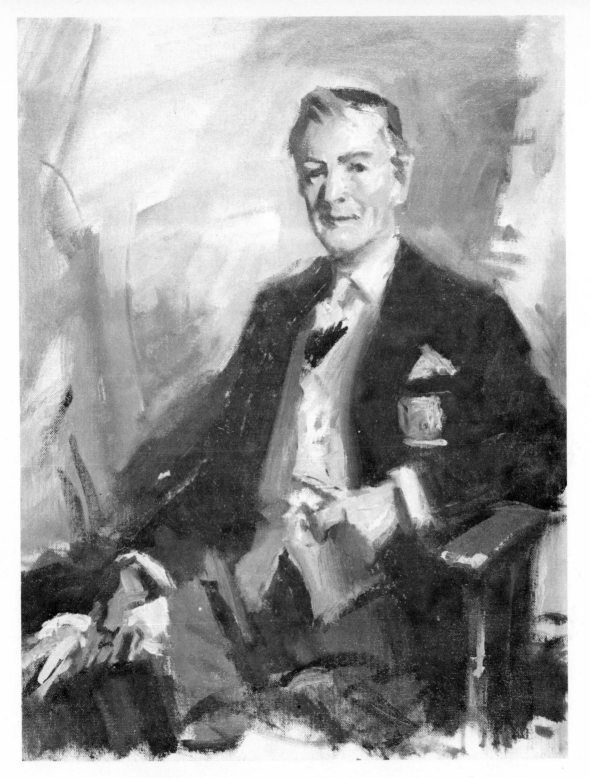

Stage Three *I remembered that Mr. King wore a top coat and used light-colored gloves that had a great deal of style. Although I retained the general placement of the body, I positioned his coat on his lap and gloves in hand, much the way he would look if he had just dropped in and sat down. I could do this without drastically changing the painting. I don't hesitate to change a painting if I think it will improve the effect and I felt the coat and gloves added just the degree of style to suggest more of the actor in him. Using my normal palette, I painted the background thinly and developed the entire painting equally, restating the lights and darks. Notice that in painting the hands, I've painted planes and gesture, not individual fingers.*

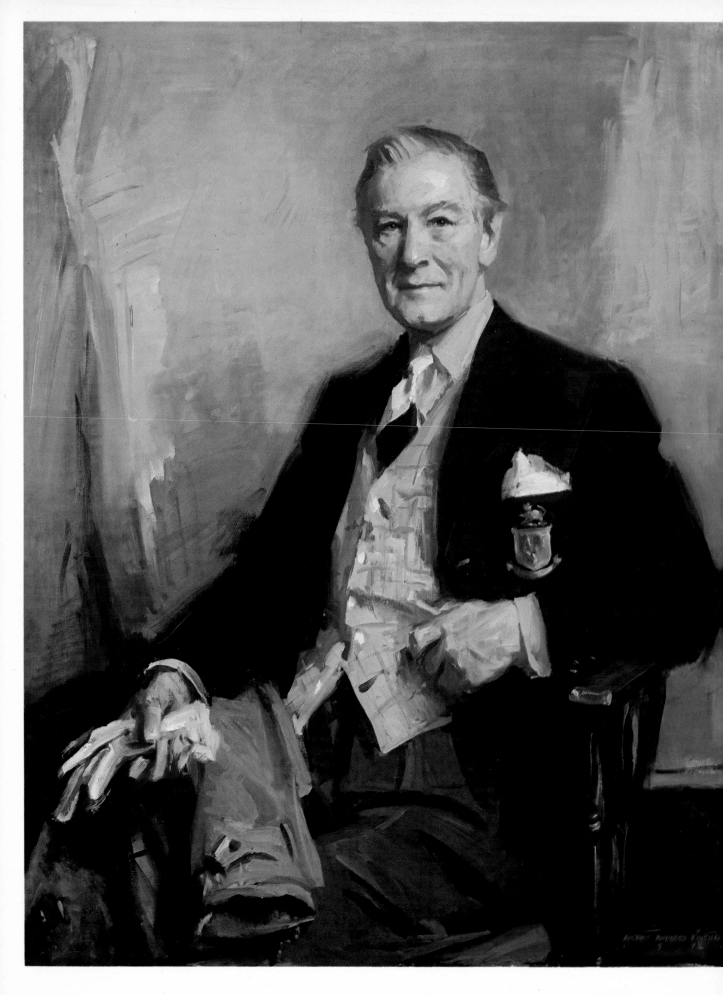

Painting a Group Portrait

In painting this group portrait of the Osborn family—grandfather, son, and grandson—I faced a challenging compositional problem: how could I place them in an interesting relationship? Three heads together would be tedious and uninteresting. I also realized that if I put the child on the floor, only a very huge canvas could include the two men as well. The same would be true if all three were standing. Although I wanted to paint a good-sized canvas, I didn't want the size to overpower the subject matter either.

I chatted with the family in my studio, hoping to get a feeling about how to resolve the problem. All three were sitting on the sofa in my studio. As we began to talk, the boy—who was about four years old—started to climb onto the cushion. The grandfather was just about to prevent the boy from putting his feet on the sofa when I said, "Let him stay." That was the beginning of my composition. The boy was elevated to the height of his grandfather and I felt this would control the scale of the painting.

Now I had a starting point, and we began to experiment with the position of the son in the composition. I asked him to sit next to the boy, but that wasn't acceptable: the grandfather and son were at the same eye level, making an undesirable horizontal band across the composition. Finally, I asked the son to lean over the back of the sofa and felt I was on the right track.

I quickly made a sketch of the little boy in pencil. At one point—while the boy was still on the sofa—he leaned over and put his hand on his grandfather's shoulder and I knew that was what I wanted in the painting. At a later date, I made two oil sketches of the grandfather, (he lived in Louisiana and couldn't come to my studio for frequent sittings). The boy and his father lived in New York, and were available to paint in my studio.

Final Stage: Dennis King 50" x 45" *I've pulled the entire painting into focus; the vest has become a specific vest, the eyes have formed a particular twinkle characteristic of the subject, and the slight quizzical lift of the eyebrow was also particular to him. I had arranged the coat to include the sleeve. I also wanted to paint in the button of the coat, but couldn't arrange the garment to include both button and sleeve. It didn't matter; I simply indicated the button as an abstract form on the coat. The button helped suggest the coat. If there had been any doubt about the form in his lap, it would have been distracting. Collection, Players Club.*

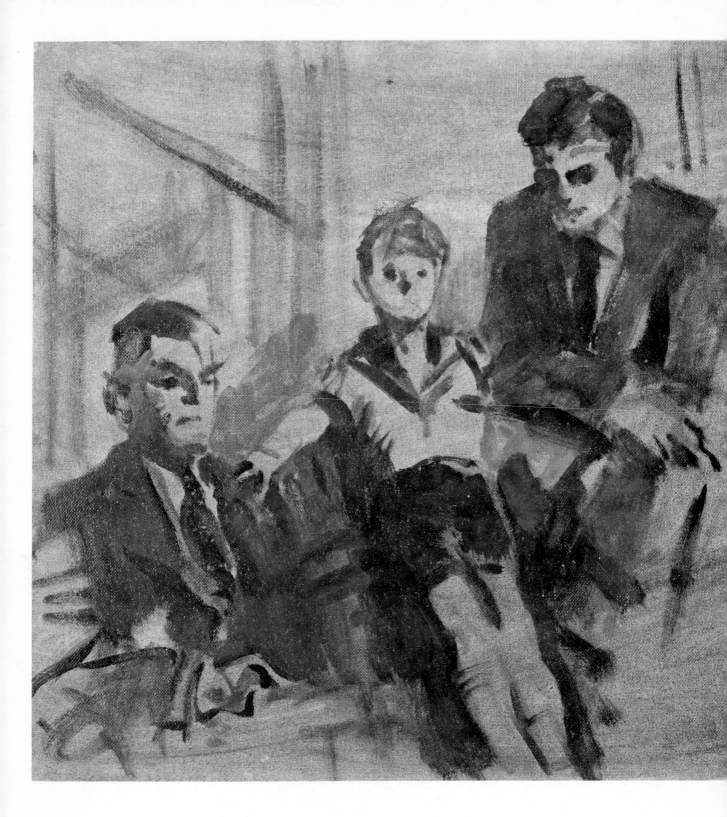

Stage One I blocked in the figures onto a toned canvas. Once I established the placement of the figures, I indicated some lines in the background to balance the composition. When I completed this stage, I began to feel there was something unnatural about the grandfather staring off into space while his grandson was reaching out to him. There was no contact between him and the boy, and this disturbed me. I thought of a solution.

I made some sketches of the grandfather's head.

Stage Two I turned the grandfather's head toward the grandson, taking full advantage of the older man's strong profile which held very well in the total composition. His looking up at the boy was more in keeping with the warmth of their relationship and helped the painting compositionally. In the background I blocked in the biggest area of space, behind the grandfather, indicating a stairwell behind him. The grandfather was an inveterate smoker and I decided to paint him with cigarette in hand. I used more of the earth colors in this painting because it was a subdued color scheme.

Stage Three I wasn't satisfied with the stairway I had painted behind the grandfather. I wanted to give the feeling of more space. I needed a dark area behind the grandfather's head to retain the strength of the profile. I must have tried every possible arrangement for the background! I tried louver doors, windows, etc., but without success. Finally, I settled on this arrangement: a doorway, giving me the dark behind the grandfather's head, a light area behind the grandson's head, and an abstract shape—a picture frame, perhaps—to set off the son's head.

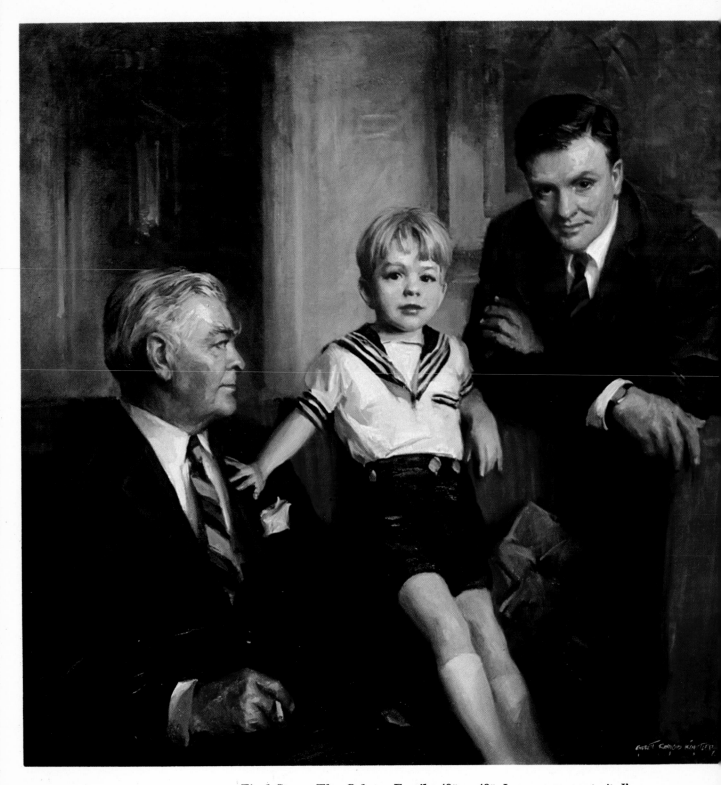

Final Stage: The Osborn Family *48" x 48"* In a group portrait I'm particularly conscious of compositional elements. While the boy was posing he brought his hand up around from behind the back of the sofa. I preferred showing both arms and hands, so I changed to this position. Even the pillow tucked in the corner helped me make a space more interesting. I think I tried dozens of arrangements before I ultimately arrived at this solution. Collection, Mr. and Mrs. Harold Gray Osborn.

Some Concluding Thoughts

In this book, I have focused on craft and technique because, without them, it is impossible to project and communicate ideas. To conclude on this note would be less than inadequate. In the exploration and pursuit of craft there are other qualities which transcend technique. To name one: observation. This includes seeing as well as looking—two different things, I assure you. Seeing is thinking about what you are looking at. An artist must train himself to observe. I don't mean that no one else does this, but an artist does it to an intense degree. Point to a sheet hanging on a clothes line, and ask someone what color it is. He will say, "white, of course." When more carefully observed, it is not white, but very pale yellow; and the luminous shadows where the wind folds it over are blue, lavender, and yellow. Such subtle distinctions of color occur on the face as well, in the clothing, and background of a portrait.

Years ago when I was studying at the Art Students League, I was fortunate to have as an instructor the late Frank V. DuMond. He was first of all an artist, well grounded in the tools of his profession. He also had a great ability to impart that knowledge and stimulate the curiosity and hearts of his students, no small achievement. He believed in exploring, not surveying. And there is a difference. On one occasion, Mr. DuMond, in reply to a question, said, "I'm not only trying to teach you to paint, but also to see." It was he who first impressed me with the necessity not only to train and control your medium, but to develop and stimulate the senses, heart, and mind.

The painter attempts to conceive from what he has observed in nature, and he must be thrilled by his concept if he hopes to convey it to others. It is his function to draw from life and to select, edit, and compose from it. His challenge and responsibility is to bring life to life. He works to transcend life, to lift it out of the dull and commonplace and give it meaning.

I have tried to emphasize the importance of developing and disciplining craft, and the importance of constantly experimenting with new ideas to best express what you are trying to communicate. Coupled with this is the nourishing of the imagination, so that one's pictures express thoughts and feelings, reflecting responses to beauty (or homeliness), and become a record of humors and sympathies, interests and individuality.

Partial Listing of Portraits by Everett Raymond Kinstler

James Fairchild Adams, *President, Albany Medical College*
Hermon J. Arnott, *Chairman, Farmers & Mechanics Bank*
E. F. Averyt, *Chairman, Colonial Life & Casualty Co. Bank*
Richard Baker, *Bishop of North Carolina*
Joseph H. Ball, *U.S. Senator; Minn.; 1940–48*
Francis Barry, *President, Downtown Athletic Club*
Dr. Glenn C. Bartle, *President, Harpur College*
Francis X. Bensell, *President, N.Y. County Lawyers Association*
Truman Bidwell, *Chairman, N.Y. Stock Exchange*
James H. Binns, *President, Armstrong-Cork Co.*
William Black, *Chairman, Chock Full O'Nuts Inc.*
Dr. Lyman Bleecker, *Rector, St. John's Church, L.I.*
Dr. W. Bryan Bolich, *Dean, School of Law, Duke University*
Lewis Bonham, *President, Norwich Pharmacal Corp.*
James M. Bovard, *Chairman Emeritus; Carnegie-Mellon Inst.*
Alan S. Boyd, *U.S. Secretary of Transportation*
Gordon S. Braislin, *Board Chairman, Dime Savings Bank*
Thomas Brittingham, *Trustee, University of Delaware*
Robert S. Brustein, *Dean, School of Drama, Yale College*
Scott Carpenter, *Astronaut*
Wilson Carraway, *President, Florida State Senate*
Prof. Elliot Cheatham, *Dean Emeritus, School of Law, Columbia University*
Owen R. Cheatham, *Board Chairman, Georgia-Pacific Corp.*
General Mark Clark, *West Point Museum*
Charles W. Cole, *President, Amherst College*
William H. Colvin, *President, Crucible Steel Corp.*
Lammot duPont Copeland, Jr.
Edgar Couper, *Chancellor, University of State of New York*
Ben Cowdery, *Publisher, Omaha Herald*
Dr. John Richard Craft, *Director, Columbia Museum of Art, S.C.*
Robert T. H. Davidson, *Chairman, Trustees, The Brooklyn Hospital*
Cleveland Dodge, *Chairman, Teachers College, N.Y.C.*
Mrs. Irenée duPont, Jr.
Miss Irene duPont
James H. Evans, *Board Chairman, Seamans Bank, N.Y.*
Benjamin F. Few, *President, Liggett & Myers*
Dr. John Fischer, *President, Teachers College, N.Y.C.*
Benjamin R. Fisher, *President, Fisher Scientific Co.*
Walter Frank, *Chairman, N.Y. Stock Exchange*
Orville Freeman, *U.S. Secretary of Agriculture*
Theodore R. Gamble, *President, Pet Inc.*
Dr. Mary Gambrell, *President, Hunter College*
John T. Gilbride, *President, Todd Shipyards*
J. Roycroft Gordon, *Chairman, International Nickel Co.*
Leo Gottlieb, *President, N.Y. County Lawyers Association*
General Wallace Greene, *Commandant, U.S. Marine Corps*
James Hagood, *President, Wm. Bird Co.*

Charles D. Halsey, *Chairman, Flower Fifth Avenue Hospital*
Clarence B. Hanson, *Publisher, Birmingham News*
Dr. A. Blair Hellman, *President, Manchester College*
A. Sydney Herlong, Jr., *U.S. Congressman*
Milton J. Higgins, *Chairman, Norton Co.*
Rt. Rev. Walter M. Higley, *Bishop, Trinity Memorial Church*
W. Randolph Hodges, *President, Florida State Senate*
Frank K. Houston, *President, Chemical Bank N.Y. Trust Co.*
W. Thomas Hoyt, *President, N.Y. Athletic Club*
Wm. Sperry Hutchinson, *President, Sperry & Hutchinson Co.*
Orrin G. Judd, *Judge, Surrogate Court, N.Y.C.*
Lucius Kellam, *Chairman, Chesapeake-Bay Bridge Tunnel Project*
David M. Kennedy, *U.S. Secretary of the Treasury*
Dennis King, *President, The Players Club*
Charles Kingsley, *President, Manufacturers Aircraft Association*
Grayson Kirk, *President, Columbia University*
General Wm. A. Knowlton, *Superintendent, U.S. Military Academy*
Dr. Harry Kruener, *Rector, Plymouth Church*
Raymond H. Lapin, *Chairman, Federal National Mortgage Association*
Herbert H. Lehman, *Governor of New York*
P. R. Mallory, *Chairman, P. R. Mallory Co.*
Forrest E. Mars, Sr., *President, Mars Corp. Ltd.*
Dr. Frances Mayfarth, *President, Wheelock College*
Bruce McClellan, *Headmaster, Lawrenceville School*
Admiral David McDonald, *Chief of Naval Operations, USN*
Dale McMillen, *Chairman, Central Soya Co.*
R. E. McNeill, *Chairman, Manufacturers-Hanover Trust Co.*
Sherley W. Morgan, *Dean, School of Architecture, Princeton College*
Edward Mortola, *President, Pace College*
Henry L. Moses, *Chairman, Montefiore Hospital*
Emil J. Pattberg, *Chairman, First Boston Corp.*
Charles Plumb, *Chairman, Franklin Society Savings & Loan Association*
General E. R. Quesada, *Administrator, Federal Aviation Agency*
Mrs. Stanley Rinehart, Jr.
Thomas Robertson, *Chairman, The First National Bank of South Carolina*
Israel Rogosin, *Chairman, Wiltwyk School*
George Emlen Roosevelt, *Chairman, Trustees, New York University*
Elihu Root, Jr., *Trustee, Hamilton College*
John Rose, *President, Kellogg-Citizens National Bank*
Mrs. Sarah Mellon Scaife, *Rolling Rock Club, Ligonier, Pa.*
Edward J. Scheider, *President, Lotos Club*
John Schiff, *Senior Partner, Kuhn-Loeb*
G. Richard Shafto, *President, Cosmos Broadcasting Corp.*
Senator Wm. A. Shands, *President, Florida State Senate*
Alan B. Shepard, Jr., *Astronaut*
Lansing P. Shield, *President, Grand-Union Corp.*
George Steele, *Assistant Headmaster, Choate School*
Mrs. DeWitt Stetten, *School of International Affairs, Columbia University*
Jerome Straka, *President, Chesebrough-Ponds, Inc.*
Robert L. Sumwalt, Sr., *President, University of South Carolina*
James E. Thomson, *President, Merrill Lynch*
Maurice Warnock, *Chairman, Armstrong-Cork*
Dr. Frederick Wertz, *President, Lycoming College*
W. Willard Wirtz, *U.S. Secretary of Labor*
George Woods, *President, World Bank*
Dr. Quincy Wright, *Dean Emeritus, School of Law, University of Chicago*

Index

Edited by Susan E. Meyer
Designed by James Craig
Photography by Peter A. Juley & Son and Brenwasser Labs
Composed in eleven point Electra by Atlantic Linotype Corp.
Printed and bound in Japan by Toppan Printing Co.